CONCEPT PHOTOGRAPHY
RICHARD J BURBRIDGE

S0-AWT-432

DIS
10/

IMAGE
0005

LOCATION
CAPILLA PEAK OBSERVATORY
ALBUQUERQUE, NEW MEXICO

INSTITUTE FOR ASTROPHYSICS
UNIVERSITY OF NEW MEXICO

OBJECT
MOON, COPERNICUS

DIRECTOR OF INSTITUTE
JOHN McGRAW

RESIDENT ASTRONOMER
RANDY GRASHUIS

IMAGE PROCESSING
LOS ALAMOS NATIONAL LABORATORY

SCIENTIFIC STAFF MEMBER
GALEN GISLER

GRADUATE RESEARCH ASSISTANT
NANCY CHABOT

FILTER	EXP. TIME	MOUNTAIN DAYLIGHT TIME	EPOCH	RA EQUIV. LONGITUDE	DEC EQUIV. LATITUDE
B	0.1	03:34:50	1994.5	23,00,48	-02,12,00

COMMENTS
TELESCOPE IS 24"DIAMETER
F RATIO 15.2
OPERATING ON RCA CCD

FIRST PUBLISHED BY BOOTH-CLIBBORN
EDITIONS, 12 PERCY STREET, LONDON W1P 9FB
©1995

DESIGN
SEAN PERKINS, KATE TREGONING

CONCEPT PHOTOGRAPHY
RICHARD J BURBRIDGE

TEXT
SEAN PERKINS, RALPH ARDILL, ADRIAN CADDY,
IN ASSOCIATION WITH IMAGINATION LTD

EDITED AND COMPILED BY
SEAN PERKINS

ISBN 1 873968 20 5

ACKNOWLEDGMENTS: THIS BOOK WOULD NOT HAVE BEEN POSSIBLE WITHOUT THE CONTRIBUTION AND CONTINUING SUPPORT OF GARY WITHERS, MANAGING AND CREATIVE DIRECTOR AND RALPH ARDILL, MARKETING DIRECTOR OF IMAGINATION LTD

DESIGN ASSISTANCE: MALCOLM GOLDIE, BRYAN EDMONDSON, PAUL WINTER
RESEARCH ASSISTANCE: SANDY GRICE

CAPTIONS AND ARTWORK IN THIS BOOK ARE BASED ON MATERIAL SUPPLIED BY THE ENTRANTS. WHILE EVERY EFFORT HAS BEEN MADE TO ENSURE THEIR ACCURACY, BOOTH-CLIBBORN EDITIONS DOES NOT UNDER ANY CIRCUM-STANCES ACCEPT ANY RESPONSIBILITY FOR ERRORS OR OMISSIONS

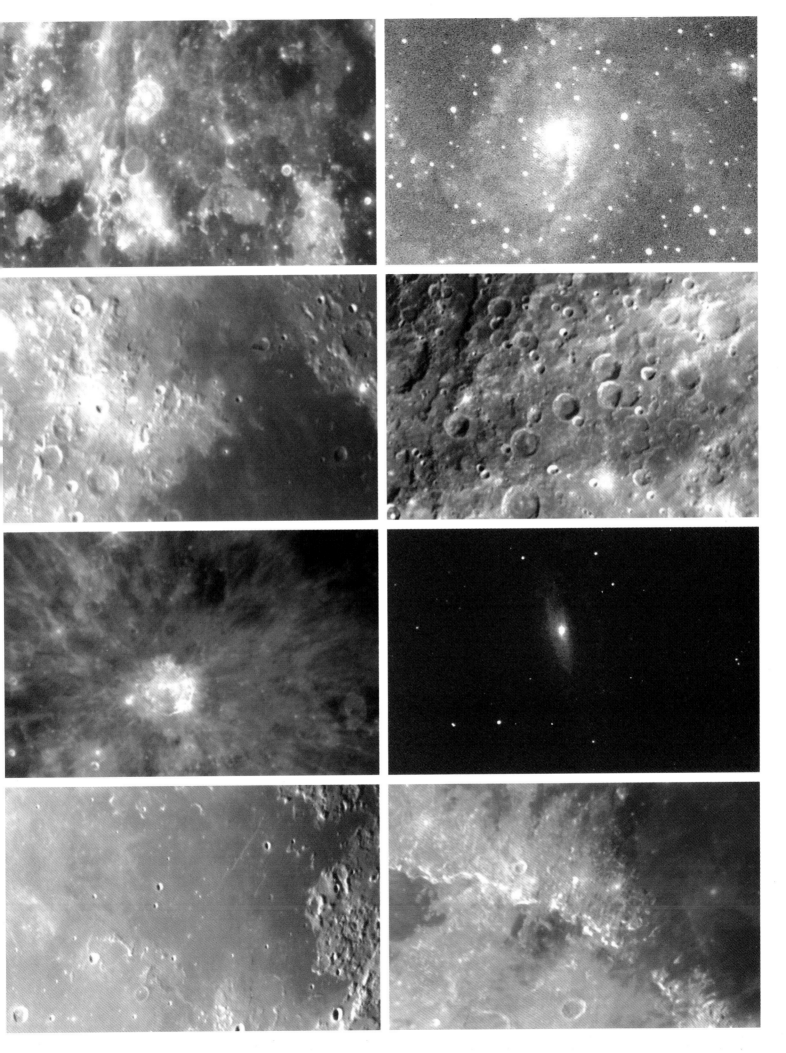

DISK
139

IMAGE
0026

OBJECT
NGL 6946

FILTER
R

EXP. TIME
120

MOUNTAIN DAYLIGHT TIME
05:15:52

EPOCH
1995.5

RA EQUIV. LONGITUDE
20,33,49.6

DEC EQUIV. LATITUDE
59,58,50

COMMENTS
BEAUTIFUL FACE-ON SPIRAL

EXPERIENCE

DISK
130

IMAGE
0026

OBJECT
NGL 6946

FILTER
R

EXP. TIME
120

MOUNTAIN DAYLIGHT TIME
05:15:52

EPOCH
1996.5

RA EQUIV. LONGITUDE
20.33.49.6

DEC EQUIV. LATITUDE
59.58.50

COMMENTS
BEAUTIFUL FACE-ON SPIRAL

DISK
126

IMAGE
0022

OBJECT
NGL 7640

FILTER
CLEAR

EXP. TIME
120

MOUNTAIN DAYLIGHT TIME
04:56:52

EPOCH
1950

RA EQUIV. LONGITUDE
23.19.42.6

DEC EQUIV. LATITUDE
40.34.15

COMMENTS
EDGE-ON SPIRAL GALAXY

OVERLEAF

'EXPERIENCE IS NOT WHAT HAPPENS TO
YOU, IT IS WHAT YOU MAKE OF WHAT
HAPPENS TO YOU.'

ALDOUS HUXLEY

DISK 128
IMAGE 0024
OBJECT NGL 7331
FILTER B
EXP. TIME 120
MOUNTAIN DAYLIGHT TIME 05:07:05
EPOCH 1995.5
RA EQUIV. LONGITUDE 22.34.46.6
DEC EQUIV. LATITUDE 34.09.21
COMMENTS CORE DOMINATED SPIRAL GALAXY

'LOOK CLOSELY AND COMPREHENSIVELY AT THESE PICTURES. INTEGRATE YOUR REACTIONS WITH ALL YOUR SPONTANEOUS RECALLS OF THE OTHER EXPERIENTIAL INFORMATION OF YOUR LIFE AS WELL AS OF OTHER LIVES AS REPORTED TO YOU. THINK AND THINK SOME MORE. FROM TIME TO TIME, HUMANS ARE ENDOWED WITH THE CAPABILITY TO DISCOVER JUST A LITTLE MORE REGARDING THE SIGNIFICANCE OF THEIR ROLE IN THE COSMIC SCENARIO. YOU TOO MIGHT CATCH ONE OF THESE 'COSMIC FISH'.'

R BUCKMINSTER FULLER

'EVERYBODY EXPERIENCES FAR MORE THAN HE UNDERSTANDS. YET IT IS EXPERIENCE, RATHER THAN UNDERSTANDING, THAT INFLUENCES BEHAVIOUR.'

MARSHALL MCLUHAN

MCLUHAN IS RIGHT. EXPERIENCE AFFECTS BEHAVIOUR. BUT AS OUR PERCEPTIONS OF THE WORLD AROUND US ARE CHALLENGED AND EVOLVE WE MUST CONTINUALLY ASK:

WHAT SHOULD THESE EXPERIENCES BE?

'YOU SEE THINGS; AND YOU SAY 'WHY?' BUT I DREAM THINGS THAT NEVER WERE; AND I SAY 'WHY NOT?'

GEORGE BERNARD SHAW

EXPERIENCE EXPLORES THIS QUESTION IN THE FORM OF A VISUAL JOURNEY.

ITS ORIGIN – THE CROSS-ROADS OF OPPORTUNITY CREATED BY THE GLOBAL COLLISION OF MARKETS, MEDIA, CULTURE AND TECHNOLOGY.

ITS DESTINATION – THE IDEAS OF THOSE WHO LIVE ON THE EDGE, RELISH NEW CHALLENGES AND RENOUNCE CONVENTIONAL THINKING.

ITS PURPOSE – TO INSPIRE YOU AND IMPRESS UPON YOU A SENSE OF ADVENTURE, EMPOWERMENT AND POSSIBILITY.

WE KNOW WHAT HAPPENS TO PEOPLE WHO STAY IN THE MIDDLE OF THE ROAD. THEY GET RUN OVER.'

ANEURIN BEVAN

WE ANTICIPATE VIRTUAL SHOPPING MALLS AND DIGITAL SUPERHIGHWAYS.

WE HAVE MORE PRODUCTS AND LESS DIFFERENCE, MORE INFORMATION AND LESS TIME.

WE DEBATE THAT CONVENTIONAL COMMUNICATION IS NO LONGER THE ANSWER.

WE FEEL THAT EXPRESSION THROUGH NEW EXPERIENCE IS.

'ONE EYE SEES, THE OTHER FEELS.'

PAUL KLEE

WHERE THE CURRENT DEBATE ENDS THIS BOOK BEGINS.

EXPERIENCE GOES BEYOND THE RHETORIC TO VISUALLY EXPLORE THE POTENTIAL TO DEFINE AND CREATE NEW COMMUNICATION EXPERIENCES.

IT IS A BOOK FOR THE COMMISSIONER, CREATIVE AND CONSUMER IN ALL OF US.

IT IS A BOOK ABOUT DESIGN, MEDIA, MARKETING AND ART.

IT IS A BOOK ABOUT WHATEVER YOUR BUSINESS OR OUR BUSINESS MIGHT BE(COME).

IT IS A BOOK OF IDEAS.

'AS LONG AS ONLY THE IMAGE OF THE IDEA IS PERCEIVED AND NOT ITS SUBSTANCE IT CANNOT BECOME A DRIVING FORCE – THE IDEA HAS TO TAKE SHAPE.'

PIERRE DE COUBERTIN

EACH IDEA COMMUNICATES TO OUR SENSES ON A MULTITUDE OF LEVELS.

IN A MOMENT, LIFETIME OR SOMEWHERE IN BETWEEN.

EACH CHALLENGES THE BOUNDARIES OF CONVENTION TO REDEFINE AND ENLIGHTEN.

ALL UNITED BY THE INSIGHT AND IMAGINATION OF THEIR CREATORS AND THE INTEGRITY AND STYLE OF THEIR EXECUTION.

'TO ME STYLE IS JUST THE OUTSIDE OF CONTENT, AND CONTENT THE INSIDE OF STYLE. LIKE THE OUTSIDE AND THE INSIDE OF THE HUMAN BODY – BOTH GO TOGETHER, THEY CAN'T BE SEPARATED.'

JEAN-LUC GODARD

LET THESE IDEAS SHOCK, CONFUSE,
ENTERTAIN AND INSPIRE YOU.

THEY PROVIDE A VISIONARY GLIMPSE OF
A FUTURE THAT IS ALREADY AMONGST
US IF WE ARE BRAVE ENOUGH TO
PURSUE IT.

SEAN PERKINS, RALPH ARDILL,
ADRIAN CADDY. IMAGINATION LTD.

'IDEALLY A BOOK WOULD HAVE NO
ORDER TO IT AND THE READER WOULD
HAVE TO DISCOVER THEIR OWN.'

RAOUL VAN EIGEM

FOG FOREST PARK

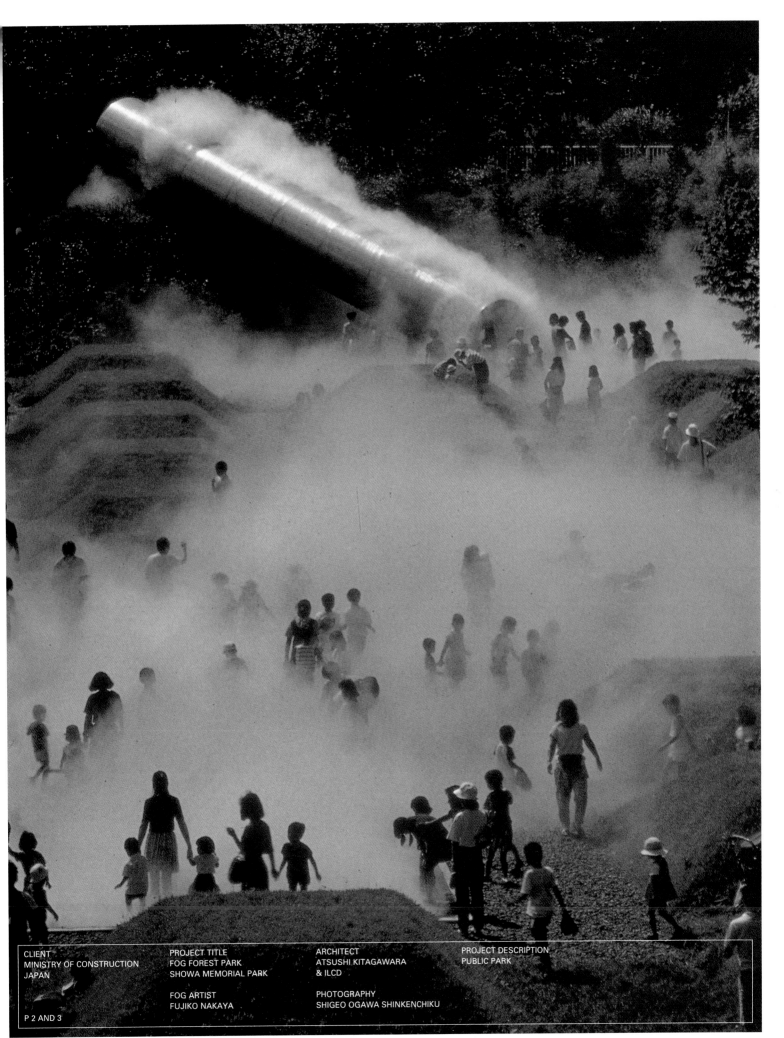

CLIENT
MINISTRY OF CONSTRUCTION
JAPAN

PROJECT TITLE
FOG FOREST PARK
SHOWA MEMORIAL PARK

ARCHITECT
ATSUSHI KITAGAWARA
& ILCD

PROJECT DESCRIPTION
PUBLIC PARK

FOG ARTIST
FUJIKO NAKAYA

PHOTOGRAPHY
SHIGEO OGAWA SHINKENCHIKU

ARTIFICIAL NATURE

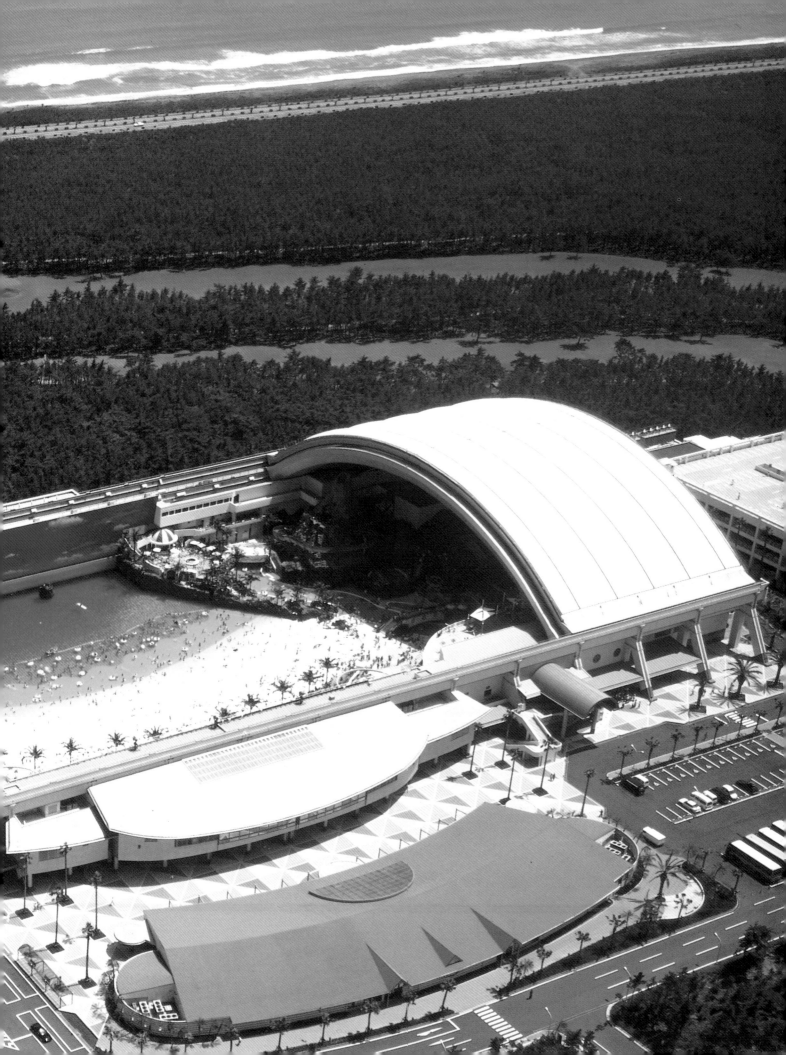

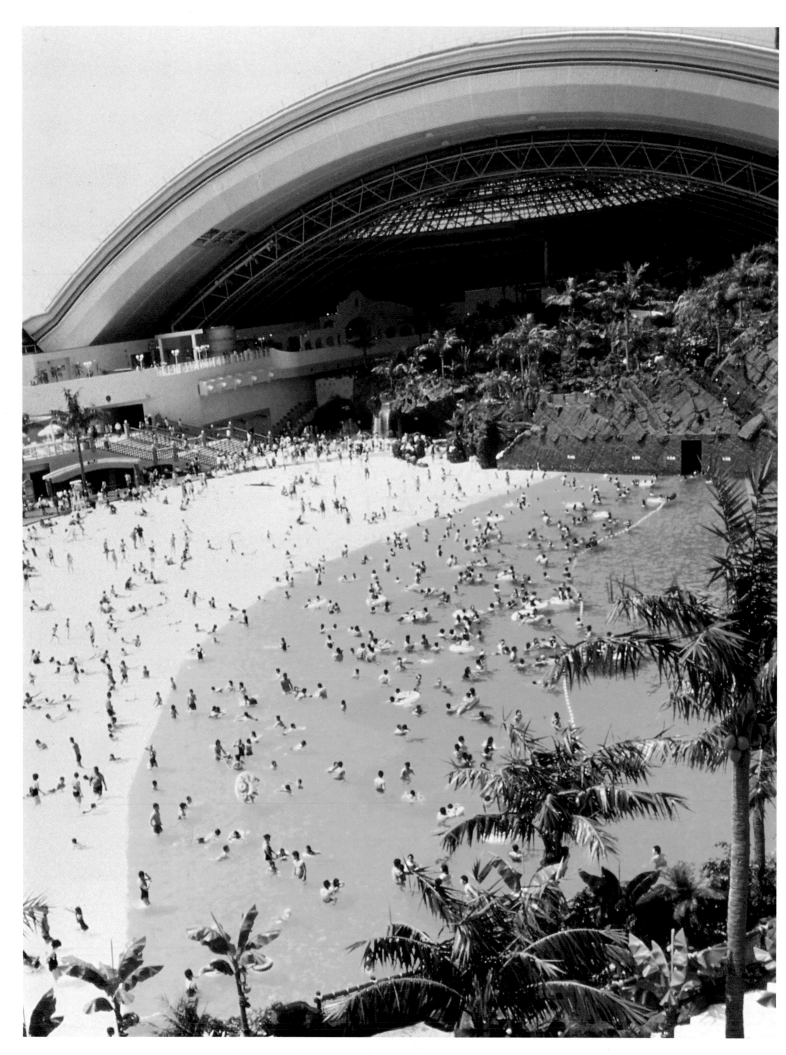

SEAGAIA IS A CONVENTION AND LEISURE RESORT COMPLEX ON THE SOUTHERN ISLAND OF KYUSHU, JAPAN.

THE PRINCIPAL THEME IS TO CREATE A 21ST CENTURY RESORT WHERE MAN, CULTURE AND NATURE CAN RELATE IN HARMONY.

THE OCEAN DOME IS THE RESORT'S PRINCIPLE ATTRACTION AND IS THE WORLD'S LARGEST ALL-WEATHER INDOOR WATER PARK.

CLIENT
PHOENIX RESORT LTD

PROJECT TITLE
OCEAN DOME, SEAGIA RESORT,
JAPAN 1994

PROJECT DESCRIPTION
TOTAL LAND AREA 84 622M²
BUILDING AREA 36 291M²
FLOOR AREA 54 795M²
BEACH AREA 2 800M²
OCEAN AREA 6 700M²
ROOF OPENING 18 000M²

P 6 AND 7 (4 AND 5 PREVIOUS)

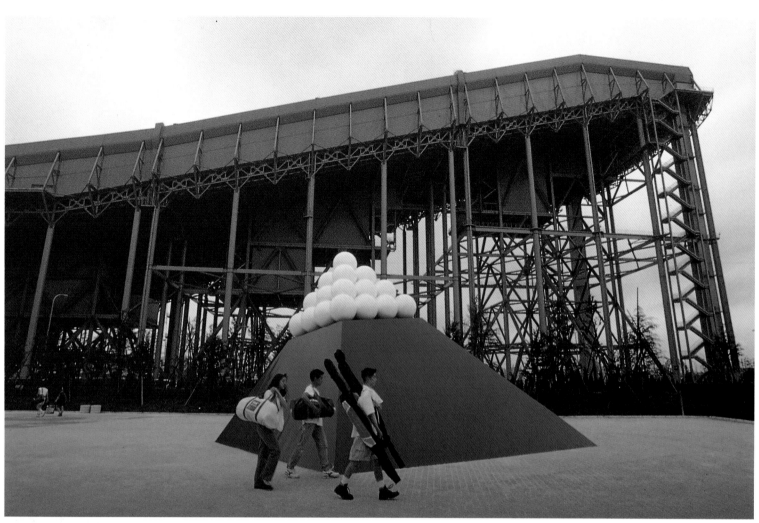

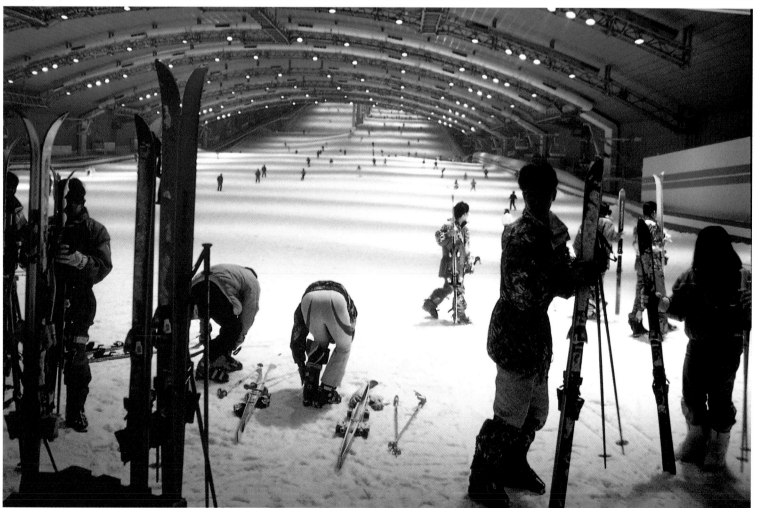

CLIENT
HITSUI FURASAN

PROJECT TITLE
LALAPORT SKI DOME

DESIGN COMPANY
KAJIMA DESIGN

SENIOR ARCHITECT
KABUNOBU ABE

ART DIRECTOR
MASASHI OKKAWA
KOHKAN SEKKEI

PHOTOGRAPHY
HIROYA KAJI

PROJECT DESCRIPTION
INDOOR SKI FACILITY

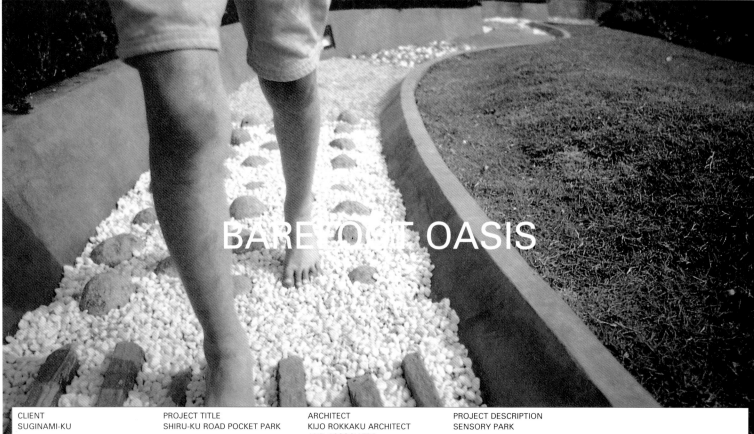

BAREFOOT OASIS

CLIENT	PROJECT TITLE	ARCHITECT	PROJECT DESCRIPTION
SUGINAMI-KU	SHIRU-KU ROAD POCKET PARK	KIJO ROKKAKU ARCHITECT AND ASSOCIATES	SENSORY PARK

P 10 AND 11

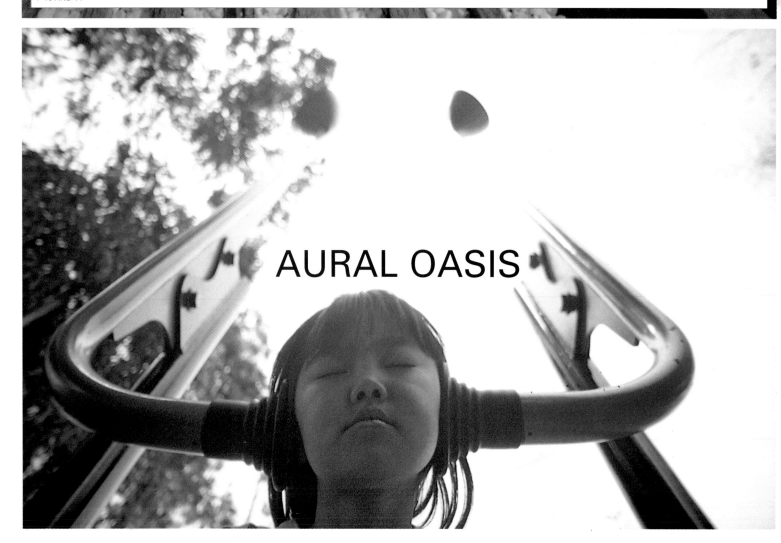

AURAL OASIS

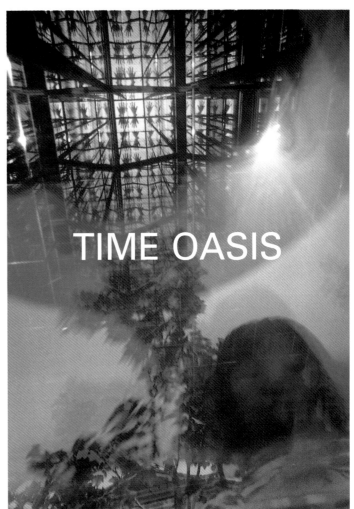

TIME OASIS

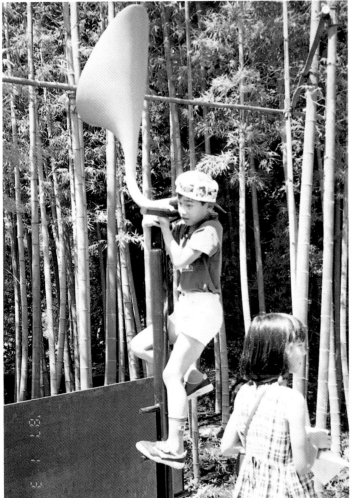

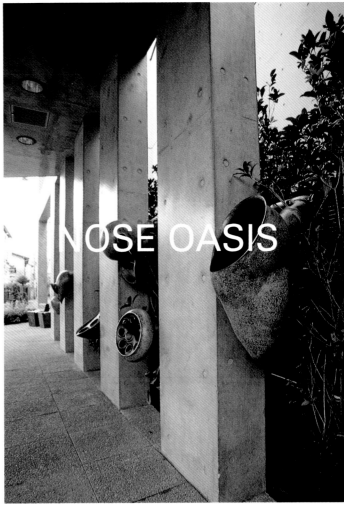

NOSE OASIS

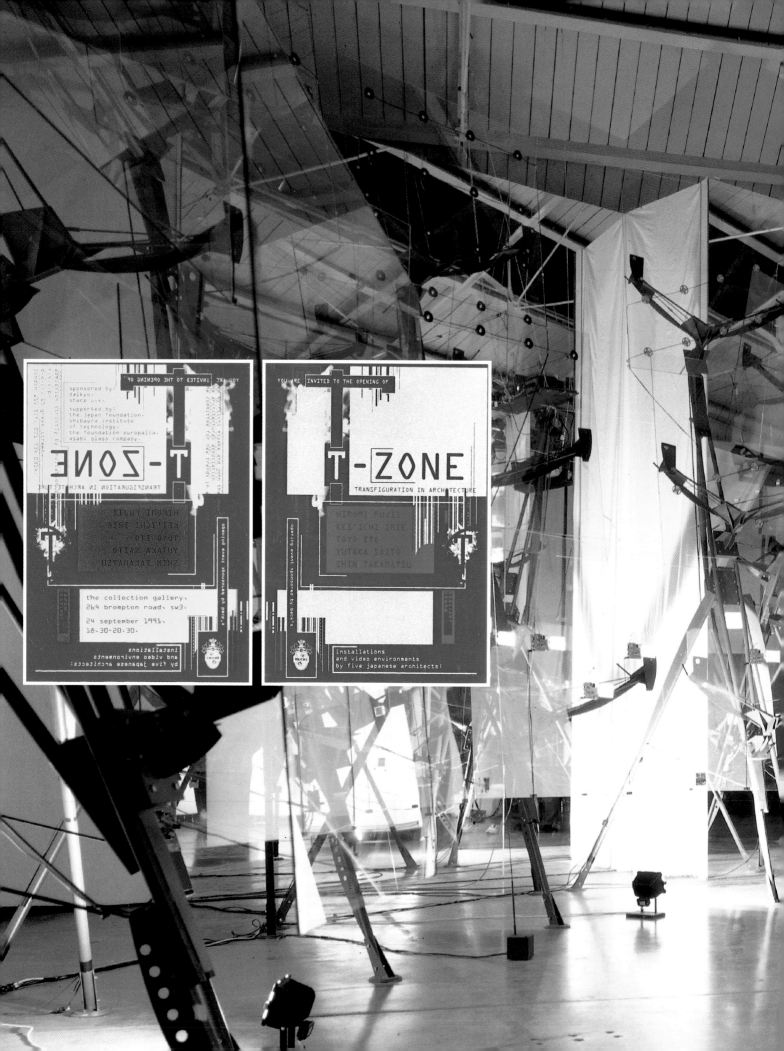

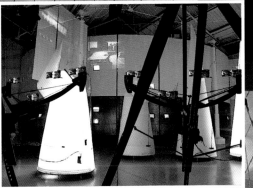

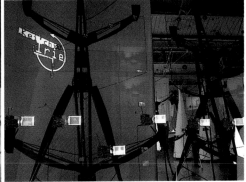

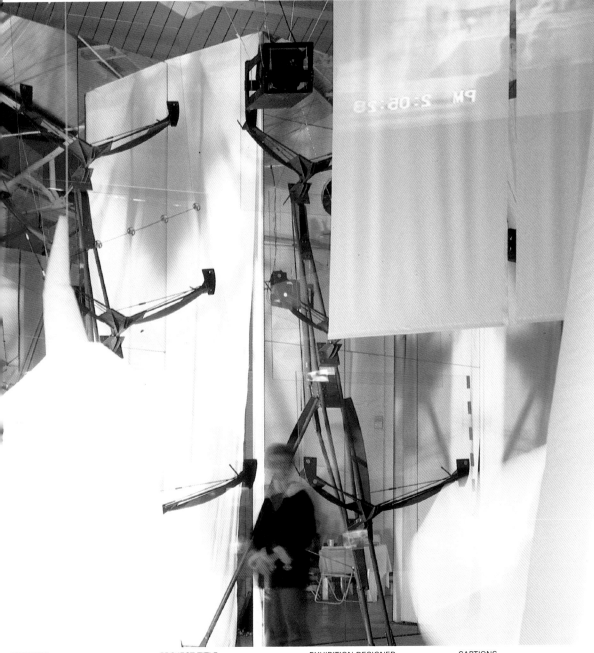

SPONSOR	PROJECT TITLE	EXHIBITION DESIGNER	CAPTIONS	
DAIKYO CO LTD	T-ZONE	ANDREW McKINLEY BAYLIS		
	A FOUR-DIMENSIONAL			1, 4, 5, 6 EXHIBITS THAT RESPOND TO SOUND
	EXHIBITION	EXHIBITION GRAPHICS		PROJECTION AND VIDEO
		WHY NOT ASSOCIATES		2, 3 EXHIBITION INVITES
		DAVID ELLIS		
		ANDREW ALTMANN		

1		4	5	6
2	3			

	CURATORS	ARCHITECTS	CAPTIONS	
	RIICHI MIYAKE	HIROMI FUJII		1 WOMB
	JOHN THACKARA	KEI'ICHI IRIE		2, 3 LASER FOREST
		TOYO ITO		
		YUTAKA SAITO		
		SHIN TAKAMATSU		

1	2	
		3

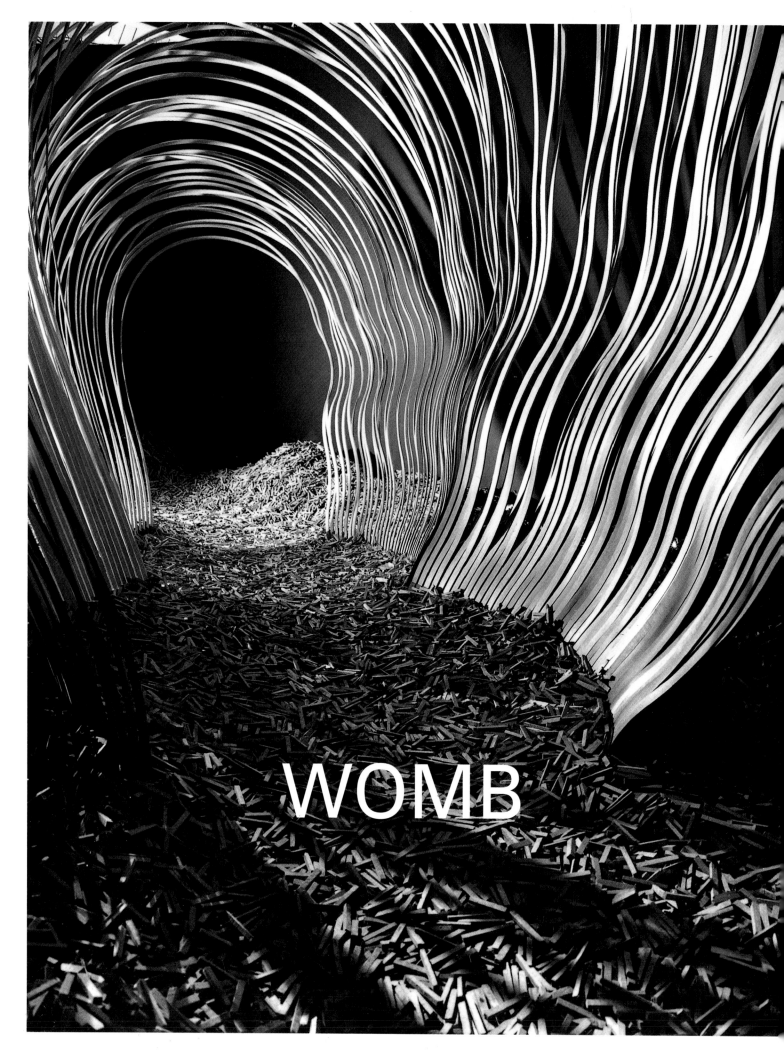

WOMB

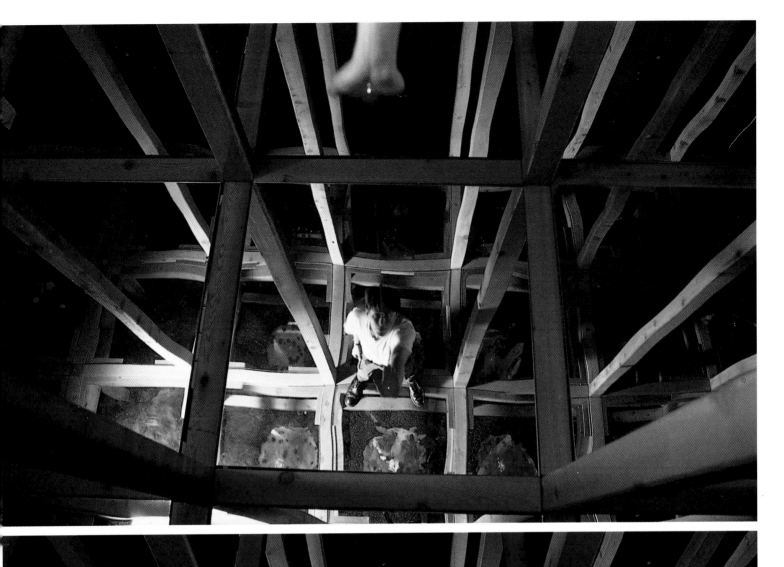

LASER FOREST

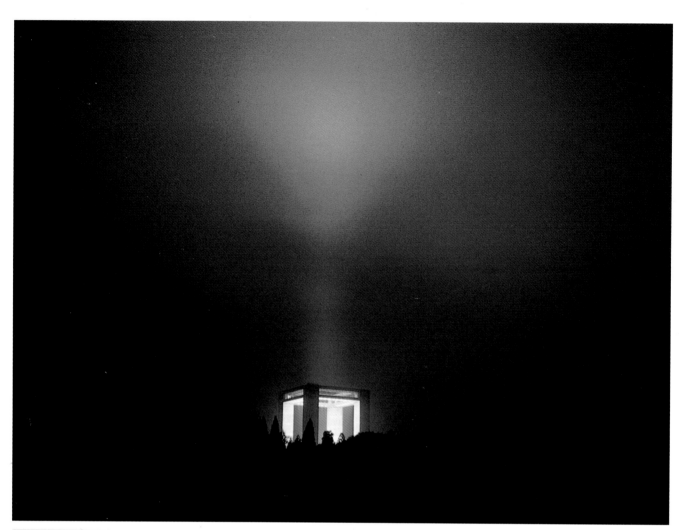

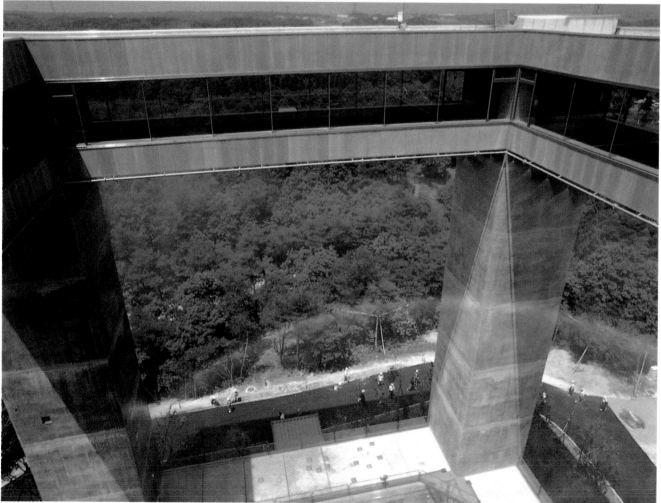

BEARING HEAVY SNOW, THE ROOF BECOMES LIKE A CLOUD IN SPACE. A RAINBOW APPEARS IN A CUBE OF AIR WHEN IT'S MISTY. NATURAL PHENOMENA FORM OUR PERCEPTIBLE WORLD, AS AN AQUARCHITECTURE.'

SHOEI YOH

CLIENT	PROJECT TITLE	ARCHITECT	PROJECT DESCRIPTION
TOYAMA PREFECTURE	PROSPECTA '92	SHOEI YOH AND ARCHITECTS	AN OBSERVATION TOWER WITH FOG AND RAINBOW MAKING APPARATUS, DESIGNED FOR THE PURE APPRECIATION OF NATURAL PHENOMENA AND THE BEAUTIFUL LANDSCAPE. TEMPORARILY THE STRUCTURE SERVES AS AN EXPOSITION PAVILION. MORE PERMANENTLY IT SERVES AS AN EXAMPLE OF HOW ARCHITECTURE CAN BE ENDOWED WITH LIFE

P 16 AND 17

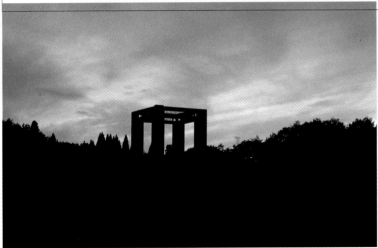
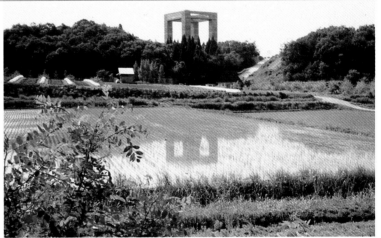

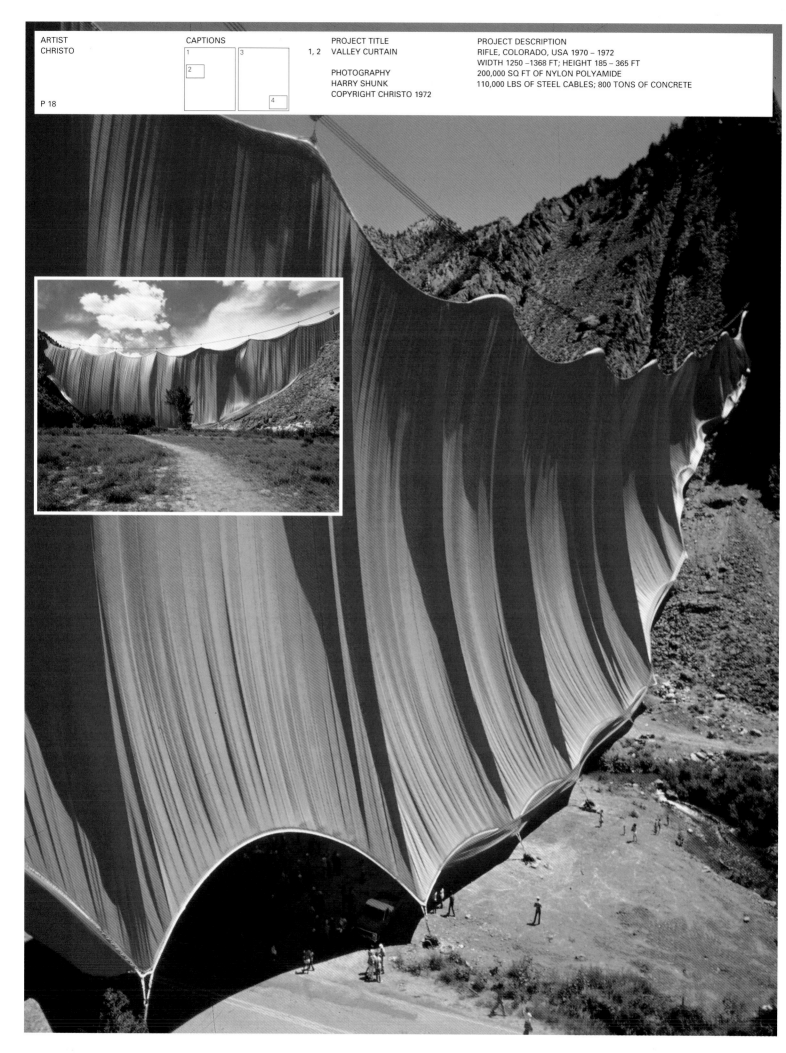

ARTIST
CHRISTO

P 18

CAPTIONS
1
2
3
4

1, 2

PROJECT TITLE
VALLEY CURTAIN

PHOTOGRAPHY
HARRY SHUNK
COPYRIGHT CHRISTO 1972

PROJECT DESCRIPTION
RIFLE, COLORADO, USA 1970 – 1972
WIDTH 1250 –1368 FT; HEIGHT 185 – 365 FT
200,000 SQ FT OF NYLON POLYAMIDE
110,000 LBS OF STEEL CABLES; 800 TONS OF CONCRETE

ARTIST
CHRISTO

3, 4 PROJECT TITLE
THE UMBRELLAS

PHOTOGRAPHY
WOLFGANG VOLZ
COPYRIGHT CHRISTO 1991

PROJECT DESCRIPTION
JAPAN – USA 1984 – 1991
1340 BLUE UMBRELLAS IN IBARAKI, JAPAN
HEIGHT 9 FT 8 IN; DIAMETER 28 FT 6 IN

P 19

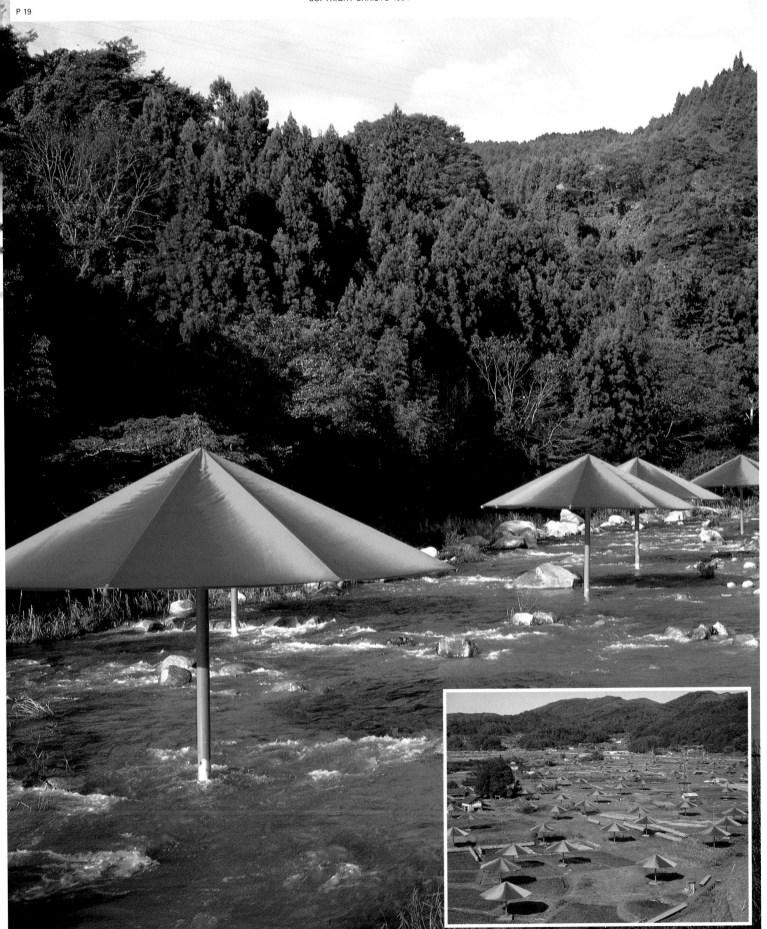

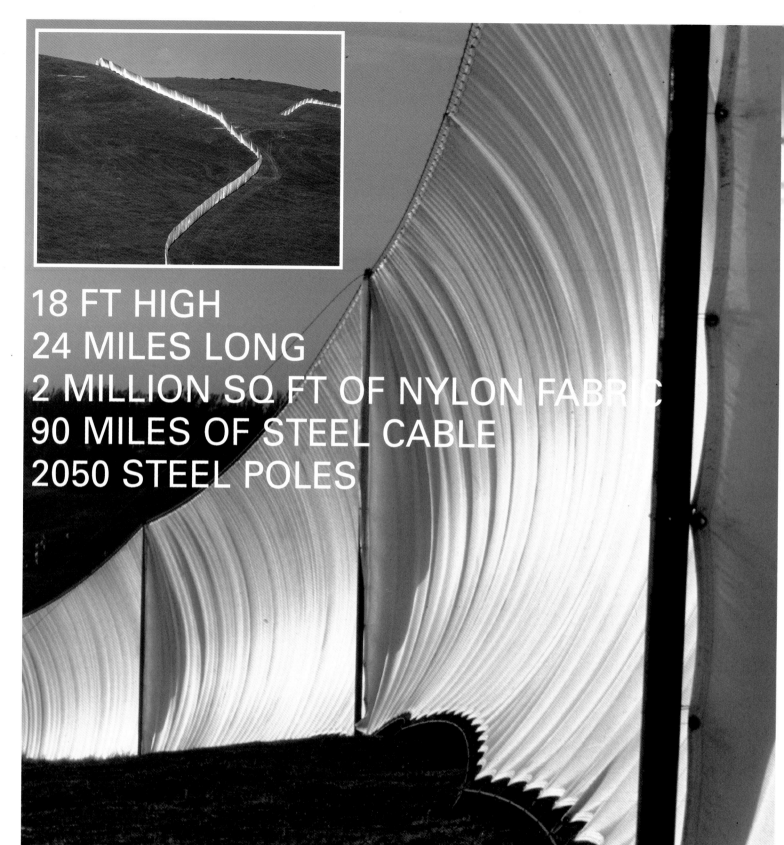

18 FT HIGH
24 MILES LONG
2 MILLION SQ FT OF NYLON FABRIC
90 MILES OF STEEL CABLE
2050 STEEL POLES

ARTIST	CAPTIONS		PROJECT TITLE	PROJECT DESCRIPTION
CHRISTO		1, 2	RUNNING FENCE	SONOMA AND MARIN COUNTIES, CALIFORNIA, USA 1972 – 1976
				18 FT HIGH; 24 MILES LONG
			PHOTOGRAPHY	TWO MILLION SQ FT OF WOVEN NYLON FABRIC
			JEANNE-CLAUDE CHRISTO	90 MILES OF STEEL CABLES; 2050 STEEL POLES
			WOLFGANG VOLZ	
			COPYRIGHT CHRISTO 1976	

ARTIST		PROJECT TITLE	PROJECT DESCRIPTION
CHRISTO	3	THE UMBRELLAS	JAPAN – USA 1984 – 1991
			1760 YELLOW UMBRELLAS IN CALIFORNIA, USA
		PHOTOGRAPHY	HEIGHT 9 FT 8 IN; DIAMETER 28 FT 6 IN
		WOLFGANG VOLZ	
		COPYRIGHT CHRISTO 1991	

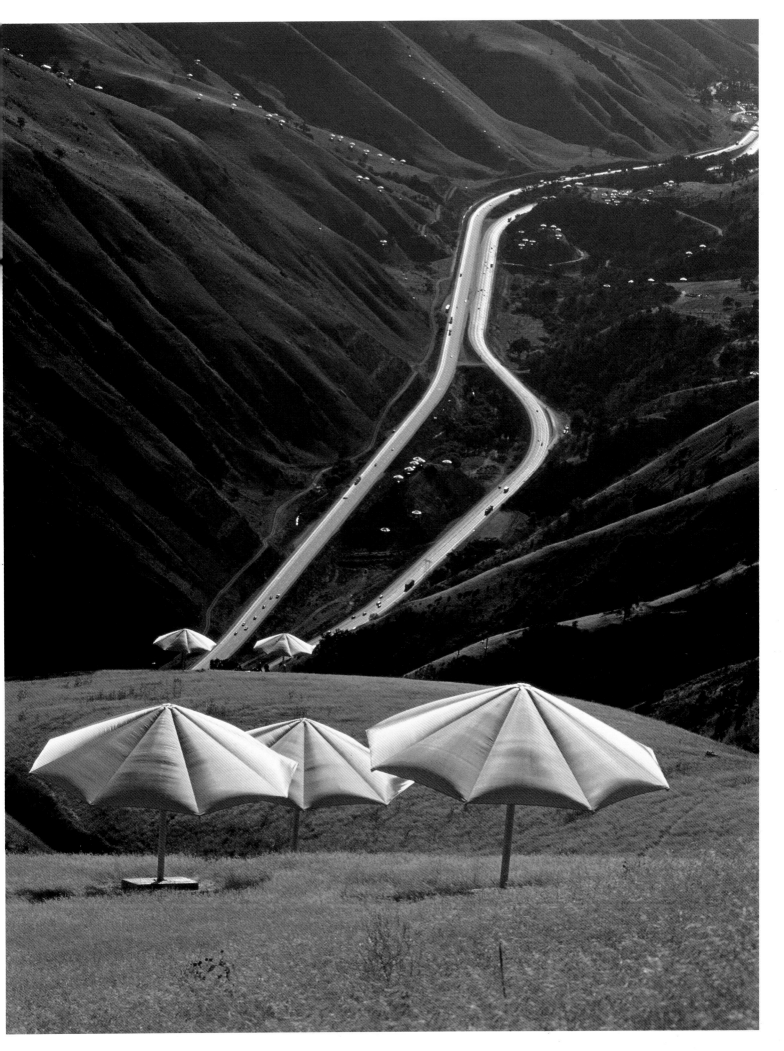

CLIENT	PROJECT TITLE	SCULPTOR	ADVERTISING AGENCY	PROJECT DESCRIPTION
CABLE & WIRELESS	THE LINE	JONATHON FROUD	CHIAT DAY	AN ENVIRONMENTAL LANDART PROJECT TO PROMOTE CABLE & WIRELESS' GLOBAL DIGITAL HIGHWAY
	EXPOSURE	PHOTOGRAPHY	CREATIVES	
	GLOBAL TV	KEVIN GRIFFIN	DAVE BUONAGUIDI	
			NARESH RAMCHANDANI	

P 22 AND 23 (24 AND 25, 26 AND 27, 28 AND 29 OVERLEAF)

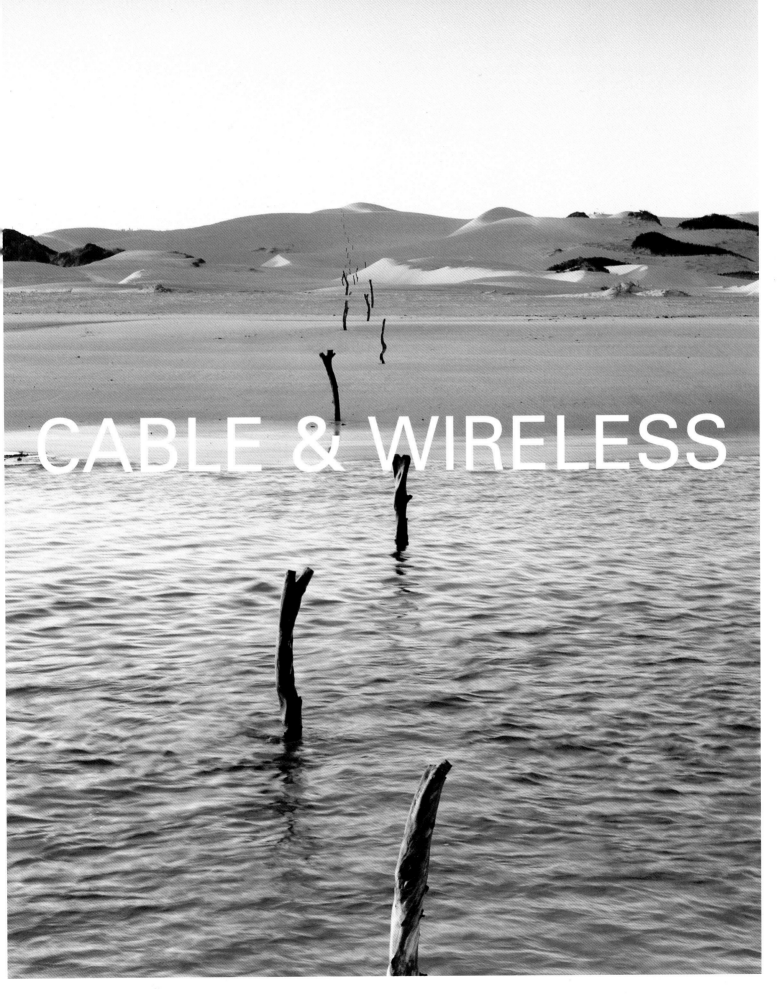

CABLE & WIRELESS

WE ARE SHOWN THE PATH TAKEN BY THE COMPANY'S CABLE THROUGH SOME INSPIRATIONAL PARTS OF THE WORLD.'

CABLE & WIRELESS

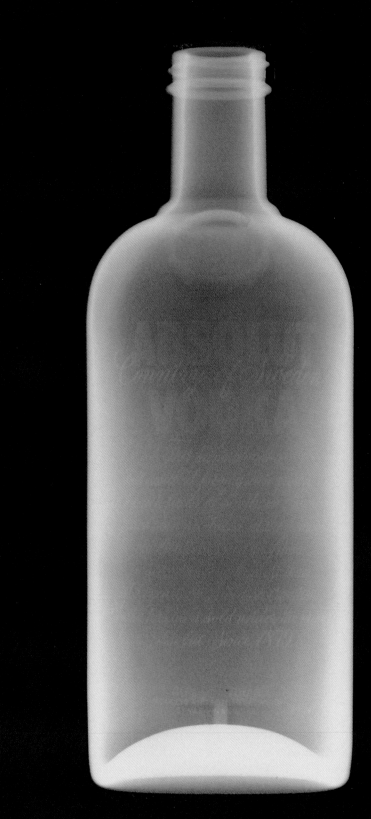

ABSOLUT X-RAY.

CLEARLY THERE IS NO PURER VODKA THAN ABSOLUT. DO IT JUSTICE DRINK IT NEAT AT 0°C.

CLIENT
ABSOLUT VODKA

ADVERTISING AGENCY
TBWA

CREATIVES
NIGEL ROSE
STEVE CHETHAM
TREVOR BEATTIE

P 30 AND 31

CAPTIONS
1 2

PROJECT DESCRIPTION
1 ABSOLUT X-RAY, ADVERTISEMENT 1993

2 ABSOLUT SPRING, 48 SHEET POSTER 1994

AT THE TOWN GATE FOR OKAWABATA
RIVER CITY 21, IS THE EGG OF WINDS. IT IS
AN EGG 16 METRES LONG AND 8 METRES
IN DIAMETER, WRAPPED WITH ALUMINIUM
PANELS, FLOATING IN FRONT OF TWO
HIGH-RISE BUILDINGS. DURING THE DAY
THE EGG IS MERELY AN OBJECT THAT
REFLECTS SUNLIGHT, BUT AT NIGHT IT
DISPLAYS BOTH PRE-RECORDED VIDEO
IMAGES AND TELEVISION BROADCASTS
ON INTERNAL SCREENS VISIBLE THROUGH
THE PARTLY PUNCHED ALUMINIUM PAN-
ELED SURFACE. THE SHINY SILVER EGG OF
DAYTIME AT NIGHT BECOMES A VAGUE,
UNREAL 3D PRESENCE LIKE A HOLOGRAM.
PASSERS-BY LOOK UP AT THE EGG, STOP
FOR A MOMENT, AND THEN WALK AWAY.
IT IS AN OBJECT OF VIDEO IMAGES THAT
SEEM TO COME AND GO WITH THE WIND.'

TOYO ITO

CLIENT	PROJECT TITLE	ARCHITECT	PROJECT DESCRIPTION
OKAWABATA CITY	EGG OF WINDS	TOYO ITO	TOWN GATE FOR OKAWABATA RIVER CITY 21, 1991

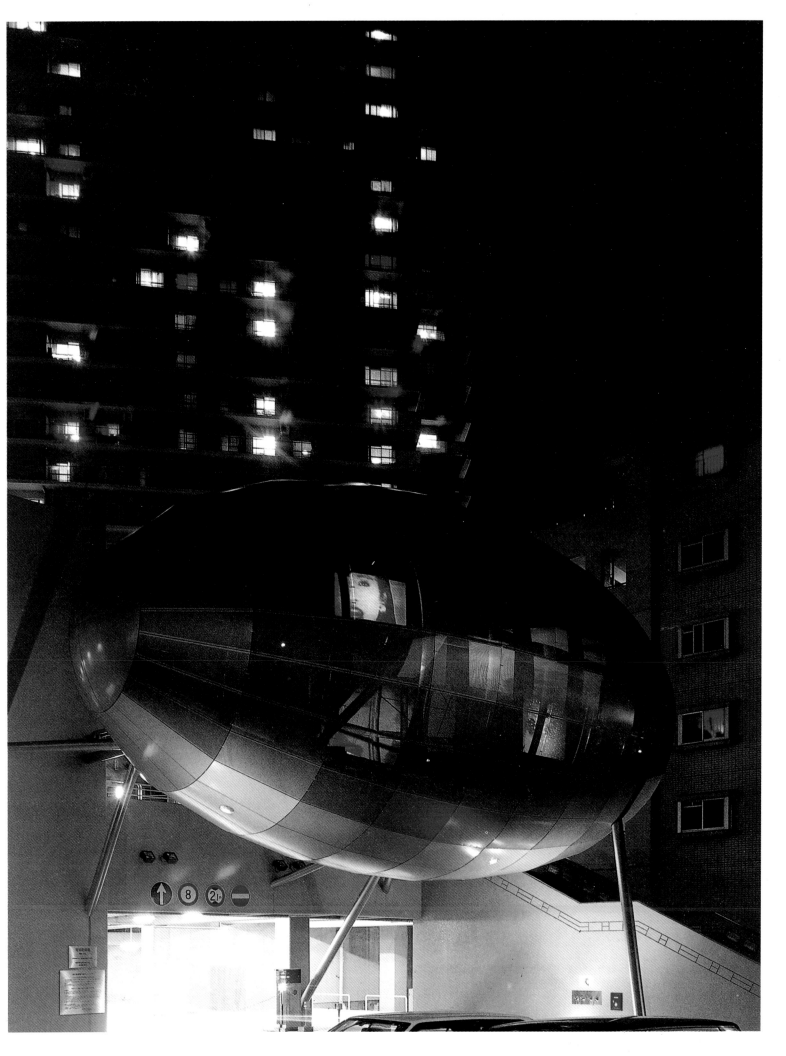

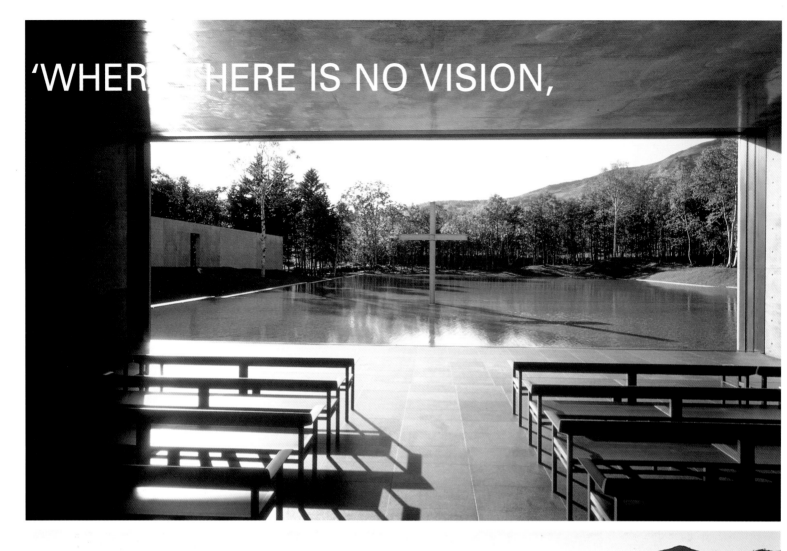

'WHERE THERE IS NO VISION,

THE PEOPLE PERISH.' BIBLE, HEBREW

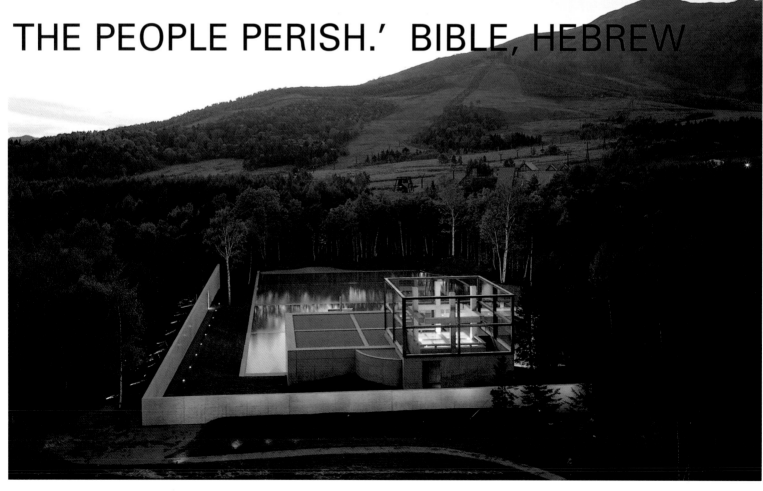

AS ONE CLIMBS UP A GENTLE SLOPE LISTENING TO THE SOUND OF THE STREAM, ONE FINDS ONESELF WITHIN THE BOX OF LIGHT. THE TOP IS OPEN, AND FOUR CROSSES ARE STANDING FACING EACH OTHER UNDER THE VAULT OF SKY. HERE ONE COMMUNICATES WITH NATURE AS ONE LISTENS TO THE SOUNDS OF WATER, WIND AND THE CHIRPING OF BIRDS. I WISHED TO BUILD AN ARCHITECTURE WHICH WOULD APPEAL NOT ONLY TO THE EYES OF VIEWERS BUT TO ALL THE FIVE SENSES OF MEN.

THE SCENERY WHICH IS CUT OUT BY THE FRAME OF THE DOOR CHANGES WITH TIME AND IS REFLECTED ON THE WATER. IN THE CHANGES ONE FEELS NATURE AND THE SACRED AT THE SAME TIME.'

TADAO ANDO

ARCHITECT	PROJECT TITLE	LOCATION	PHOTOGRAPHY
TADAO ANDO	CHURCH ON THE WATER	TOMAMU, HOKKAIDO	MITSUO MATSUOKA
		JAPAN	

P 34 AND 35

CHURCH OF THE LIGHT
'FOR WE WALK BY FAITH, NOT BY SIGHT'

BIBLE, II CORINTHIANS

ARCHITECT	PROJECT TITLE	LOCATION	PHOTOGRAPHY
TADAO ANDO	CHURCH OF THE LIGHT	IBARAGI, OSAKA JAPAN	MITSUO MATSUOKA

P 36 AND 37

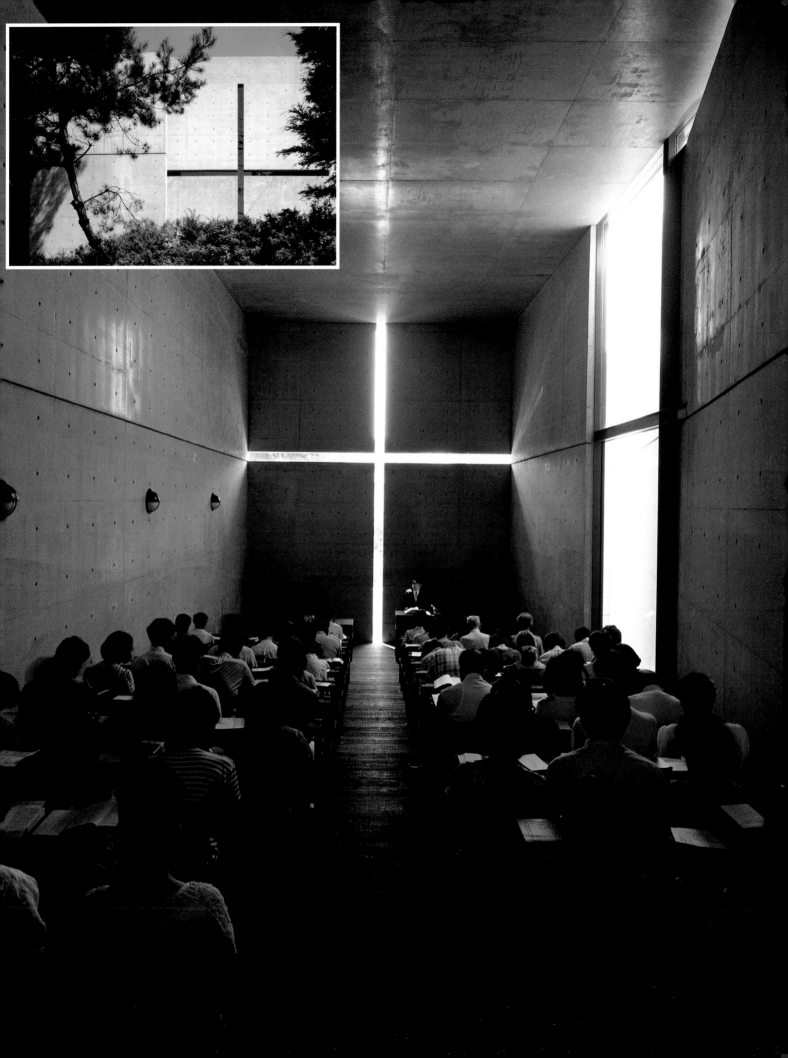

BENETTON

CLIENT
BENETTON GROUP

PROJECT TITLE
FABRICA
BENETTON ART SCHOOL

ARCHITECT
TADAO ANDO

PROJECT DESCRIPTION
THE BUILDING IS A RESEARCH CENTRE THAT ACCEPTS YOUNG PEOPLE FROM AROUND THE WORLD
WITH ACHIEVEMENTS IN THE APPLIED ARTS SUCH AS ARCHITECTURE, DESIGN, PHOTOGRAPHY,
GRAPHIC ART, THE IMAGE MEDIA AND TEXTILES, AS WELL AS IN WOODWORKING, METALWORKING AND
CERAMICS. THE INFUSION AND ULTIMATE HARMONY OF CONTRASTING CULTURES IS AN ADDITIONAL
THEME OF THE CENTRE, WHICH ANTICIPATES AND PROMOTES ACTIVE EXCHANGE AMONG THE YOUNG
PEOPLE WHO GATHER THERE

P 38 AND 39

IF THE EARTH HAS BECOME A GLOBAL VILLAGE, THEN BENETTON IS THE VILLAGE CLOTHING STORE. AND, LIKE EVERY GOOD LEADING CITIZEN, IT FEELS AN OBLIGATION TO NOT ONLY SUCCEED IN BUSINESS BUT ALSO TO IMPROVE THE NEIGHBOURHOOD. ITS COMMUNICATIONS PROGRAMME IS MEANT TO RAISE AN AWARENESS OF ISSUES THAT AFFECT THE LIFE OF THE VILLAGE, ITS ADVERTISING REFLECTS ITS CONCERNS FOR THE COMMUNITY.

TO FURTHER THESE EFFORTS BENETTON HAS FOUNDED COLORS, THE VILLAGE MAGAZINE. IT IS ABOUT WHAT PEOPLE IN THE VILLAGE DO AND SEE AND THINK. IT IS ABOUT HOW EACH PERSON IN THE VILLAGE IS DIFFERENT.

IT'S A VISUAL MAGAZINE. AND BECAUSE THE PEOPLE IN THE VILLAGE SPEAK DIFFERENT LANGUAGES, COLORS APPEARS IN FIVE BILINGUAL EDITIONS.'

TIBOR KALMAN

COLORS

oops!

ecology now
voilà l'écologie

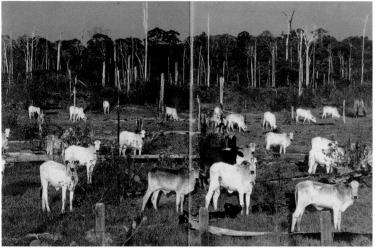

food
la nourriture

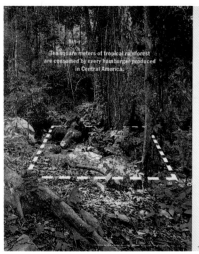

Ten square meters of tropical rainforest are consumed by every hamburger produced in Central America.

A space like this might contain
one mature tree, eighteen meters tall.
Below the tree would be a hundred saplings and seedlings in some thirty different species; several of which might be extremely rare with limited distribution. Living in the vegetation would be thousands of insects in more than a hundred species. Several of these insects would likely belong to species not yet known to science. Dozens of birds, reptiles and several species would regularly pass through and use this patch of forest.

Un espace de cette grandeur
pourrait contenir un grand arbre, de dix-huit mètres d'hauteur. Sous l'arbre se trouveraient des centaines de jeunes plantes, appartenantes à quelque trente espèces différentes, dont plusieurs extrêmement rares. Dans cette végétation vivraient des milliers d'insectes appartenant à des centaines d'espèces, dont certains encore inconnus à la science.

Dix mètres de forêt tropicale sont consommés par chaque hamburger produit en Amérique Centrale.

les centres commerciaux en plages,
shopping malls into beaches,

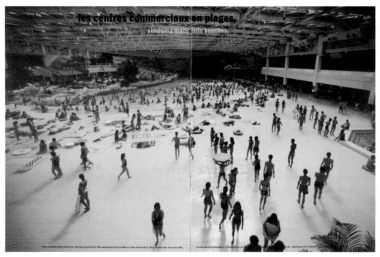

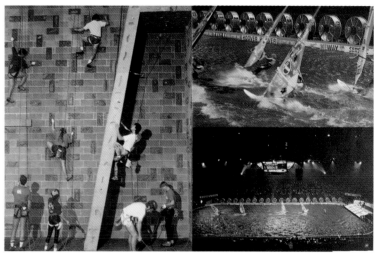

THE MESSAGE OF THIS MAGAZINE IS
THAT YOUR CULTURE (WHOEVER YOU
ARE) IS AS IMPORTANT AS OUR CULTURE
(WHOEVER WE ARE).'

TIBOR KALMAN

CLIENT
BENETTON GROUP

PROJECT TITLE
COLORS MAGAZINE
NOS 6, 7 AND 8

PRINT RUN
1 MILLION COPIES

P 40 AND 41 (42 AND 43 OVERLEAF)

DESIGNER
TIBOR KALMAN

EDITORS
OLIVIERO TOSCANI
TIBOR KALMAN

PROJECT DESCRIPTION
'COLORS, WHICH IS PUBLISHED BY BENETTON, IS NOT A CATALOGUE IN
DISGUISE, OR AN ADVERTORIAL, IT'S A REAL MAGAZINE THAT TAKES ITS
GLOBAL OUTLOOK AND ITS UNDERLYING EDITORIAL MESSAGE – DIVERSITY
IS GOOD – FROM BENETTON'S WELL KNOWN ADVERTISING CAMPAIGN.'
TIBOR KALMAN

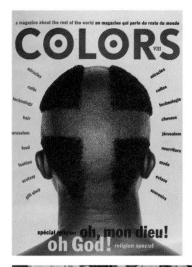

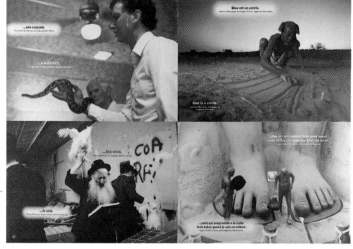

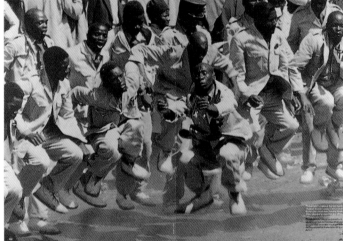

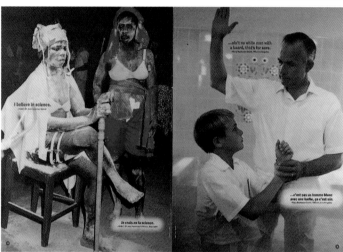

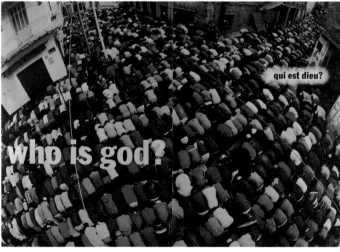

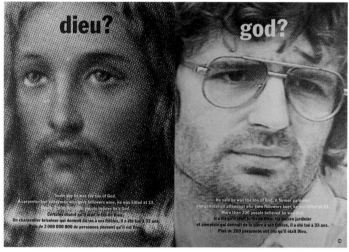

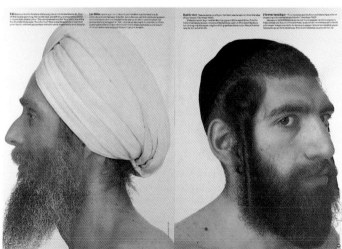

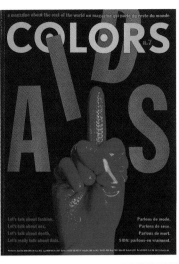

COLORS n.7

a magazine about the rest of the world · un magazine qui parle du reste du monde

AIDS

Let's talk about fashion.
Let's talk about sex.
Let's talk about death.
Let's really talk about Aids.

Parlons de mode.
Parlons de sexe.
Parlons de mort.
SIDA: parlons-en vraiment.

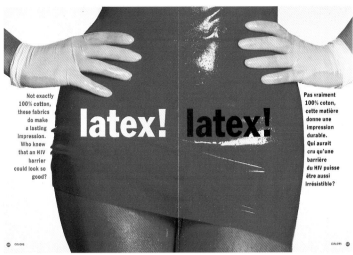

Not exactly 100% cotton, these fabrics do make a lasting impression. Who knew that an HIV barrier could look so good?

latex! latex!

Pas vraiment 100% coton, cette matière donne une impression durable. Qui aurait cru qu'une barrière du HIV puisse être aussi irrésistible?

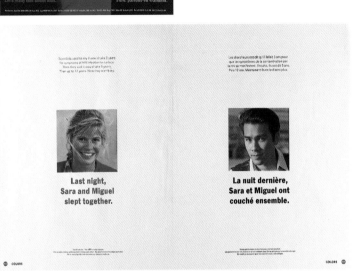

Last night, Sara and Miguel slept together.

La nuit dernière, Sara et Miguel ont couché ensemble.

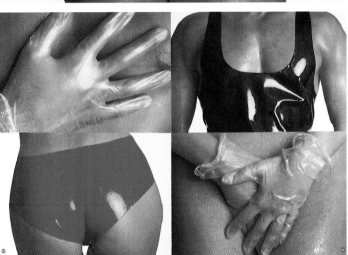

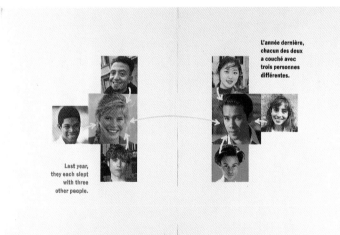

L'année dernière, chacun des deux a couché avec trois personnes différentes.

Last year, they each slept with three other people.

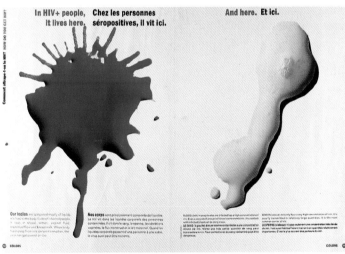

In HIV+ people, it lives here. **Chez les personnes séropositives, il vit ici.** And here. Et ici.

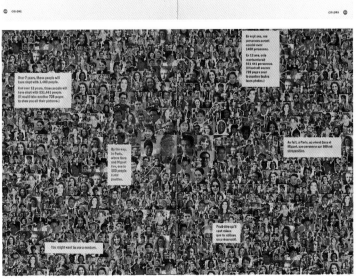

Over 7 years, these people will have slept with 1,460 people. And over 12 years, these people will have slept with 531,441 people. (It would take another 728 pages to show you all their pictures.)

By the way, in Paris, where Sara and Miguel live, one in 100 people is HIV healthy.

You might want to use a condom.

'DEREK JARMAN WAS ONE OF ENGLAND'S MOST ADMIRED FILMMAKERS. HE WAS ALSO AN ACTOR, A WRITER, A PAINTER, A SET DESIGNER AND AN OUTSPOKEN CAMPAIGNER FOR GAY RIGHTS. IN 1986 HE TESTED HIV POSITIVE.

JARMAN WROTE AND DIRECTED BLUE WHILE LOSING HIS SIGHT, A SIDE EFFECT OF AIDS.

FOR 76 MINUTES THE ONLY VISUAL IMAGE IS A BLUE SCREEN WITH AN OCCASIONAL SHADOW. AS THE AUDIENCE STARES INTO THE BLUE, THEY HEAR A SOUNDTRACK OF MUSIC, SOUNDS AND ACTOR'S VOICES READING LINES FROM JARMAN'S EVOCATIVE HOSPITAL DIARIES.

JARMAN DIED ON FEBRUARY 19 1994, AT THE AGE OF 52 AFTER FINALLY REFUSING THE MEDICINE THAT WAS KEEPING HIM ALIVE.'

COLORS ISSUE NO 7

WRITER/DIRECTOR	TITLE	SOUND DESIGN	VOICES	PRODUCERS
DEREK JARMAN	BLUE	MARVIN BLACK	JOHN QUENTIN	JAMES MACKAY
			NIGEL TERRY	TAKASHI ASAI
	COMPOSER	ASSOCIATE DIRECTOR	DEREK JARMAN	
	SIMON FISHER TURNER	DAVID LEWIS	TILDA SWINTON	A BASILISK COMMUNICATIONS/
				UPLINK PRODUCTION

P 48 AND 49 (44 AND 45, 46 AND 47 PREVIOUS)

H.I.V.
POSITIVE

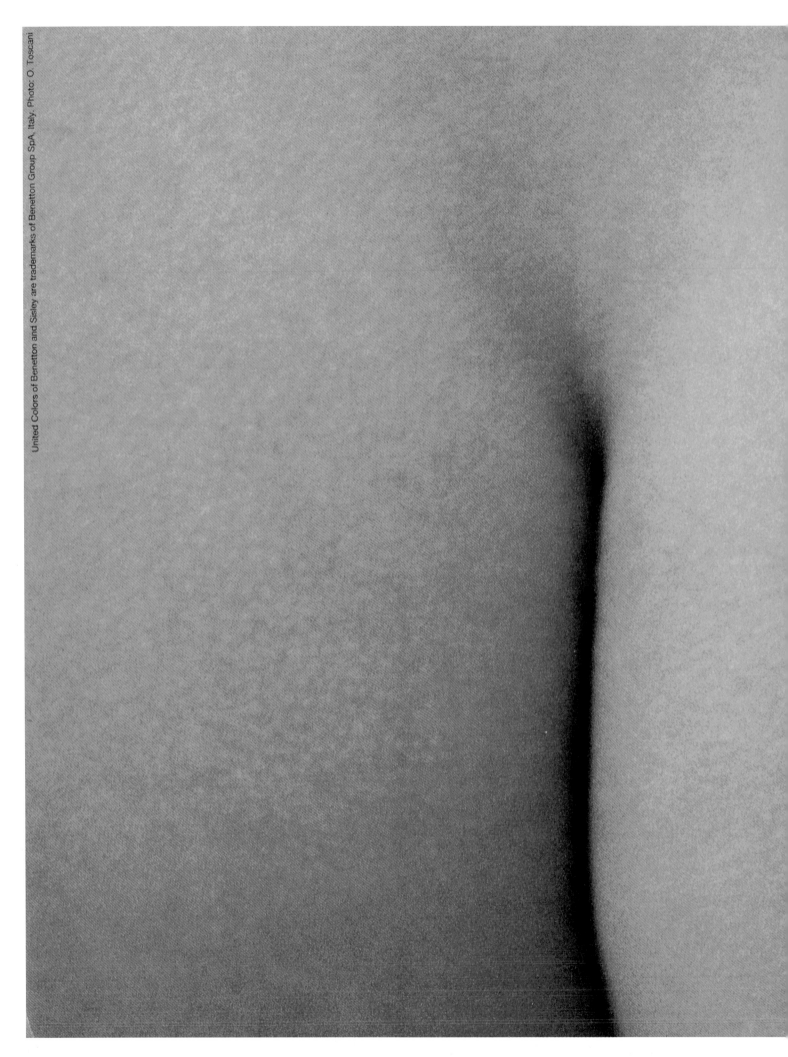

H.I.V.
POSITIVE

UNITED COLORS
OF BENETTON.

'FEW PEOPLE CAN SEE GENIUS IN SOMEONE WHO HAS OFFENDED THEM.'
ROBERTSON DAVIES

UNITED COLORS
OF BENETTON.

United Colors of Benetton and Sisley are trademarks of Benetton Group Spa Italy - Ph. Toscani

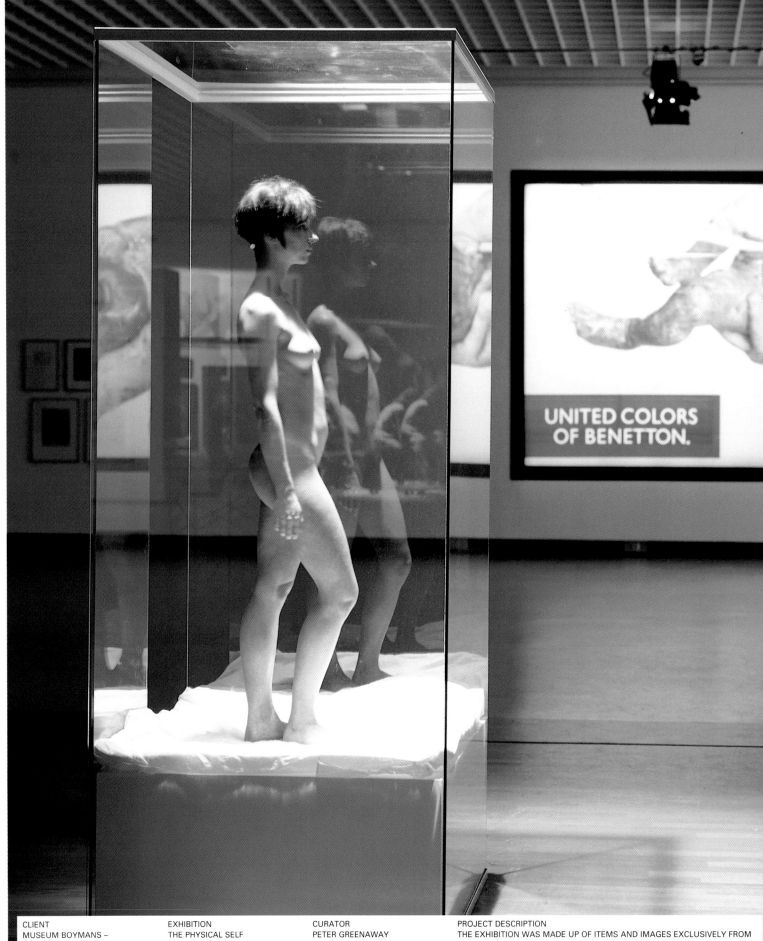

CLIENT
MUSEUM BOYMANS –
VAN BEUNINGEN,
ROTTERDAM

EXHIBITION
THE PHYSICAL SELF
27 10 91 – 12 01 92

CURATOR
PETER GREENAWAY

PROJECT DESCRIPTION
THE EXHIBITION WAS MADE UP OF ITEMS AND IMAGES EXCLUSIVELY FROM
THE BOYMANS-VAN BEUNINGEN COLLECTION THAT COMMENT UPON THE
PHYSICAL HUMAN PREDICAMENT. THE PIECES WERE CHOSEN BY GUEST
CURATOR PETER GREENAWAY. EXHIBITS INCLUDED 4 UNCLOTHED FIGURES.
THESE FIGURES ARE THE TEMPLATES – THE BASIC MODELS TO WHICH ALL
THE PAINTINGS, SCULPTURES AND ARTIFACTS IN THE EXHIBITION RELATE

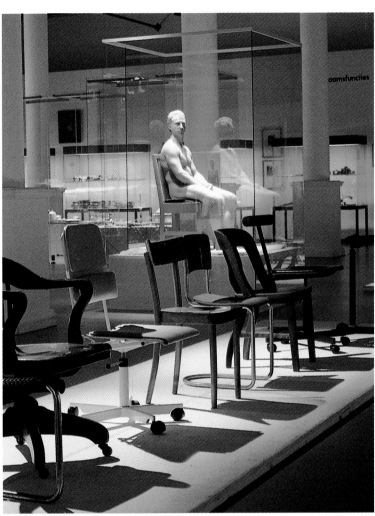
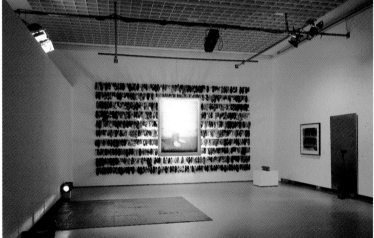
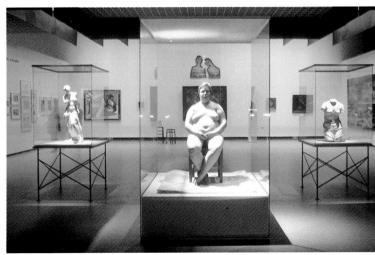

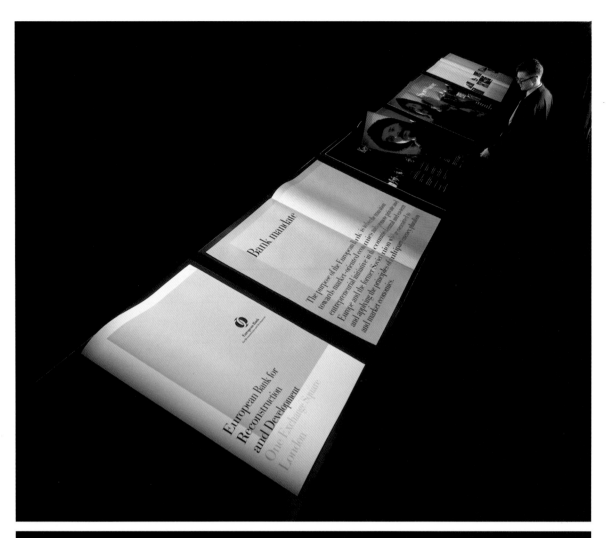

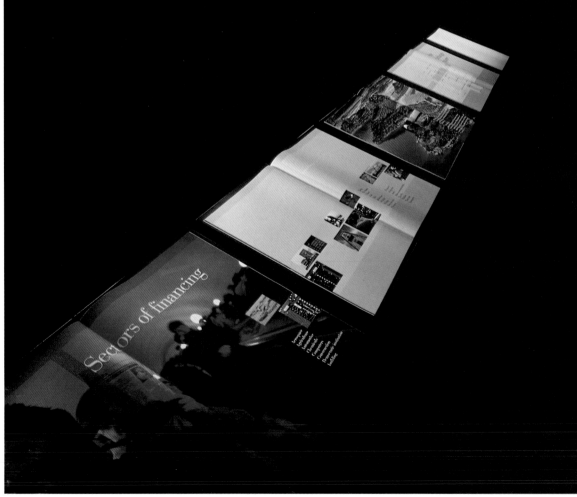

CLIENT
EUROPEAN BANK FOR RECONSTRUCTION
AND DEVELOPMENT

DESIGN COMPANY
WILLIAMS AND PHOA

PHOTOGRAPHY
JON PREW

INTERIOR DESIGNERS
KONU AND MORROW

PROJECT DESCRIPTION
AN EXHIBITION 'BOOK' DOCUMENTING THE EUROPEAN BANK'S INITIATIVES IN EASTERN
EUROPE

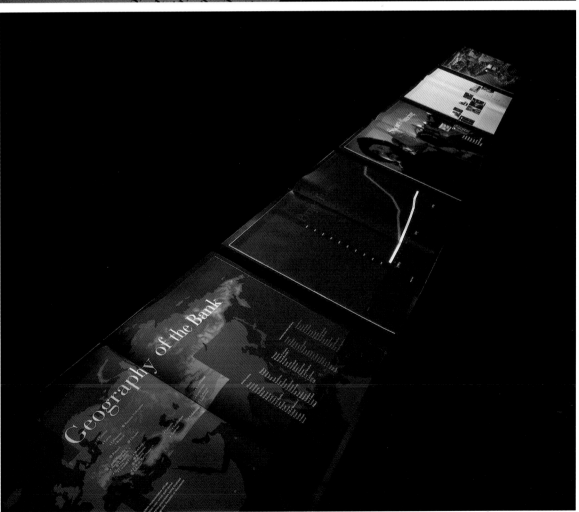

'THE AGE OF THE BOOK IS ALMOST GONE.'

GEORGE STEINER

CLIENT
FOREIGN AND COMMONWEALTH
OFFICE

PROJECT TITLE
INVENTIVE SPIRIT

DESIGN COMPANY
WHY NOT ASSOCIATES

GRAPHIC DESIGNERS
ANDREW ALTMANN
DAVID ELLIS

PHOTOGRAPHY
ROCCO REDONDO

PROJECT DESCRIPTION
EXHIBITION, BRUSSELS 1992

P 60 AND 61

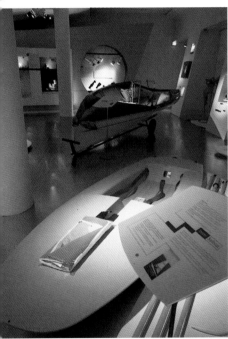

the**inventivespirit**

NEW DESIGN FROM **BRITAIN** DES NOUVELLES CONCEPTIONS DE **GRANDE-BRETAGNE**

NIEUW DESIGN UIT **GROOT-BRITTANNIE**

AUTOWORLD BRUSSELS
PARC DU CINQUANTENAIRE 11, JUBELPARK 11,
1040 BRUSSELS - BRUSSEL
13.10.92. - 06.11.92. 10.00am - 5.00pm.

'WE SHAPE OUR BUILDINGS: THEREAFTER THEY SHAPE US.'

SIR WINSTON CHURCHILL

CLIENT	PROJECT TITLE	ARCHITECT	PROJECT DESCRIPTION
OBAYASHI, TOKYO	MILLENNIUM TOWER	SIR NORMAN FOSTER AND PARTNERS	MULTI-USE TOWER FOR 50,000 INHABITANTS

P 62 AND 63

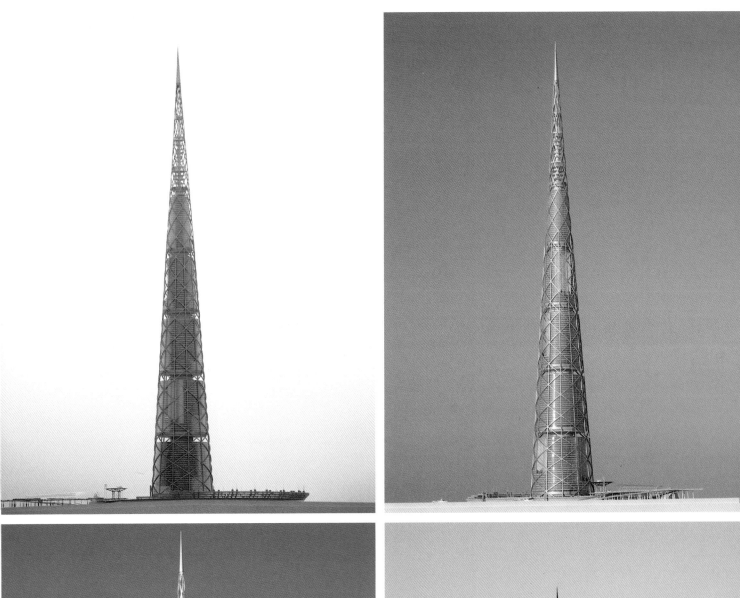

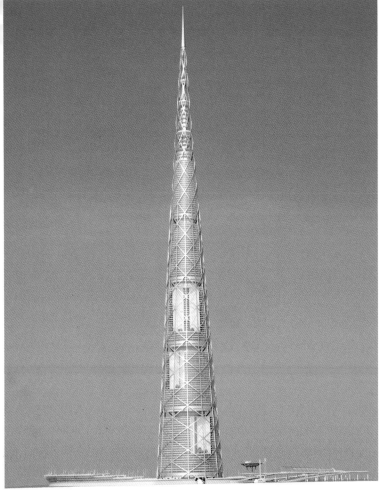

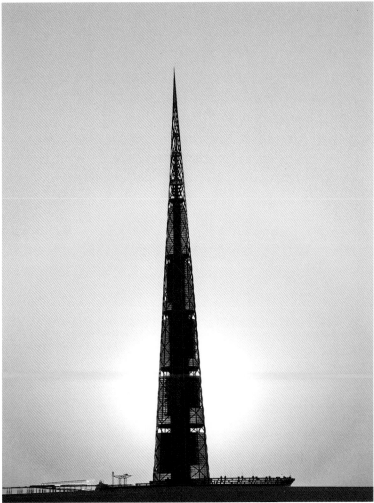

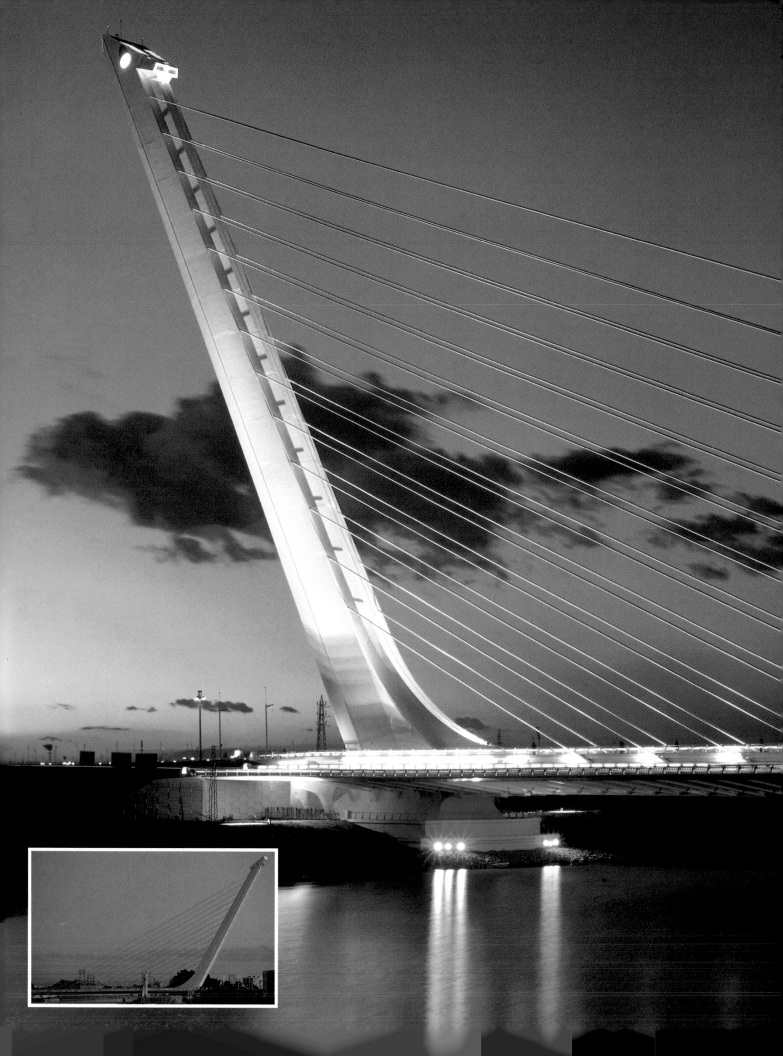

EXPERIENCE IS NEVER LIMITED, AND IT IS NEVER COMPLETE; IT IS AN IMMENSE SENSIBILITY, A KIND OF HUGE SPIDER-WEB OF THE FINEST SILKEN THREADS SUSPENDED IN THE CHAMBER OF CONSCIOUSNESS, AND CATCHING EVERY AIRBORNE PARTICLE IN ITS TISSUE.'

HENRY JAMES

ARCHITECT
SANTIAGO CALATRAVA

PROJECT TITLE
EL ALAMILLO BRIDGE
SEVILLE 1992

PHOTOGRAPHY
JOHN EDWARD LINDON
NICK KANE
COURTESY ARCAID

P 64 AND 65

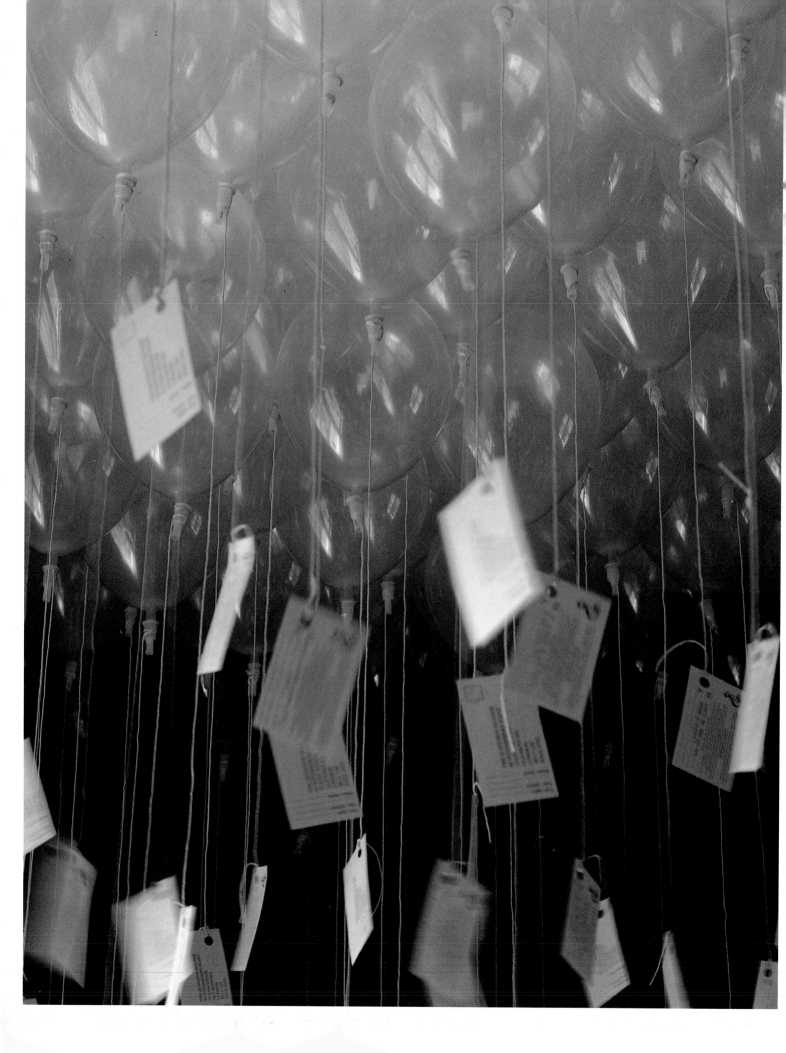

OVER A THREE MONTH PERIOD ADVERTS WERE PLACED IN MAGAZINES, NEWS-PAPERS, SCHOOLS AND AN OLD PEOPLES' HOME TO COLLECT AS MANY QUESTIONS AS POSSIBLE ON ANY SUBJECT – WHETHER IMPORTANT, TRIVIAL, PERSONAL OR UNIVERSAL.

FROM BEING EARTHBOUND, CONTAINED AND ENCLOSED, THE BALOON RELEASE OF THESE QUESTIONS UTILISED THE CHAOTIC POWER OF NATURE TO PLOT OUT AN INDEPENDENT AND RANDOM INFORMATION SYSTEM.

OVER THE NEXT THREE MONTHS OVER 600 ANSWERS WERE RETURNED, FROM PLACES AS DIVERSE AS CROYDON AND MURAT IN SOUTHERN FRANCE.

ARTIST
CHRIS GROTTICK

PROJECT TITLE
METASAMATISM
BALLOON PROJECT

PROJECT DESCRIPTION
AN INFORMATION SYSTEM WHICH INCORPORATES HUMAN OPINION AND NATURE TO HIGHLIGHT THE ESSENTIAL CONNECTION BETWEEN THE TWO, SEPTEMBER 1993 – MAY 1994

P 66 AND 67

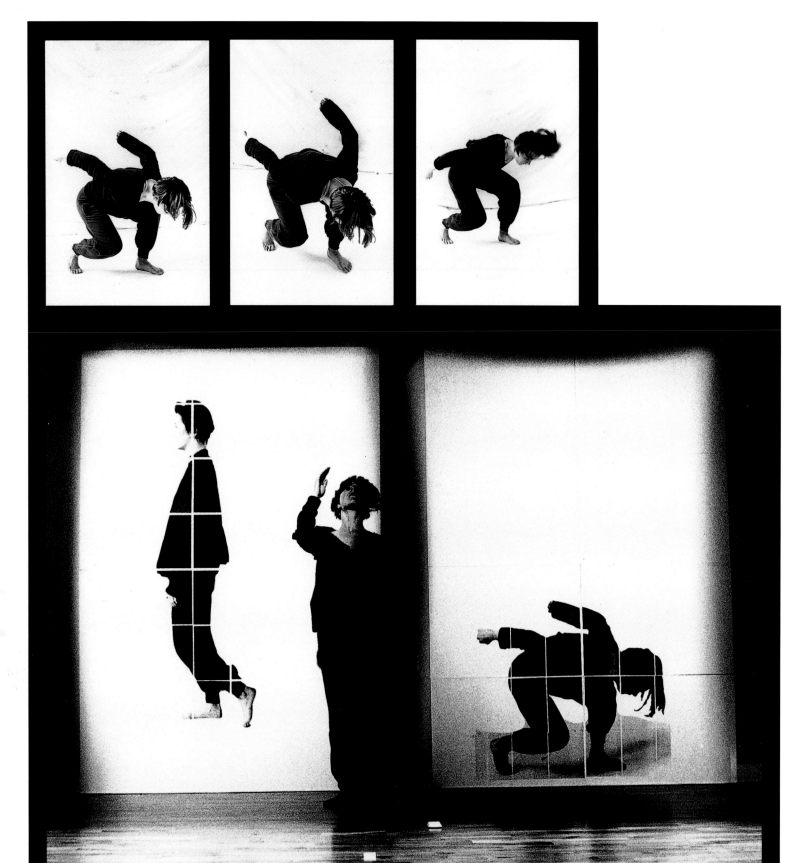

CLIENT	PROJECT TITLE	DANCERS	DESIGNER	PROJECT DESCRIPTION
BARCLAYS	BODY AS SITE	MICHAEL POPPER	PAUL ELLIMAN	LIVE INSTALLATION PERFORMANCE
NEW STAGES AWARD	IMAGE AS EVENT	MICHELLE SMITH		1992 –1993
		FIN WALKER	PHOTOGRAPHY	
	DANCE COMPANY		MARK LEWIS	
	ROSEMARY BUTCHER	MUSIC		
P 68 AND 69		SIMON TURNER		

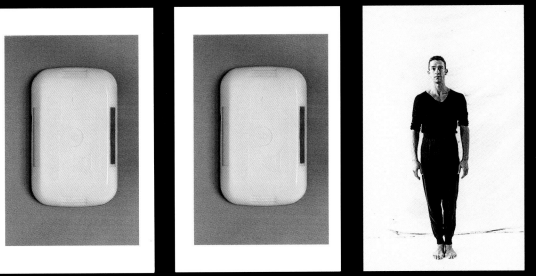

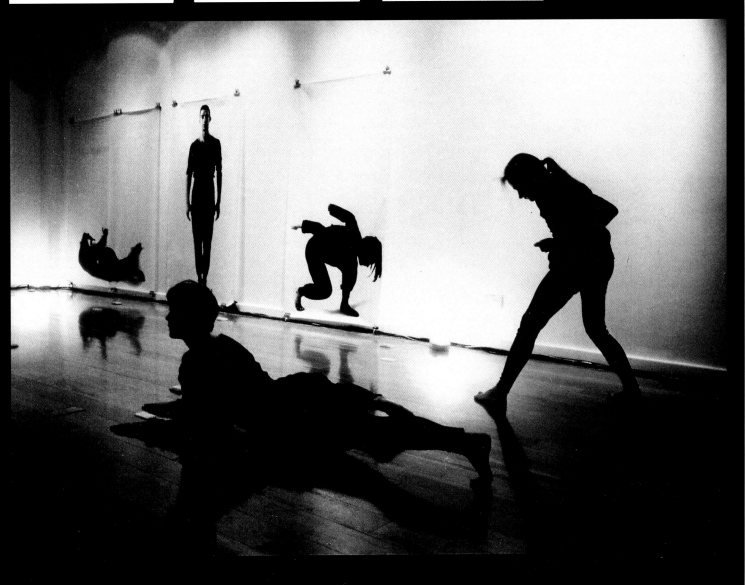

ART

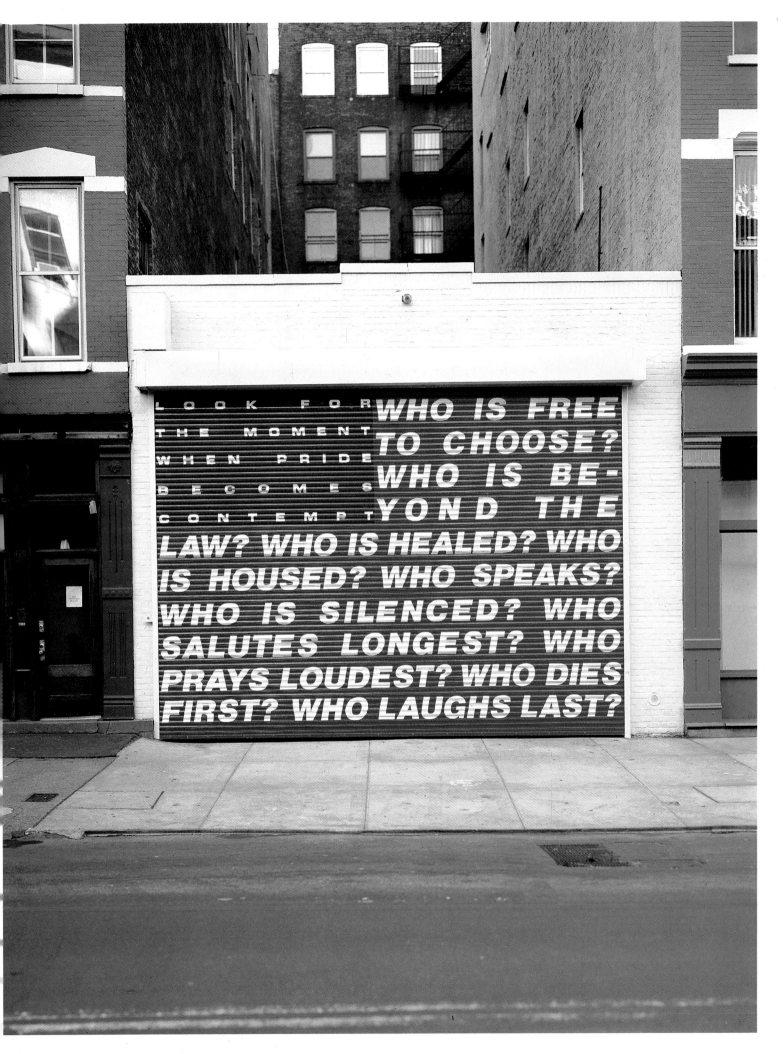

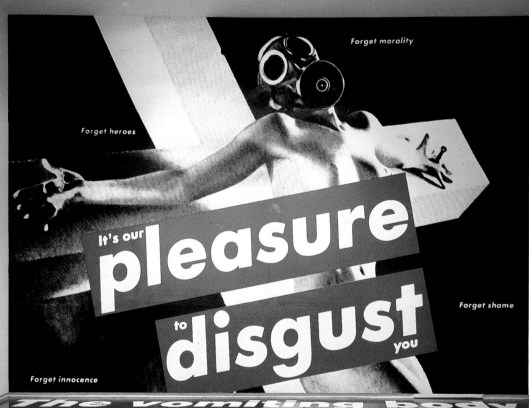

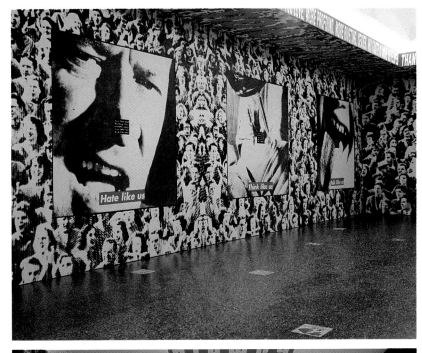

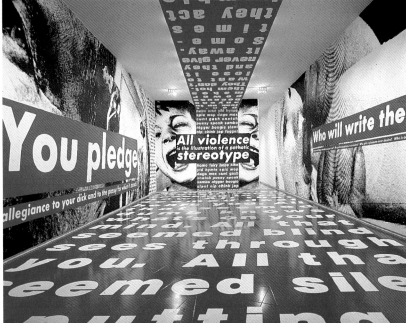

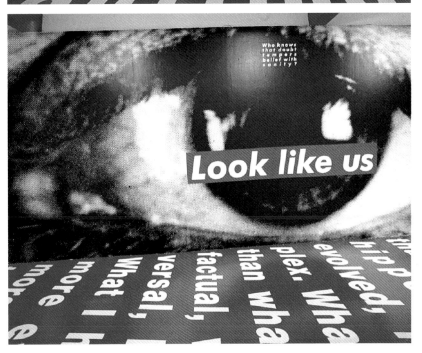

ARTIST
BARBARA KRUGER

CAPTIONS

1

1 PROJECT DESCRIPTION
ENAMEL/ALUMINIUM 1990 186" X 254"
PHOTOGRAPHY DOROTHY ZIEDMAN/FREMONT
COURTESY MARY BOONE GALLERY, NEW YORK

2 PHOTOGRAPHIC SILKSCREEN/PAPER 1990 192" X 276"
3, 4 INSTALLATIONS AT MARY BOONE GALLERY
NEW YORK 1994 AND JANUARY 1991
2, 3, 4 PHOTOGRAPHY DOROTHY ZIEDMAN/FREMONT
COURTESY MARY BOONE GALLERY, NEW YORK

5 INSTALLATION AT SERPENTINE GALLERY, LONDON 1994
PHOTOGRAPHY HUGO ELENDINNING
COURTESY SERPENTINE GALLERY, LONDON

2

3 4 5

No

hidden agenda

The Economist

Open your eyes

The
Economist

Truth

hurts

The Economist

ADVERTISING

CLIENT
THE ECONOMIST

ADVERTISING AGENCY
SP LINTAS

TYPE AND LAYOUT DESIGN
BARBARA KRUGER

SPL WRITER/ART DIRECTOR
ADRIAN KEMSLEY

SPL TYPOGRAPHER
MARK OSBORNE

PROJECT DESCRIPTION
PAN-EUROPEAN ADVERTISING CAMPAIGN 1994

CAPTIONS

1 2

3

PHOTOGRAPHY
1 SANDRA LOUSADA
2 JED ROOT
3 UNKNOWN

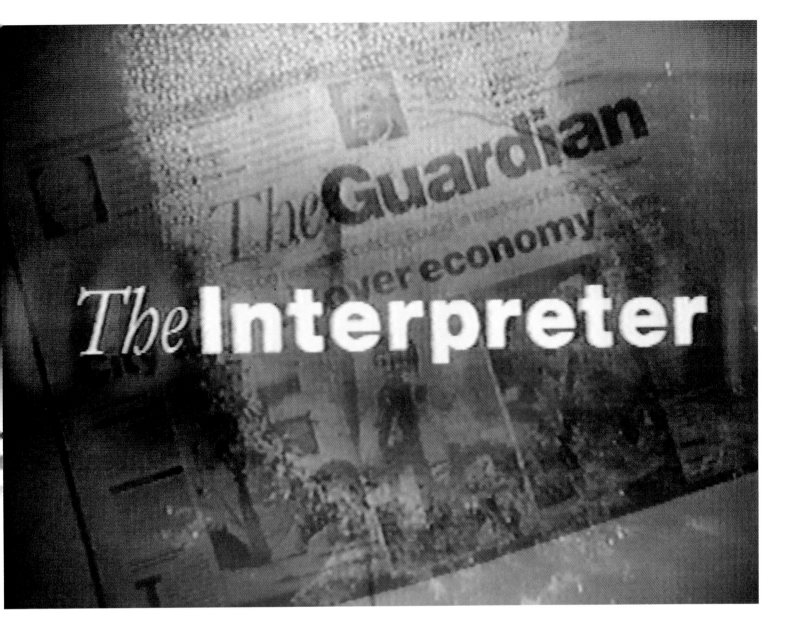

CLIENT	PROJECT TITLE	ADVERTISING AGENCY	DESIGN COMPANY	PROJECT DESCRIPTION
THE GUARDIAN NEWSPAPER	LANGUAGE	LEAGUS DELANEY	TOMATO	TV AND CINEMA ADVERTISING CAMPAIGN FOR THE GUARDIAN NEWSPAPER 1993
		CREATIVES	DIRECTOR	
		TIM DELANEY	GRAHAM WOOD	
		STEVE DUNN		
P 78 AND P 79 (80 AND 81 OVERLEAF)		CHRISTINE JONES		

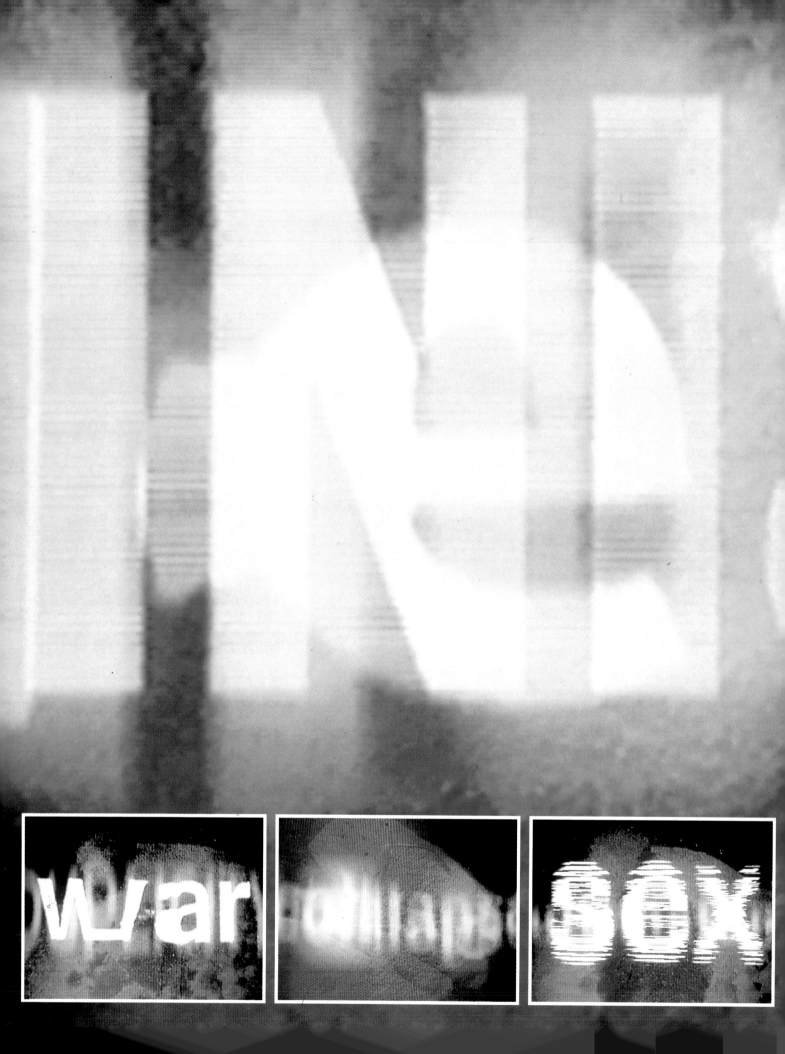

CLIENT
NEWS INTERNATIONAL

PROJECT TITLE
TODAY NEWSPAPER ADVERTISING

ADVERTISING AGENCY
BAINSFAIR SHARKEY TROTT

DESIGN COMPANY
TOMATO

PROJECT DESCRIPTION
ADVERTISING CAMPAIGN FOR
TODAY NEWSPAPER 1994

DIRECTOR
KEVIN GODLEY

CREATIVE
PAUL LEEVES

DESIGNER
GRAHAM WOOD

P 82 AND 83

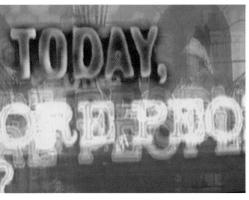
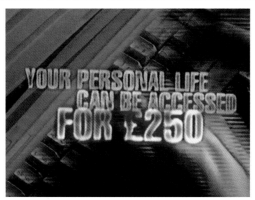

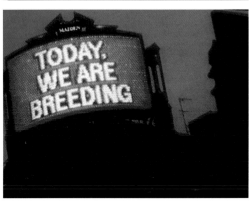

FIRST DIRECT

CLIENT	PROJECT TITLE	ADVERTISING AGENCY	PROJECT DESCRIPTION
MIDLAND BANK	FIRST DIRECT	HOWELL HENRY CHALDECOTT LURY	THE DESIGN OF AN IDENTITY, BANK CARDS AND LAUNCH CAMPAIGN FOR FIRST DIRECT, MIDLAND BANK'S TELEPHONE BANK, THE BANK WITHOUT BRANCHES
		IDENTITY DESIGN	
		PAUL JARVIS	
		SEAN PERKINS	

24 hr person-to-person banking. it's extraordinary.

first direct
0800 22 2000

24 hr person-to-person banking. it's extraordinary.

first direct
0800 22 2000

banking without branches. it's extraordinary.

first direct
0800 22 2000

24 hr person-to-person banking. it's extraordinary.

first direct
0800 22 2000

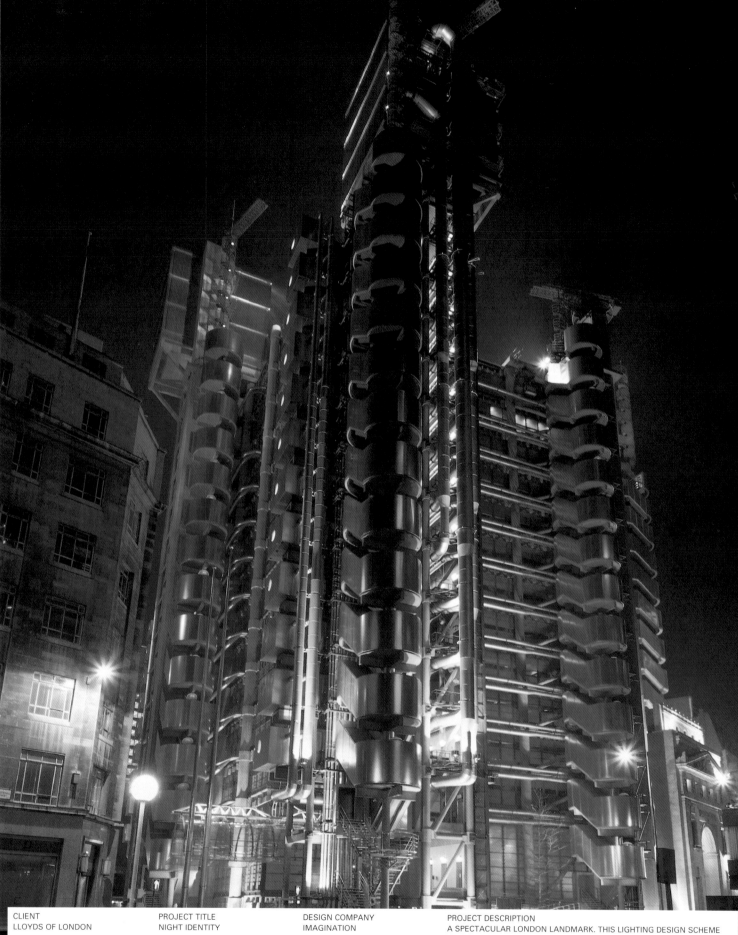

CLIENT
LLOYDS OF LONDON

PROJECT TITLE
NIGHT IDENTITY

DESIGN COMPANY
IMAGINATION

PROJECT DESCRIPTION
A SPECTACULAR LONDON LANDMARK. THIS LIGHTING DESIGN SCHEME
WAS ONE OF A NUMBER OF CREATIVE SOLUTIONS DEVISED BY
IMAGINATION TO CELEBRATE THE 300TH ANNIVERSARY OF LLOYDS OF
LONDON

LLOYDS
OF LONDON

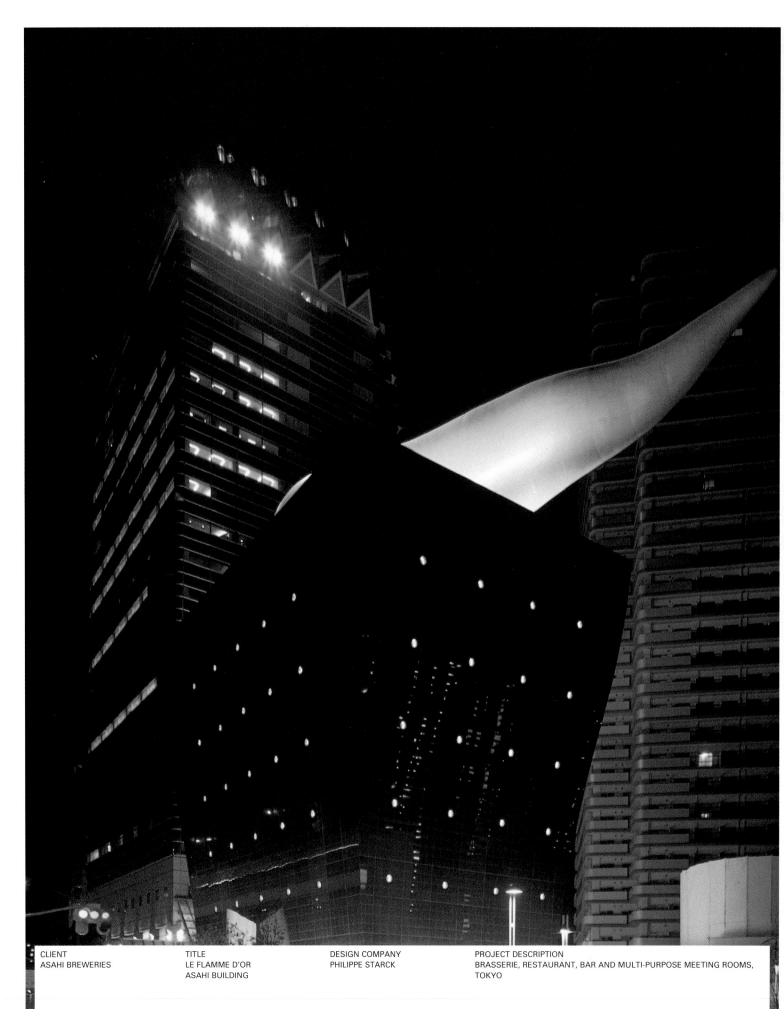

CLIENT	TITLE	DESIGN COMPANY	PROJECT DESCRIPTION
ASAHI BREWERIES	LE FLAMME D'OR	PHILIPPE STARCK	BRASSERIE, RESTAURANT, BAR AND MULTI-PURPOSE MEETING ROOMS,
	ASAHI BUILDING		TOKYO

P 88 AND 89

IN TERMS OF A CORPORATE IDENTITY IT IS A SYMBOL OF CORPORATE HEALTH AND A PROMISE OF THE TWENTY-FIRST CENTURY.

A VISUAL MANIFESTATION OF A BRAND, ASAHI.

ITS SYMBOLISM EXERTS MAGNETIC PULLING POWER UPON LARGE NUMBERS OF VISITORS WHO COME TO EXPERIENCE THE POWERFUL LOOKING BUILDING AND DRINK ASAHI BEER.

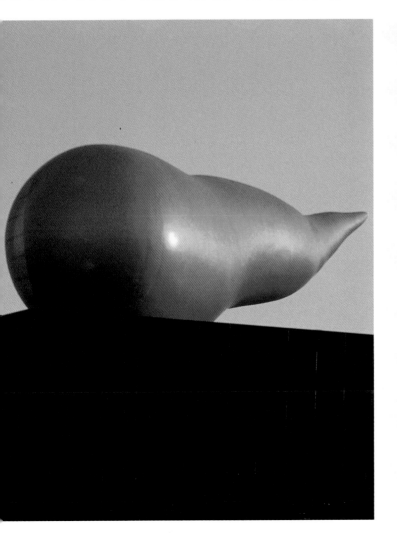

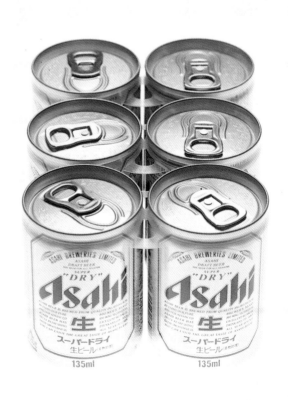

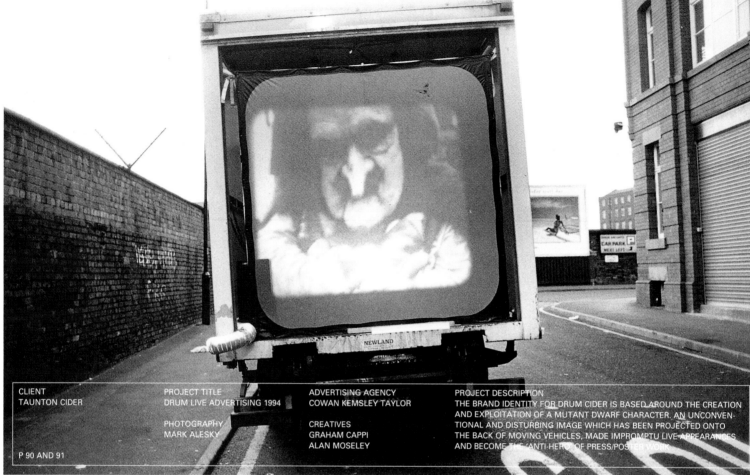

CLIENT	PROJECT TITLE	ADVERTISING AGENCY	PROJECT DESCRIPTION
TAUNTON CIDER	DRUM LIVE ADVERTISING 1994	COWAN KEMSLEY TAYLOR	THE BRAND IDENTITY FOR DRUM CIDER IS BASED AROUND THE CREATION
			AND EXPLOITATION OF A MUTANT DWARF CHARACTER. AN UNCONVEN-
	PHOTOGRAPHY	CREATIVES	TIONAL AND DISTURBING IMAGE WHICH HAS BEEN PROJECTED ONTO
	MARK ALESKY	GRAHAM CAPPI	THE BACK OF MOVING VEHICLES, MADE IMPROMPTU LIVE APPEARANCES
P 90 AND 91		ALAN MOSELEY	AND BECOME THE 'ANTI-HERO' OF PRESS/POSTER WORK

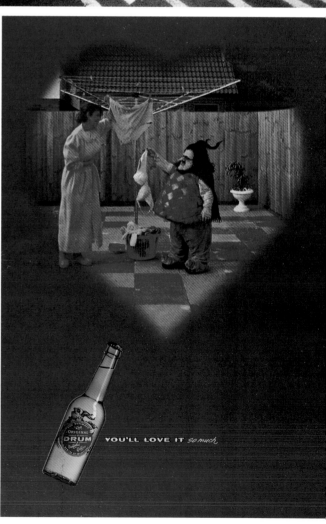

YOU'LL LOVE IT *so much*

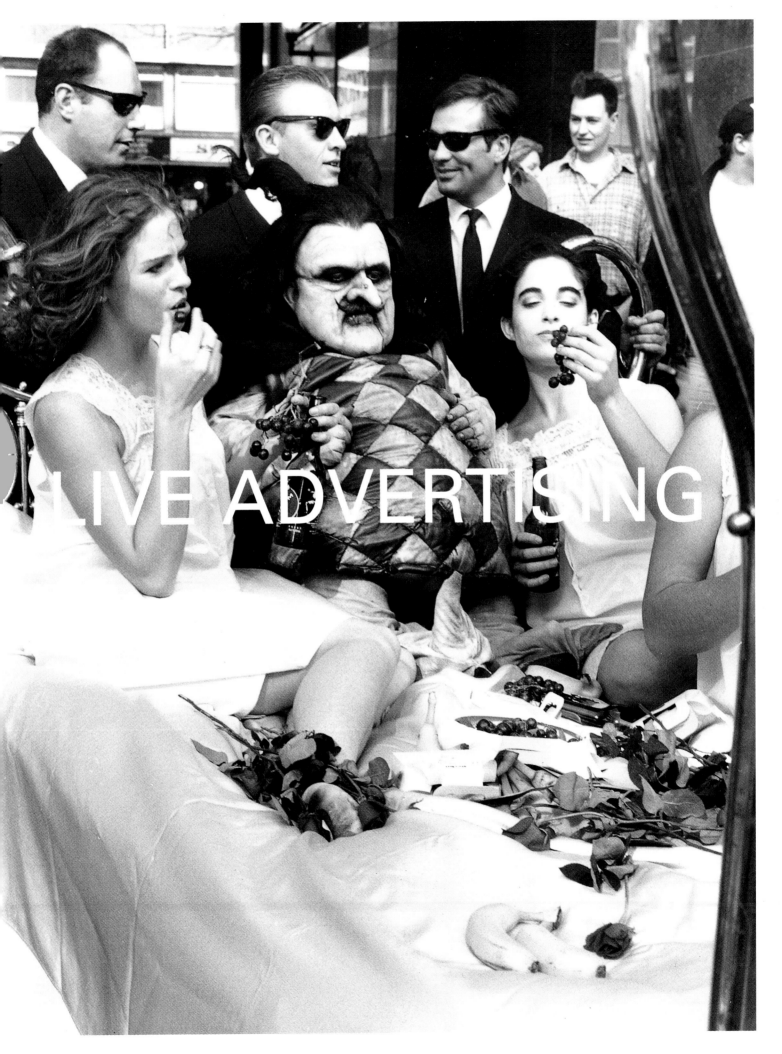

CLIENT
BRITISH AIRWAYS

PROJECT TITLE
SURPRISE SURPRISE

ADVERTISING AGENCY
SAATCHI & SAATCHI

CREATIVES
MATT RYAN
JOHN PALLANT
MARK HANRAHAN

PRODUCTION COMPANY
PAUL WEILAND FILM CO LTD

DIRECTOR
FRANK BUDGEN

PROJECT DESCRIPTION
AT SELECTED CINEMAS BRITISH AIRWAYS RAN AUDIENCE PARTICIPATION ADS FOR THEIR
CITY BREAK COMMERCIALS. A MEMBER OF THE AUDIENCE (PLANTED BY THE ADVERTISING
AGENCY) STANDS UP IN THE MIDDLE OF THE COMMERCIAL AND INTERACTS WITH THE
CELLULOID COUPLE ON SCREEN

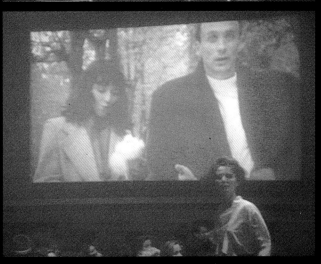

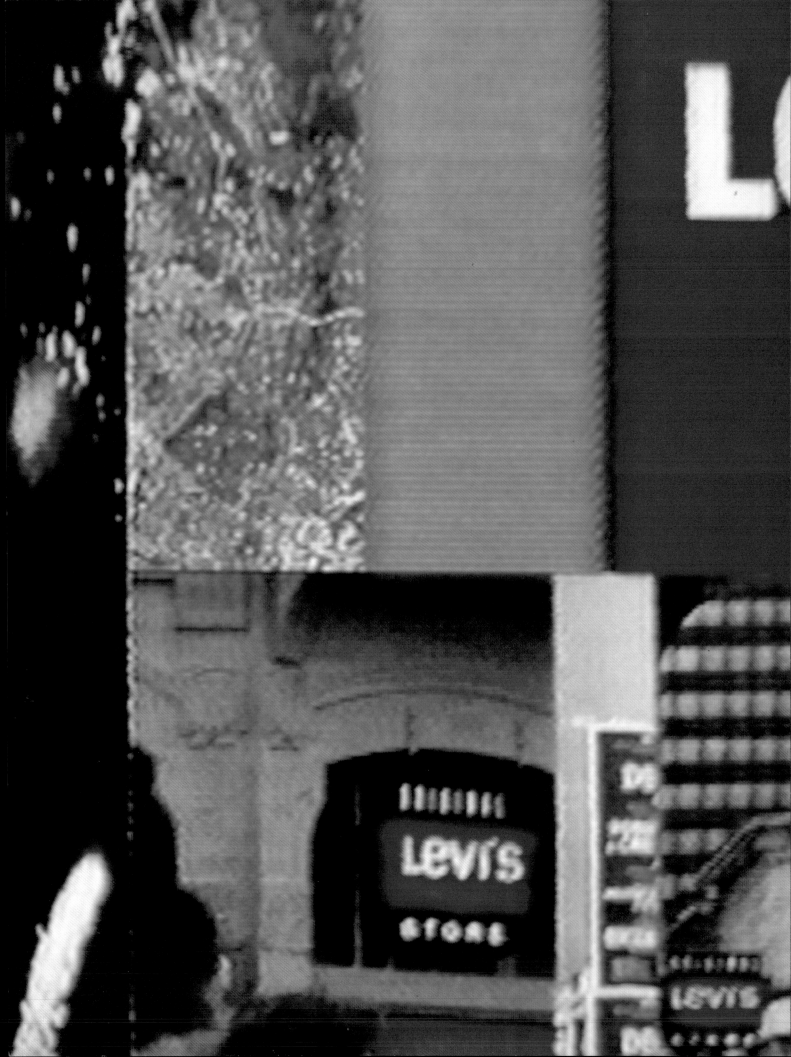

LEVI'S SATELLITE PARTY

LEVI'S STAGED A SERIES OF LIVE, SATELLITE LINKED PARTIES TO LAUNCH THEIR NEW SEASON AND COMMERCIALS TO ALL STAFF AND FRANCHISES AROUND EUROPE.

'EVERYONE FROM JEANS MANUFAC-TURERS TO DESIGNER-LAGER BREWERS HAS A STYLE-LEADER ADVERTISING AND MEDIA STRATEGY, BUT, IF YOU WANT TO KEEP UP WITH THE PEOPLE WHOM OTHER PEOPLE WANT TO KEEP UP WITH, IT TAKES SOMETHING SPECIAL – AND THIS WAS IT.'

SIMON WALDMAN, MEDIA WEEK

CLIENT
LEVI STRAUSS EUROPE

PROJECT TITLE
LEVI'S LIVE TV

CREATIVE DIRECTOR
SALLI HOLLINSON

DESIGNER
PERRY WESTWOOD

PROJECT DESCRIPTION
LEVI'S 1993 PAN-EUROPEAN SEASON
AND CAMPAIGN LAUNCH

DESIGN COMPANY
VISAGE BUSINESS TELEVISION

EXECUTIVE PRODUCER
BOB CLARKE

P 96 AND 97 (94 AND 95 PREVIOUS)

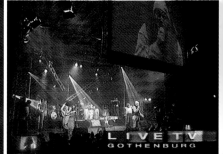

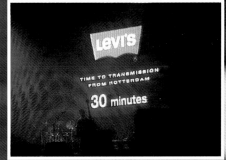

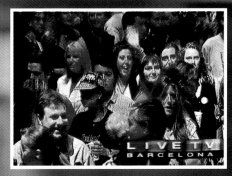

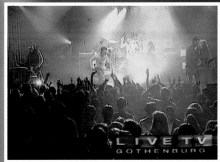

ZOO TV

BONO HAS DEVELOPED A HABIT OF MAKING CALLS DURING THE SHOW FROM THE LIVE PHONE LINES ON STAGE.

HIGHLIGHTS INCLUDE ORDERING PIZZA FOR THE ENTIRE AUDIENCE, CALLING THE HOME SHOPPING CLUB AND LIVE SEX LINES. HE'S EVEN PLACED CALLS TO THE WHITE HOUSE AND TO JOHN MAJOR TO PROTEST ABOUT THE SELAFIELD NUCLEAR FUEL REPROCESSING PLANT.

THE EBB AND FLOW OF SUCH A VAST COLLAGE OF INFORMATION AND IMAGES FROM SO MANY DIFFERENT SOURCES CREATES THE EFFECT OF CHANNEL-ZAPPING ON AN URBAN SCALE.

LIVE

CLIENT
U2

PROJECT TITLE
ZOO TV OUTSIDE BROADCAST
1992 WORLD TOUR

DESIGN COMPANY
FISHER PARK

DESIGNERS
MARK FISHER
JONATHAN PARK

LIGHTING DIRECTOR
PETER WILLIAMS

VIDEO DIRECTOR
CAROL DODDS

P 100 AND 101 (98 AND 99 PREVIOUS)

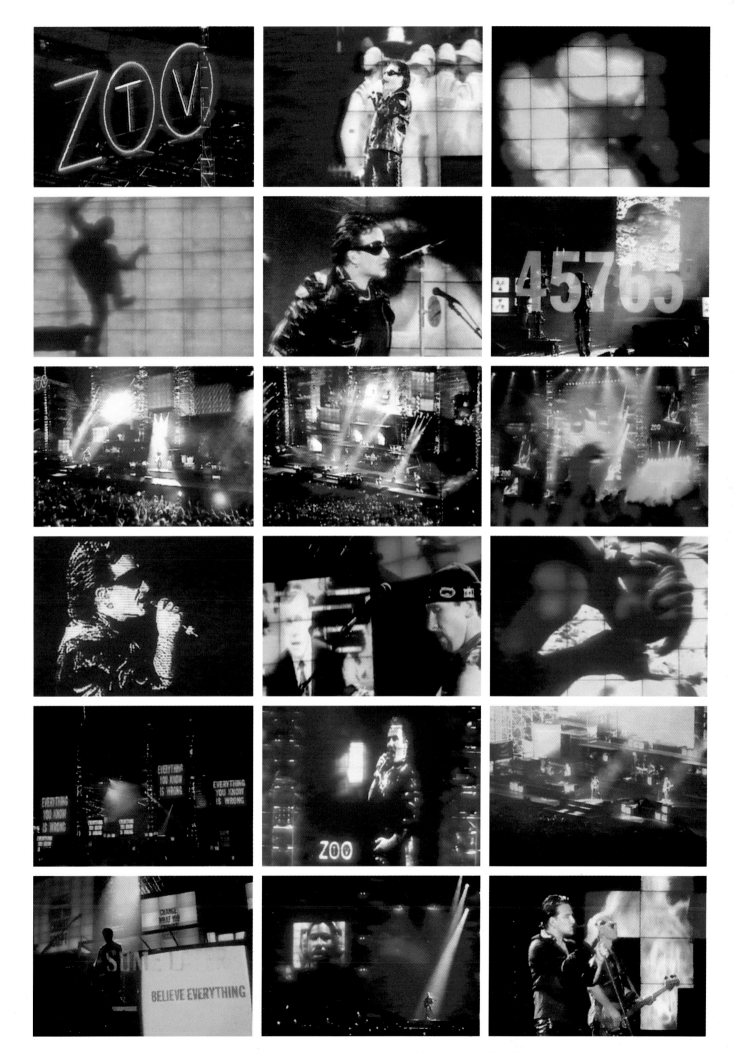

'NOWADAYS PEOPLES' VISUAL IMAGINA-
TION IS SO MUCH MORE SOPHISTICATED,
SO MUCH MORE DEVELOPED, PARTICU-
LARLY IN YOUNG PEOPLE, THAT NOW
YOU CAN MAKE AN IMAGE WHICH JUST
SLIGHTLY SUGGESTS SOMETHING, THEY
CAN MAKE OF IT WHAT THEY WILL.'

ROBERT DOISNEAU

CLIENT	TITLES	DESIGN COMPANY	PROJECT DESCRIPTION
MTV EUROPE	SAVE FUEL	FUEL	THREE THIRTY-SECOND IMAGE SPOTS 1994
	FAST FOOD		
	HAIR	DESIGNERS	
		PETER MILES	
		DAMON MURRAY	
P 102 AND 103		STEPHEN SORRELL	

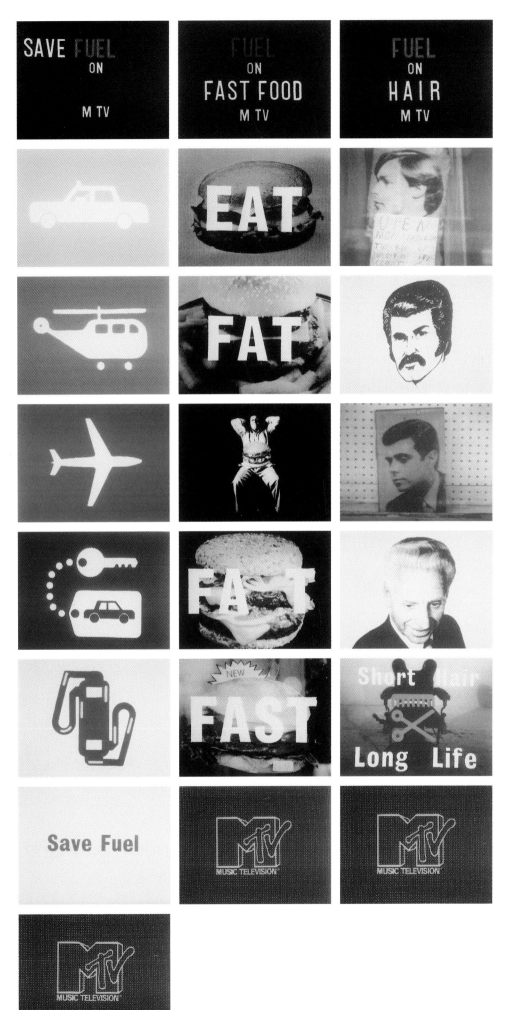

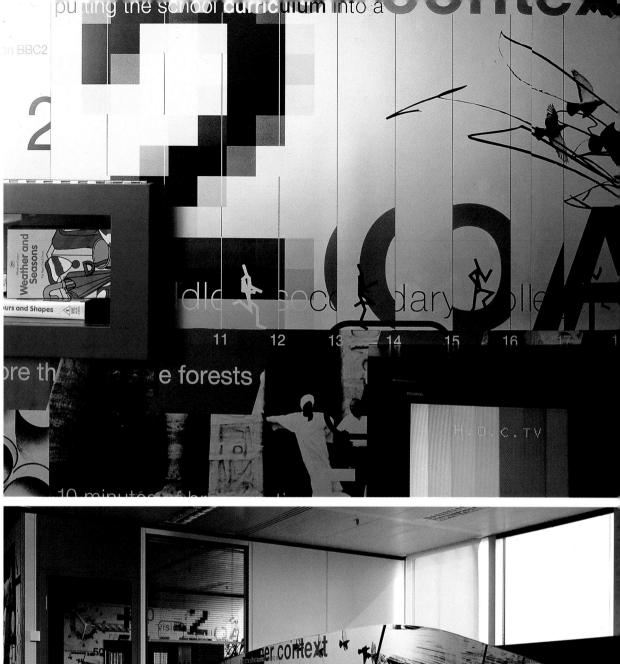

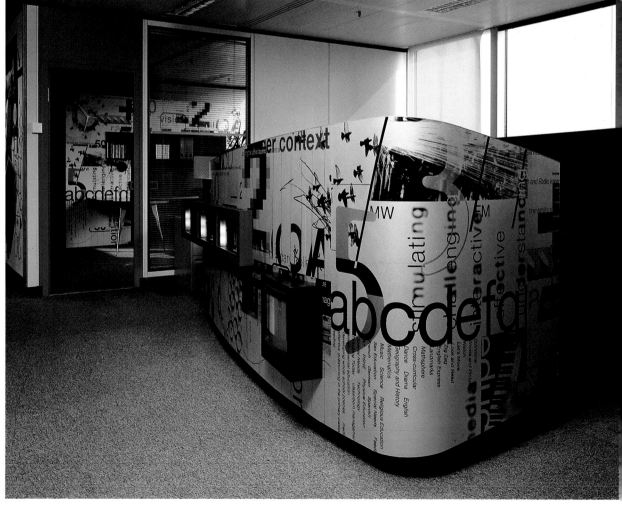

THE DESIGN PROVIDES BBC SCHOOL TELE-
VISION WITH A HIGHLY ANIMATED VISUAL
IDENTITY THAT BEFITS AN ORGANISATION
WORKING AT THE FOREFRONT OF MEDIA
TECHNOLOGY. THE EXUBERANCE OF
VISUAL ACTIVITY IS APPROPRIATE FOR A
COMPANY DISTRIBUTING VISUAL AND
ACOUSTIC MATERIAL THAT EDUCATES
AND INSPIRES MORE YOUNG PEOPLE ALL
OVER THE WORLD THAN ANY OTHER
BROADCASTING COMPANY.'

NICK BELL

CLIENT	DESIGN COMPANY	INTERIOR DESIGNERS	PROJECT DESCRIPTION
BBC SCHOOL TELEVISION	NICK BELL	CASSON MANN	TYPOGRAPHIC SKIN TO COVER THE WALLS OF AN OFFICE AT BBC SCHOOL TELEVISION, WHITE CITY, LONDON 1993

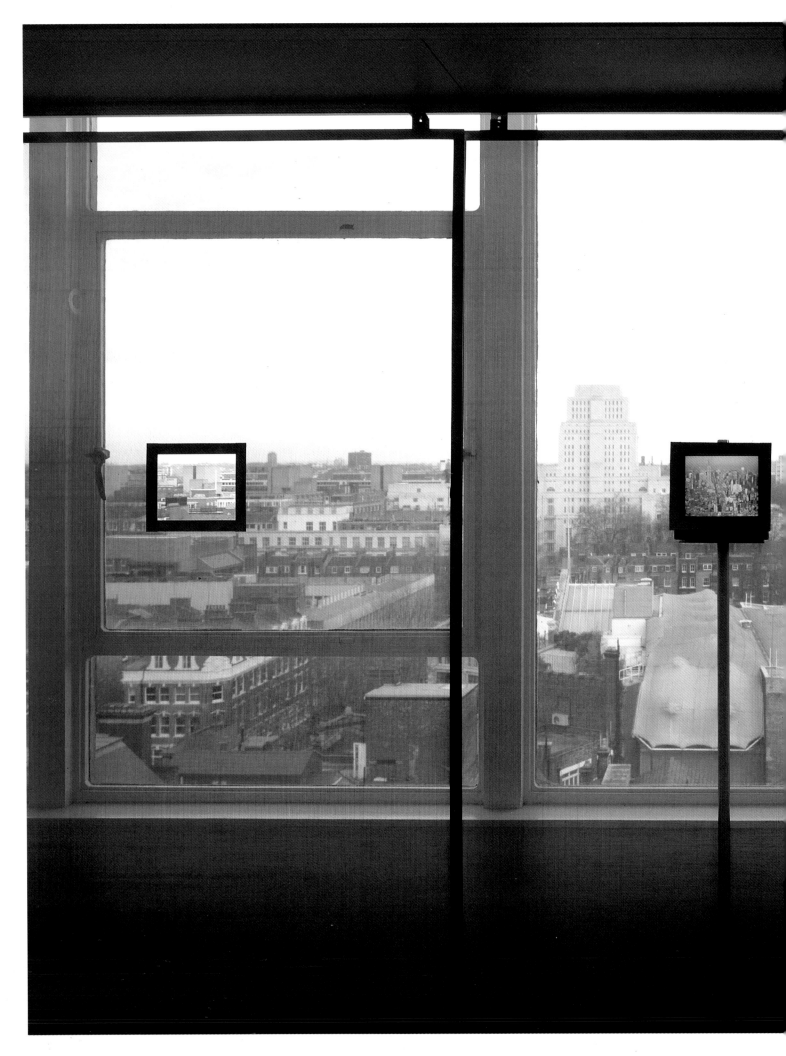

CLIENT
LEAGUS SHAFFRON DAVIS
CHICK AYER

DESIGN COMPANY
FERN AND GREEN
PARTNERSHIP

DESIGNERS
NIGEL GREEN
DAVID FERN

PHOTOGRAPHY
ALAN WILLIAMS

PROJECT DESCRIPTION
REFURBISHMENT OF 9000 SQ FT COMPANY OFFICE ON THE NINTH AND TENTH FLOORS OF A 1960'S
TOWER BLOCK IN CENTRAL LONDON. THE MAIN ATTRIBUTE OF THE BUILDING WAS CONSIDERED TO
BE THE VIEW FROM THE LONG GLAZED ELEVATION. THIS VIEW IS BROUGHT SHARPLY INTO FOCUS
BY REDUCING THE OPEN WINDOW AREA DOWN TO SMALL VIEWING APERTURES WITHIN FINE MESH
SCREENS WHICH COVER THE ENTIRE ELEVATION. THE OPEN APERTURES ARE ALTERNATED WITH
MEDIA GENERATED IMAGES OF A CITY SKYLINE SHOWN ON SMALL VIDEO MONITORS

ONE OF THE FIRST PRODUCTS DESIGNED BY PHILIPPE STARCK FOR THE FRENCH ELECTRICAL COMPANY THOMSON GROUP.

CLIENT	PROJECT TITLE	DESIGN COMPANY	PROJECT DESCRIPTION
SABA	JIM NATURE	THOMSON – DESIGN CENTRE	WOODEN TV 1993
			THE TELEVISION SHELL IS MADE OF WOOD AND CAN BE RECYCLED
		DESIGNER	
		PHILIPPE STARCK	

P 108 AND 109

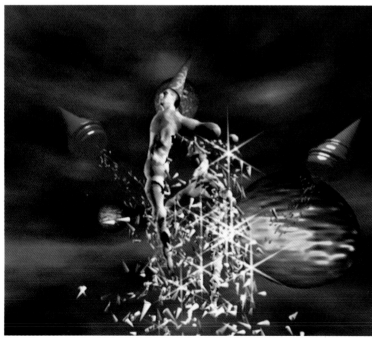

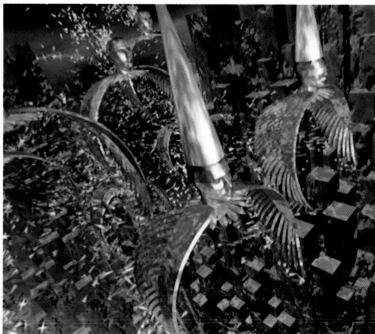

THE PET SHOP BOYS VIDEO 'LIBERATION'
CAN BE EXPERIENCED THROUGH THE
WORLD OF VIRTUAL REALITY AND ARTI-
FICIAL NATURE.

CLIENT	PROJECT TITLE	DESIGN COMPANY	3D ANIMATION	PROJECT DESCRIPTION
PET SHOP BOYS	LIBERATION 1994	FUTURE REALITY LTD	IAN BIRD	3D COMPUTER ANIMATION AND
WHY NOT FILMS				MOTION SIMULATOR 1994
			SIMULATION	
			IAN WILLIAMS	

P 110 AND 111

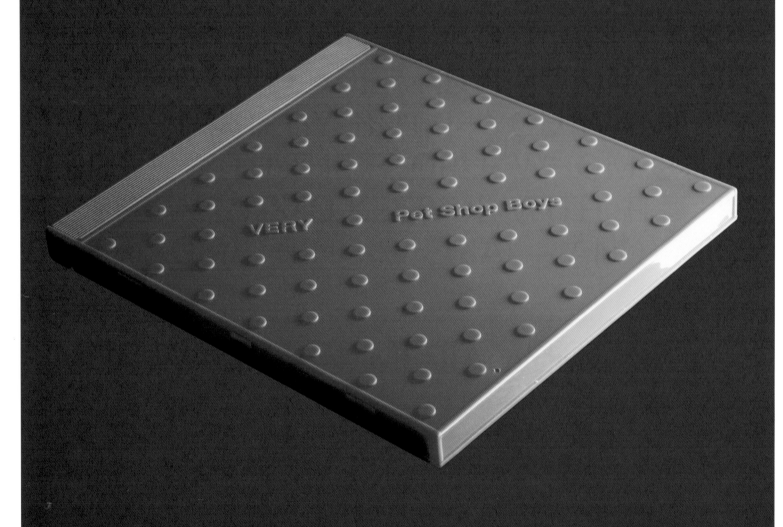

CLIENT	PROJECT TITLE	DESIGN COMPANIES	PRODUCT DESIGNER	PROJECT DESCRIPTION
PET SHOP BOYS	VERY PET SHOP BOYS	PENTAGRAM	DANIEL WEIL	CD PACKAGE 1993
PARTNERSHIP		FARROW		
			PHOTOGRAPHY	
		GRAPHIC DESIGNERS	CHRIS NASH	
		MARK FARROW		
P 112 AND 113		ROB PETRIE		

PET SHOP BOYS

CLIENT
IBM DIRECT

PROJECT TITLE
48 SHEET BILLBOARD 1994

DESIGN AND PHOTOGRAPHY
MALCOLM GOLDIE

PROJECT DESCRIPTION
TO HELP PROJECT IBM'S BELIEF IN THE FUSION OF INDUSTRY AND ART, THE COMPANY ISSUED A BRIEF TO
LONDON'S ROYAL COLLEGE OF ART TO DESIGN A 48 SHEET BILLBOARD WHICH INCORPORATED THE IBM DIRECT
TELEPHONE NUMBER. SEVEN DESIGNS WERE CHOSEN AND PLACED AT PROMINENT SITES AROUND ENGLAND FOR
A PERIOD OF TWO MONTHS. THIS DESIGN INTERPRETS THE TELEPHONE NUMBER IN THE FORM OF A MODULAR GRID
WHERE EACH RECTANGLE IS EITHER POSITIVE OR NEGATIVE TO REFLECT THE BINARY NUMBER SYSTEM. THE DOG
STANDS IN THE LUGGAGE COMPARTMENT OF A NUMBER 31 BUS. ITS BREED AND OWNER ARE UNKNOWN

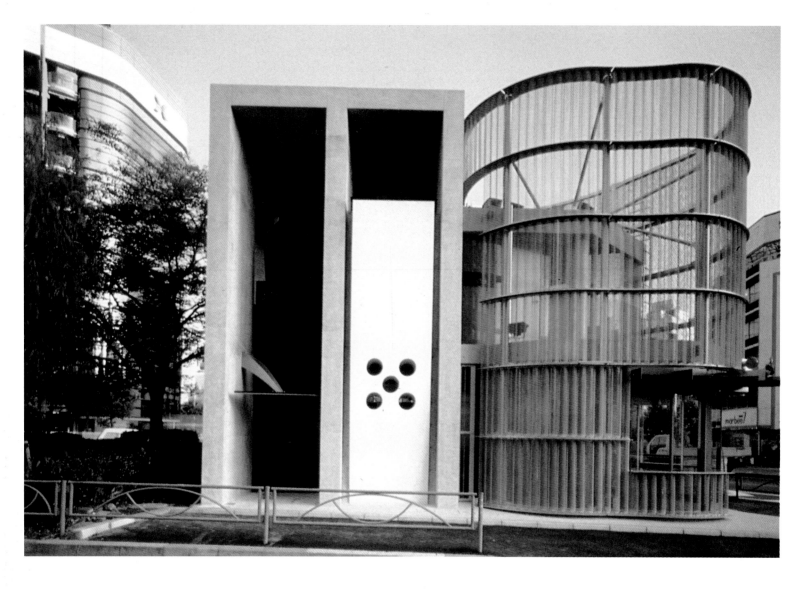

CLIENT
METROPOLITAN POLICE

PROJECT TITLE
HIGASHI-NIHONBASHI
POLICE BOX

ARCHITECT
ATSUSHI KITAGAWARA & ILCD

PHOTOGRAPHY
SHIGEO OGAWA SHINKENCHIKU©

PROJECT DESCRIPTION
POLICE BOX 1992

P 116 AND 117

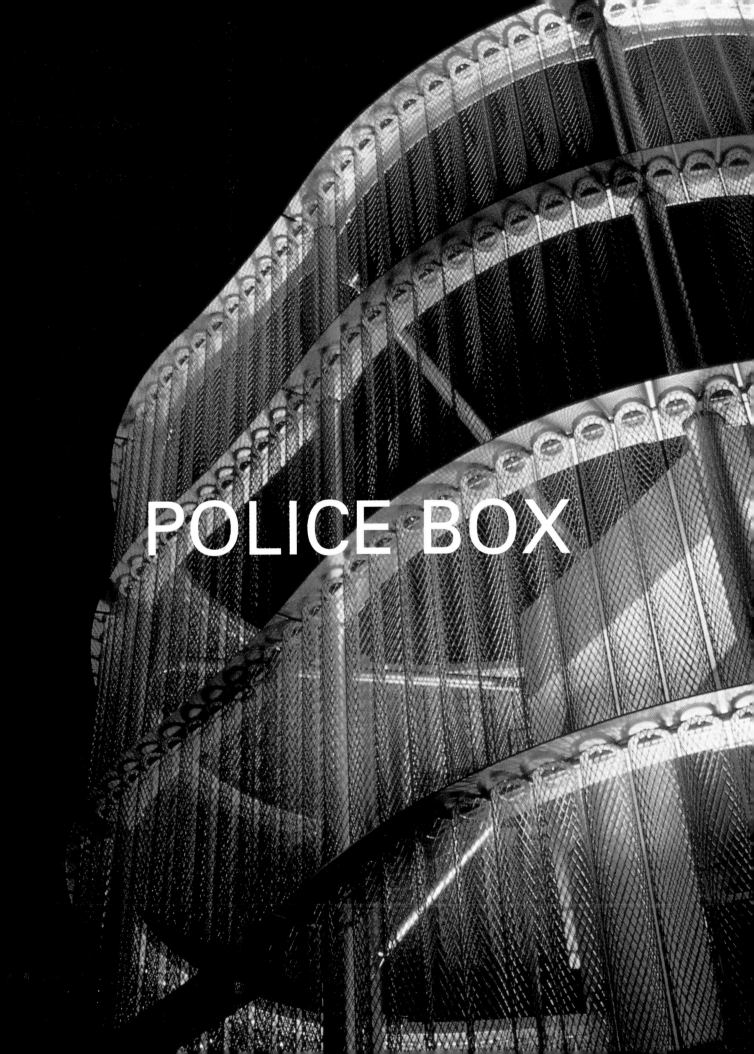

POLICE BOX

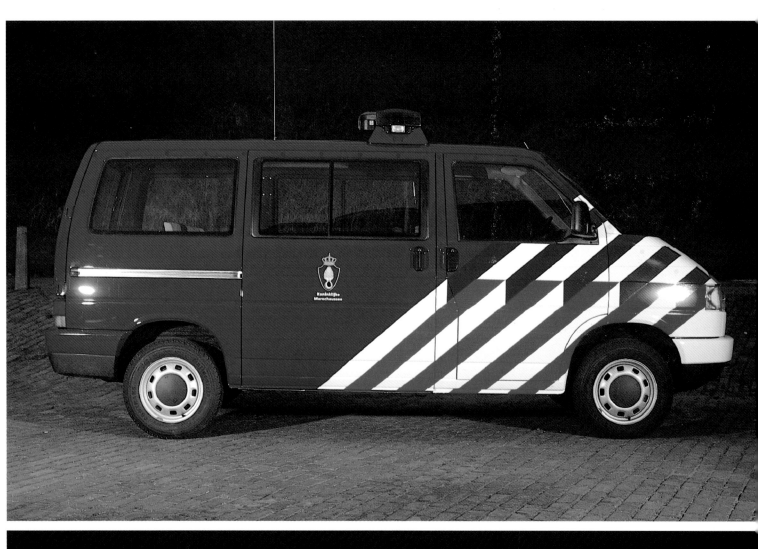
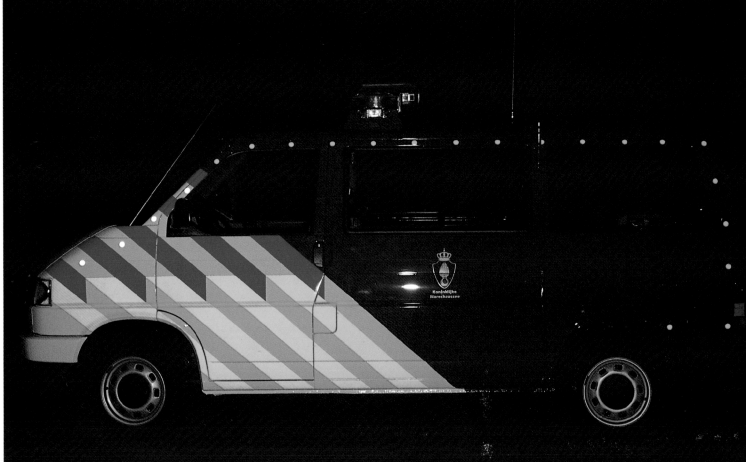

DESIGN COMPANY
STUDIO DUMBAR

PHOTOGRAPHY
LEX VAN PIETERSON

CAPTIONS

1		3
2		

CLIENT
1, 2 KONINKLUKE MARECHAUSSEE

3 DUTCH POLICE

PROJECT DESCRIPTION
DAY AND NIGHT REFLECTION
1993

CORPORATE IDENTITY
1993

P 118 AND 119

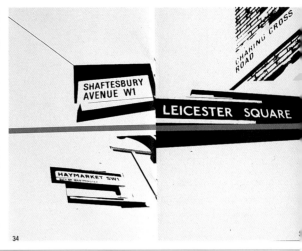

DESIGNER	STUDENT AT	CAPTIONS	PROJECT DESCRIPTION
JAYNE ALEXANDER	ROYAL COLLEGE OF ART LONDON		1, 2, 3 ACCESS GUIDE IN RESPONSE TO HOW DISABLED PEOPLE EXPERIENCE THE CITY OF LONDON 1994
			4, 5 GETTING FROM A - B
			POSTERS TO ACCOMPANY ACCESS GUIDE 1994
P 120			

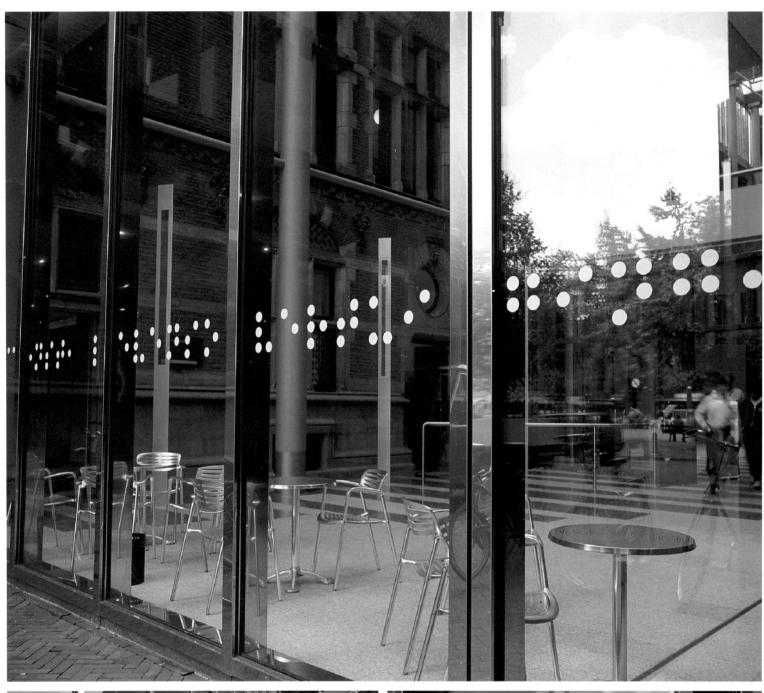

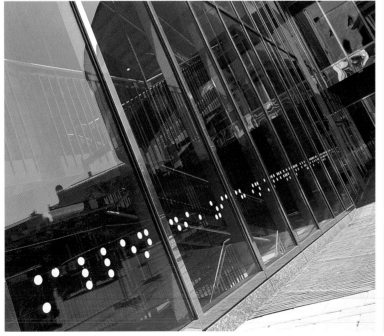

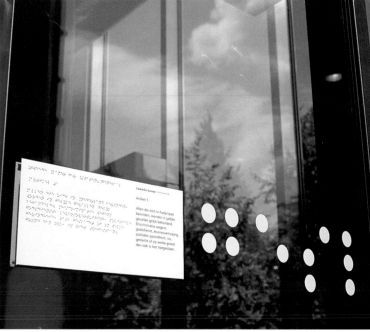

Tweede kamer

Artikel 1

Allen die zich in Nederland
bevinden, worden in gelijke
gevallen gelijk behandeld.
Discriminatie wegens
godsdienst, levensovertuiging,
politieke gezindheid, ras,
geslacht of op welke grond
dan ook is niet toegestaan.

IN AUTUMN 1992 SDU TAPPAN WAS
COMMISSIONED TO DESIGN MARKINGS
FOR THE GLASS WINDOWS OF THE
DUTCH PARLIAMENT BUILDING
ESPECIALLY FOR VISUALLY HANDICAPPED
PERSONS.

THE DESIGN DISTINGUISHES ITSELF FROM
OTHER STANDARD SOLUTIONS BECAUSE
IT GIVES THE TEXT OF ARTICLE 1 OF THE
DUTCH CONSTITUTION IN BRAILLE.
ARTICLE 1 OF THE DUTCH CONSTITUTION
DECLARES EACH PERSON IN THE
NETHERLANDS EQUAL BEFORE THE LAW.

CLIENT
THE MINISTRY OF HOUSING
AND CONSTRUCTION

DESIGN COMPANY
SDU TAPPAN

PRODUCTION
BRUNS BV

DESIGNERS
JORGE STEENBERGEN
ALBERT HENNIPMAN

PHOTOGRAPHY
LIGHTHART & VAN AARSEN

PROJECT DESCRIPTION
BRAILLE SAFETY RIBBON FOR THE NEW DUTCH PARLIAMENT BUILDING 1993

P 122 AND 123

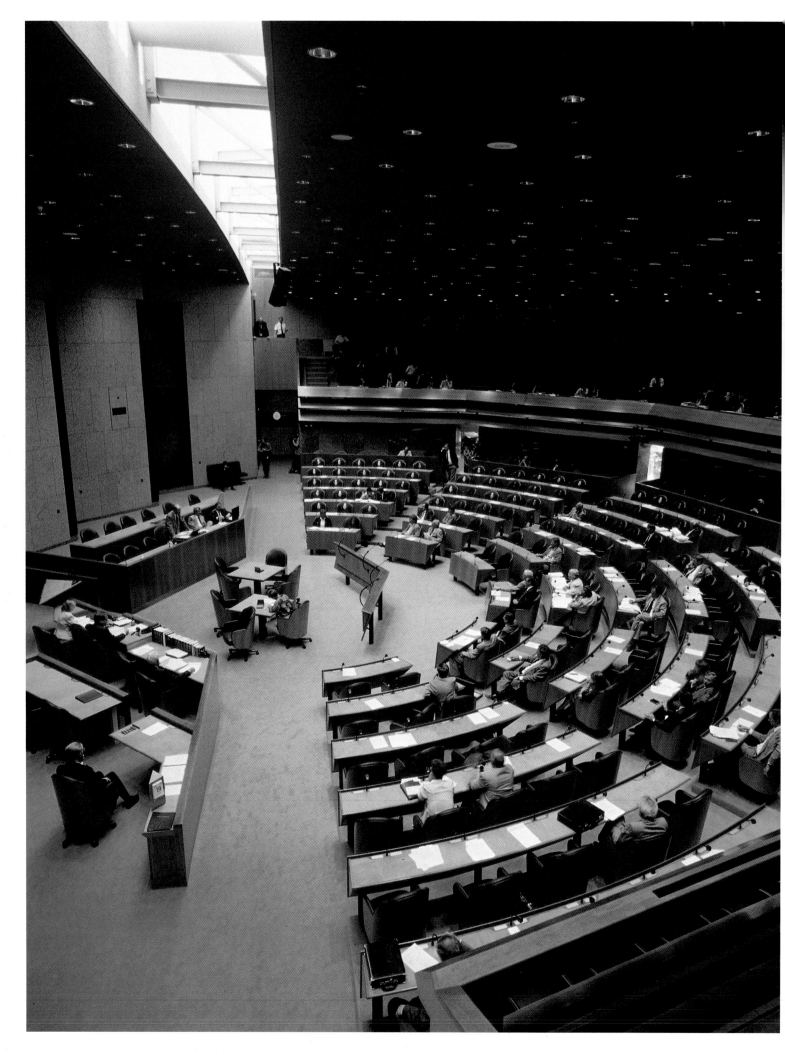

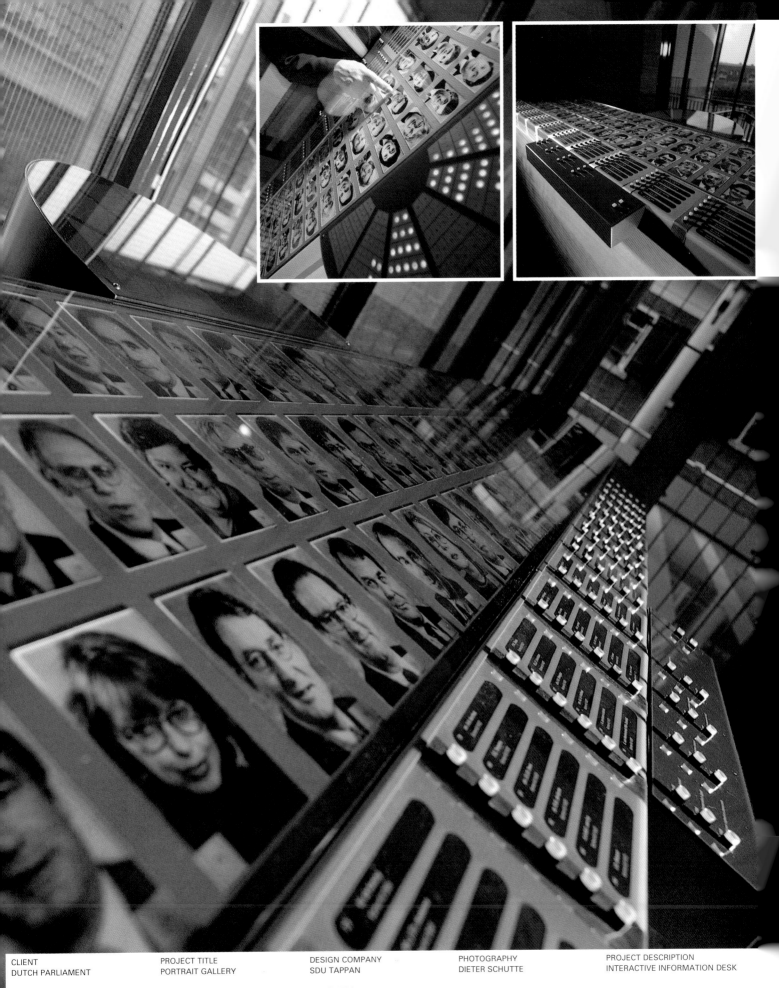

CLIENT
DUTCH PARLIAMENT

PROJECT TITLE
PORTRAIT GALLERY

PRODUCTION
BRUNS BV

DESIGN COMPANY
SDU TAPPAN

DESIGNERS
JORGE STEENBERGEN
ALBERT HENNIPMAN

PHOTOGRAPHY
DIETER SCHUTTE

PROJECT DESCRIPTION
INTERACTIVE INFORMATION DESK

CLIENT	PROJECT TITLE	DESIGN COMPANY	
THE CITY OF NANTES	SIGNAGE SYSTEM FOR	ATELIER DE CREATION GRAPHIQUE – GRAPUS	ARCHITECTS
	THE CONGRESS HALL OF NANTES		YVES LION
	1991		ALAN LEVITT
		DESIGNERS	
		DIRK BEHAGE	
P 126 AND 127		PIERRE BERNARD	
		FOKKE DRAAIJER	

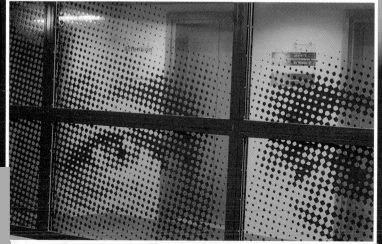

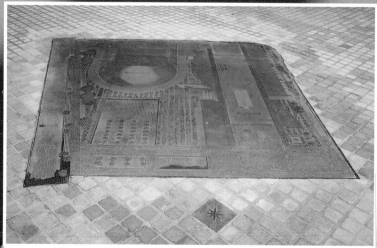

CAPTIONS

1 SIGN SHOWING COLOURS AND IMAGES FOR EACH FLOOR OF THE CAR PARK
2 DETAIL OF A PORTRAIT OF JULES VERNE (A WRITER BORN IN NANTES)
3 4 X 4M CAST-IRON PLATE PLAN OF THE BUILDING AND GARDEN
4 CAR PARK ENTRANCE, HERE YOU CAN SEE THE COLOURS OF EACH LEVEL
5 DOOR SIGN FOR THE ARTISTS' ROOM IN THE THEATRE

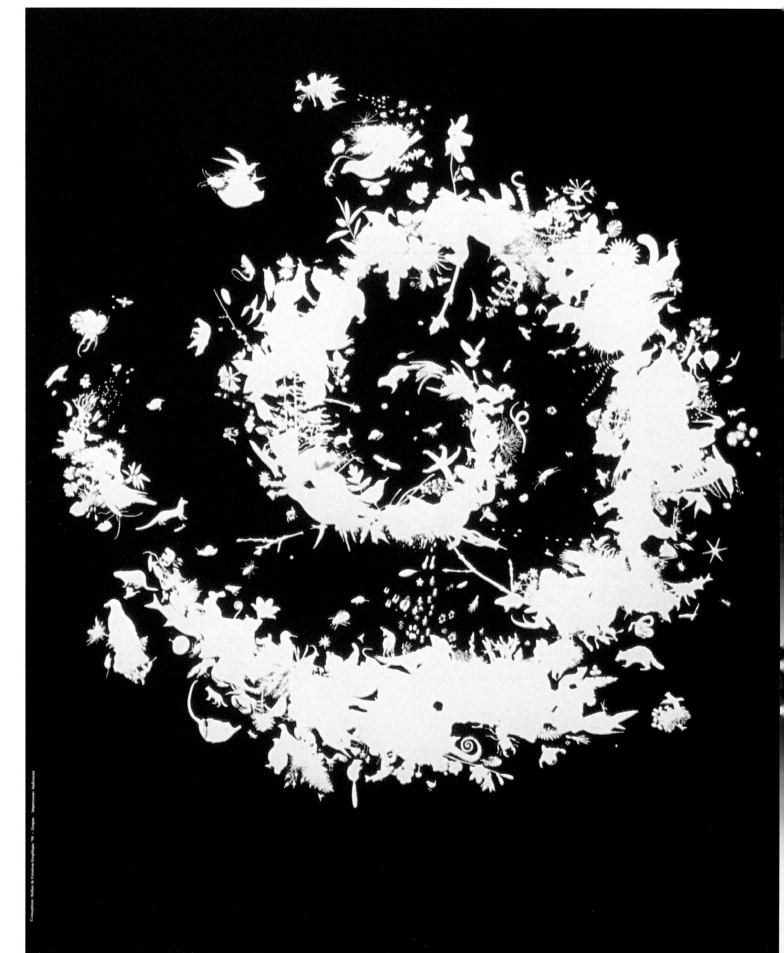

CLIENT
THE NATIONAL PARKS
OF FRANCE

PROJECT TITLE
GRAPHIC IDENTITY FOR
THE NATIONAL PARKS OF FRANCE
1990 TO PRESENT

DESIGN COMPANY
ATELIER DE CREATION GRAPHIQUE – GRAPUS

DESIGNERS
DIRK BEHAGE
PIERRE BERNARD
FOKKE DRAAIJER

PROJECT DESCRIPTION
A GRAPHICAL REPRESENTATION OF THE NATIONAL PARKS AND EVERYTHING IN THEM
BECOMES THE INSPIRATION FOR THE VISUAL IDENTITY OF THE PARKS

CAPTIONS

1 EMBLEM REPRESENTING 7 PARKS
2 INTERNAL POSTER TO PRESENT THE EMBLEM OF THE 7 PARKS
3 POSTER CELEBRATING THE 30TH ANNIVERSARY OF THE NATIONAL PARKS
4 INTERNAL POSTER TO PRESENT THE GRAPHIC IDENTITY AND THE SIGNAGE SYSTEM

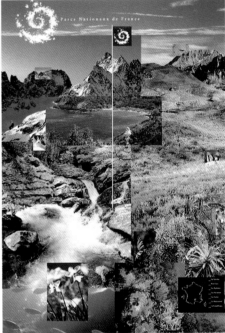
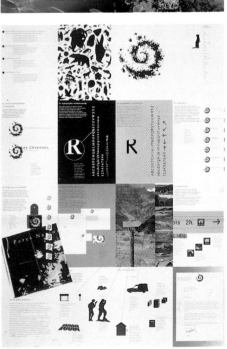

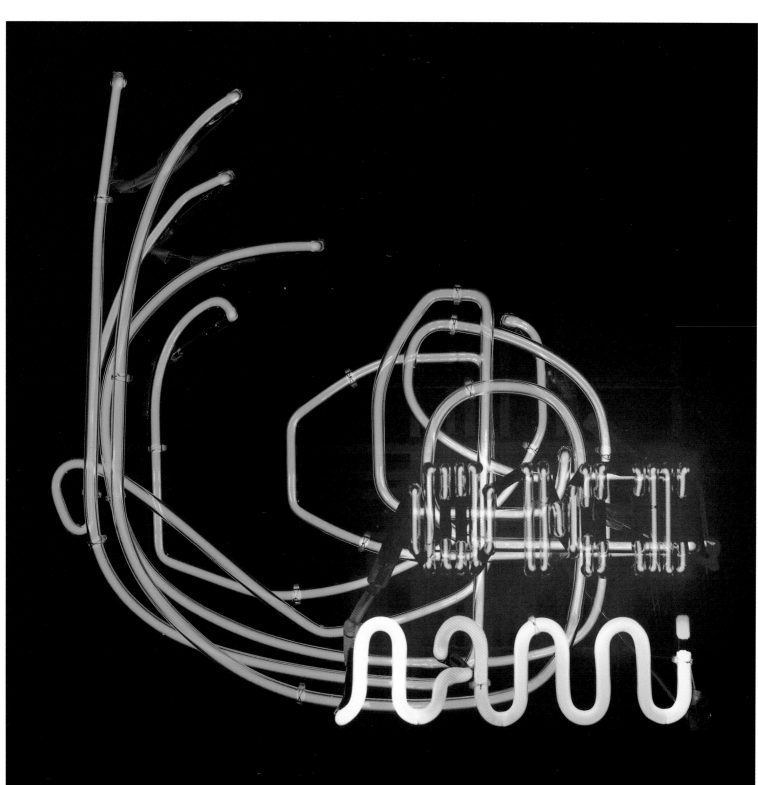

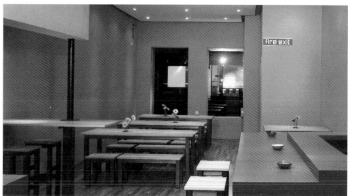

CLIENT
OKI-NAMI

PROJECT TITLE
OKI-NAMI (BIG WAVE)

DESIGN COMPANY
GRAPHIC THOUGHT FACILITY

PHOTOGRAPHY
ANDREW PENKETH

PROJECT DESCRIPTION
RESTAURANT IDENTITY

DESIGNERS
PAUL NEALE
ANDREW STEVENS

P 130 AND 131

DO NOT TOUCH DANGER

10,000 VOLTS

EVENING 18.00–23.30

LUNCHTIME 12.00–14.30

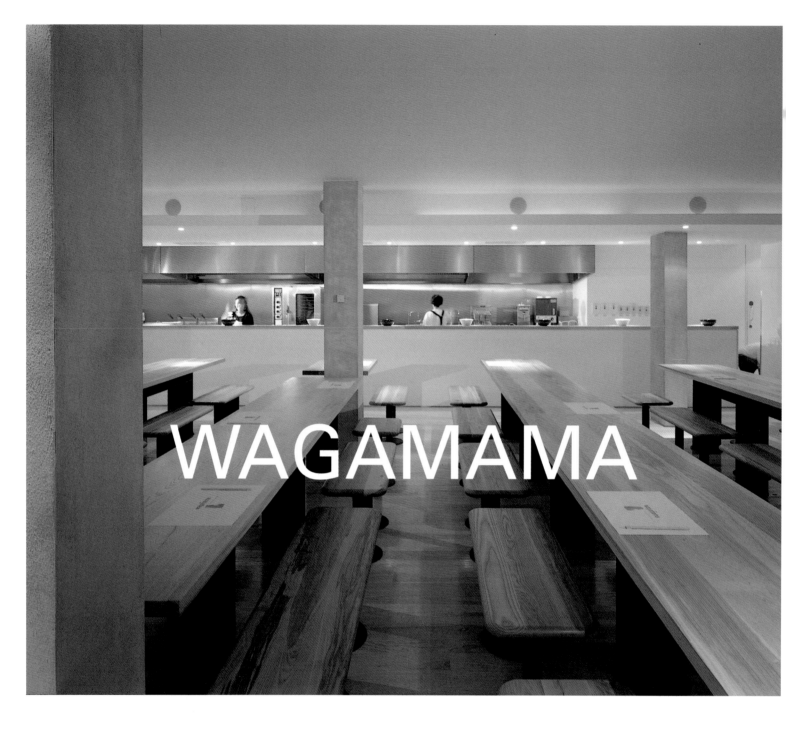

WAGAMAMA

CLIENT
ALAN YAU-WAGAMAMA LTD

PROJECT TITLE
WAGAMAMA

ARCHITECT
JSP ARCHITECTS
MICHAEL STIFF
RICHARD BLANDY
AND JOHN PAWSON

PHOTOGRAPHY
MATTHEW REINREB

PROJECT DESCRIPTION
NOODLE BAR, BLOOMSBURY
LONDON 1992

P 132 AND 133

POSITIVE EATING
POSITIVE LIVING

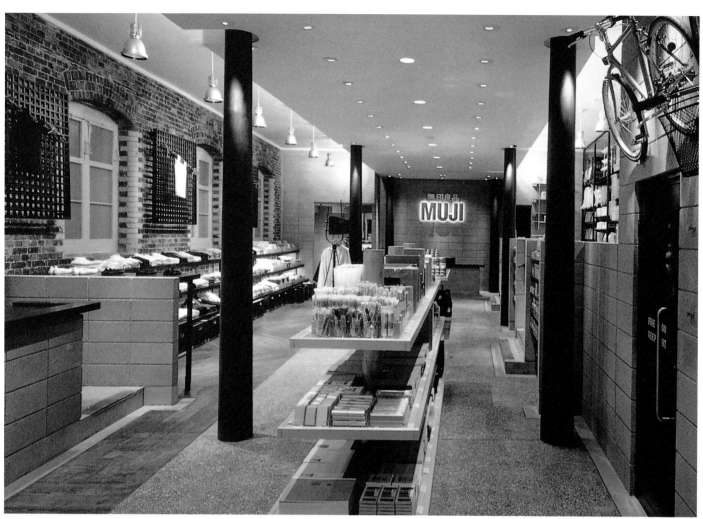

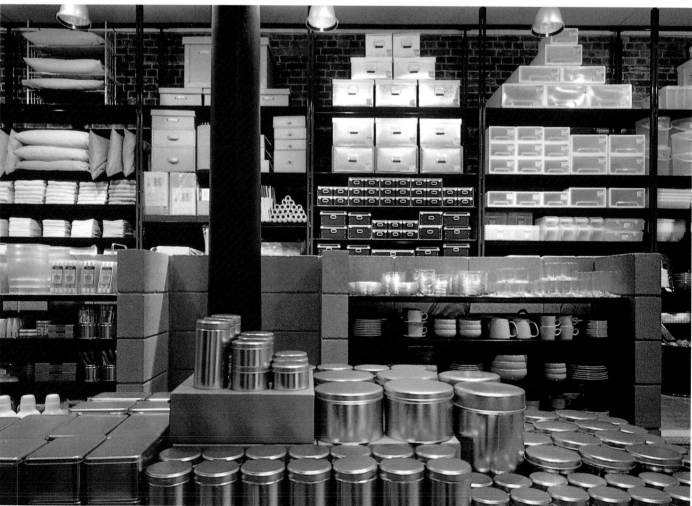

MUJI SELLS PRODUCTS THAT ARE WELL MADE AND MADE OF QUALITY MATERIALS.

WE TRY TO OFFER THESE PRODUCTS AT REASONABLE COST.

WE AVOID FUSSY OR UNNECESSARY OVER DESIGN.

WE PRESENT OUR PRODUCTS SIMPLY IN SHOPS WITH BASIC SHELVING.
THE PRODUCTS SHOULD BE EASY TO SEE.

THERE IS NO MUJI LOGO ON ANY PRODUCT.

THERE ARE OVER 200 MUJI OUTLETS IN JAPAN, 5 IN HONG KONG, 4 IN THE UK.'

CLIENT
MUJIRUSHI RYOHIN EUROPE

PROJECT TITLE
NO BRAND GOODS

ARCHITECT (UK)
HARPER MCKAY LTD

P 134 AND 135

ADSITE IS A PROJECT THAT UTILISES THE BUS SHELTER TO PROMOTE COLLABORATION BETWEEN PRACTITIONERS OF DIFFERENT VISUAL DISCIPLINES WITH AN EMPHASIS TOWARDS NEW CONCEPTUAL AND CRITICAL TENDENCIES IN THE VISUAL ARTS. THE BENEFITS OF THIS COLLABORATION WILL BE TO CHALLENGE EXISTING NOTIONS OF WHAT IS PERCEIVED TO BE PUBLIC ART.

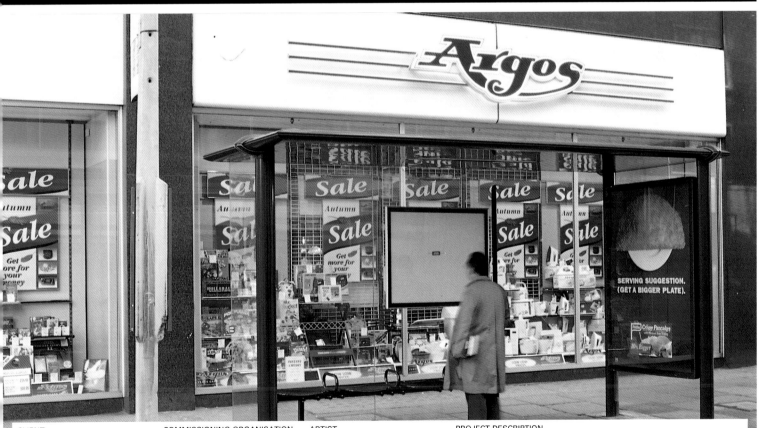

CLIENT	COMMISSIONING ORGANISATION	ARTIST	PROJECT DESCRIPTION
LONDON TRANSPORT	FAT (FASHION, ARCHITECTURE, TASTE)	EMMA DAVIS	THE WAY IN WHICH IDENTITY IS MEDIATED AND EXPERIENCED IS EXPLORED THROUGH THIS IMAGE. DENTAL MIRRORS, CLASPED BETWEEN PERFECTLY MOULDED TEETH, REFLECT THE VIEWER, WHO WHILST INVESTIGATING THE IMAGE UNAVOIDABLY BECOMES THE OBJECT OF THEIR OWN SCRUTINY
		PROJECT TITLE THE SPECTATOR SMILES 1993	

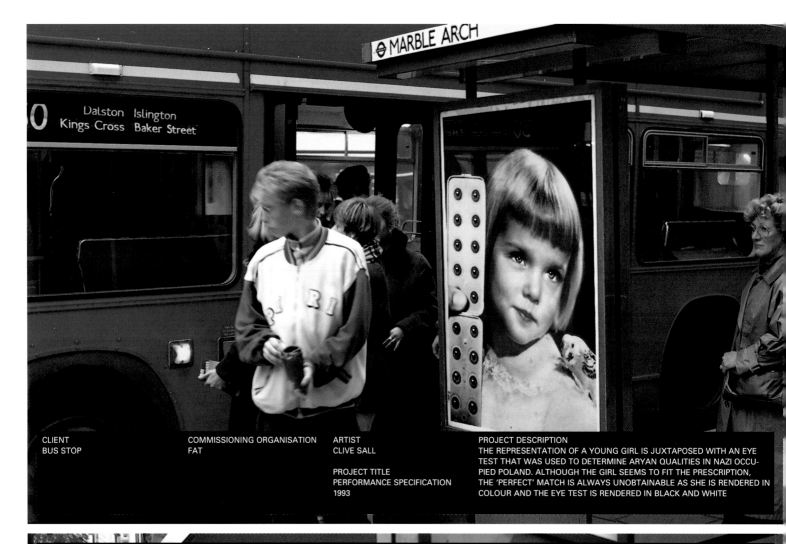

CLIENT
BUS STOP

COMMISSIONING ORGANISATION
FAT

ARTIST
CLIVE SALL

PROJECT TITLE
PERFORMANCE SPECIFICATION
1993

PROJECT DESCRIPTION
THE REPRESENTATION OF A YOUNG GIRL IS JUXTAPOSED WITH AN EYE
TEST THAT WAS USED TO DETERMINE ARYAN QUALITIES IN NAZI OCCU-
PIED POLAND. ALTHOUGH THE GIRL SEEMS TO FIT THE PRESCRIPTION,
THE 'PERFECT' MATCH IS ALWAYS UNOBTAINABLE AS SHE IS RENDERED IN
COLOUR AND THE EYE TEST IS RENDERED IN BLACK AND WHITE

ARTIST
DINA BURNSTOCK

PROJECT TITLE
UNTITLED
1993

PROJECT DESCRIPTION
TWO FEET CRUSHED WITHIN A JAR SYMBOLISE PERSONAL OBSESSION
WITH PHYSICAL PRESERVATION. THE IMAGE EXPLORES A SHIFT IN SOCIETY,
AWAY FROM THE SEARCH FOR ONE'S 'TRUE' SELF TOWARDS THE DESIRE
TO CREATE AN IDEALISED AND RECONSTRUCTED SELF

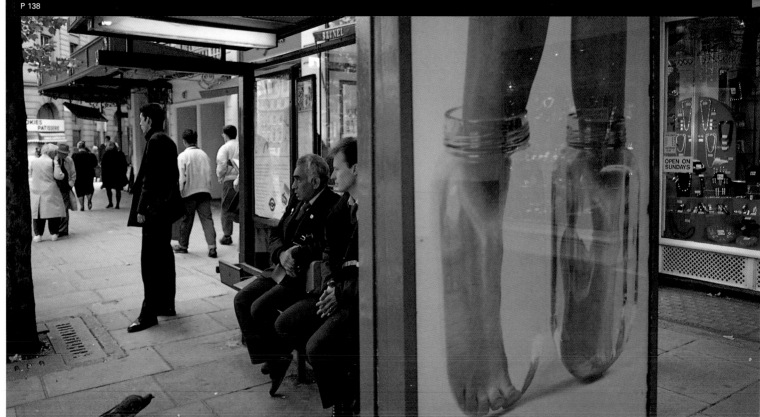

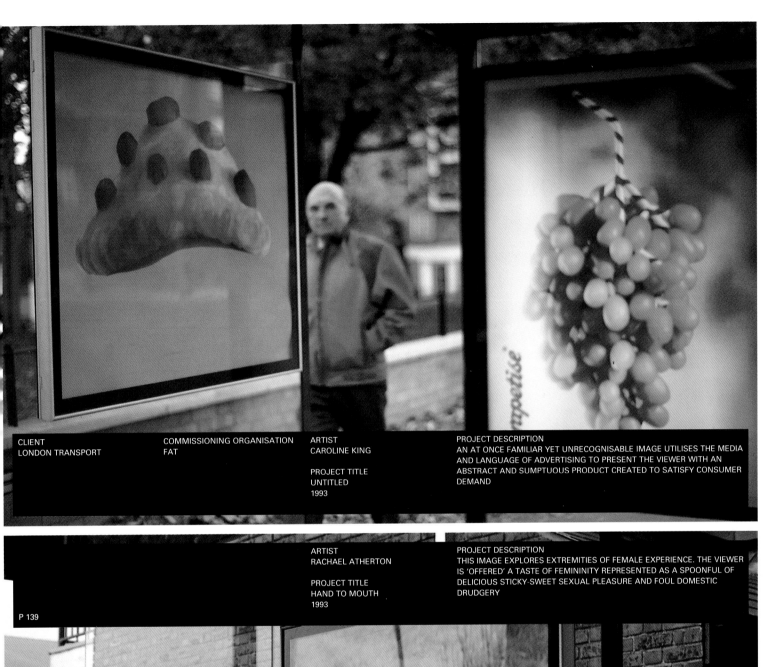

CLIENT
LONDON TRANSPORT

COMMISSIONING ORGANISATION
FAT

ARTIST
CAROLINE KING

PROJECT TITLE
UNTITLED
1993

PROJECT DESCRIPTION
AN AT ONCE FAMILIAR YET UNRECOGNISABLE IMAGE UTILISES THE MEDIA
AND LANGUAGE OF ADVERTISING TO PRESENT THE VIEWER WITH AN
ABSTRACT AND SUMPTUOUS PRODUCT CREATED TO SATISFY CONSUMER
DEMAND

ARTIST
RACHAEL ATHERTON

PROJECT TITLE
HAND TO MOUTH
1993

PROJECT DESCRIPTION
THIS IMAGE EXPLORES EXTREMITIES OF FEMALE EXPERIENCE. THE VIEWER
IS 'OFFERED' A TASTE OF FEMININITY REPRESENTED AS A SPOONFUL OF
DELICIOUS STICKY-SWEET SEXUAL PLEASURE AND FOUL DOMESTIC
DRUDGERY

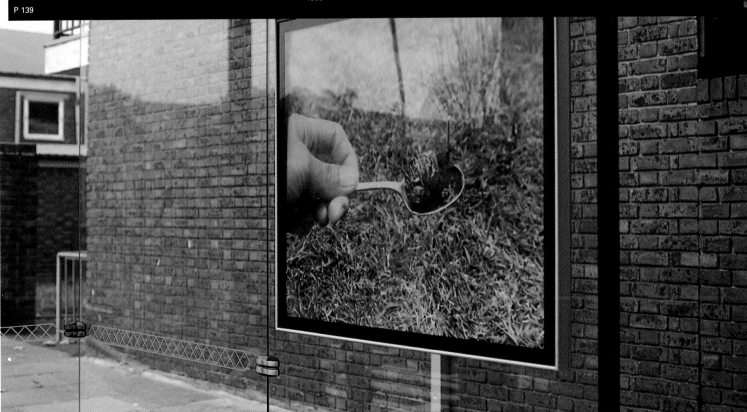

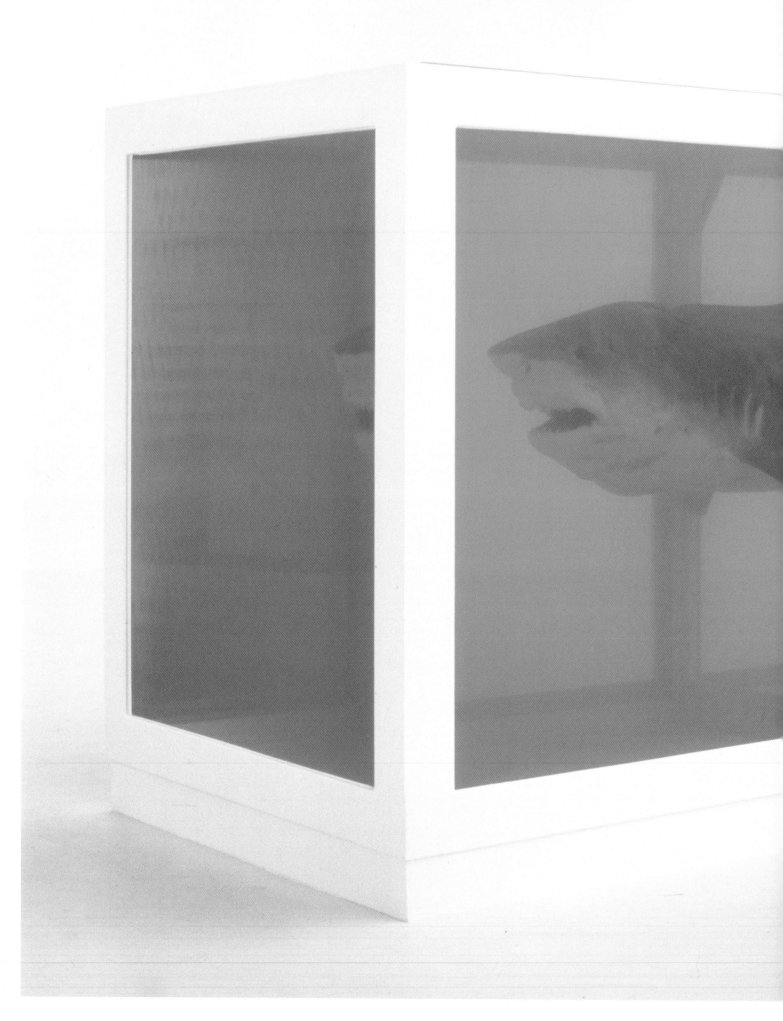

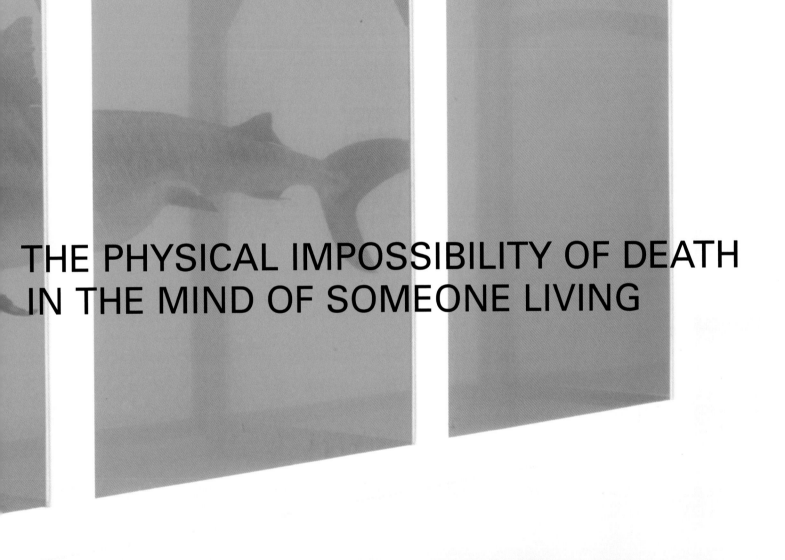

THE PHYSICAL IMPOSSIBILITY OF DEATH
IN THE MIND OF SOMEONE LIVING

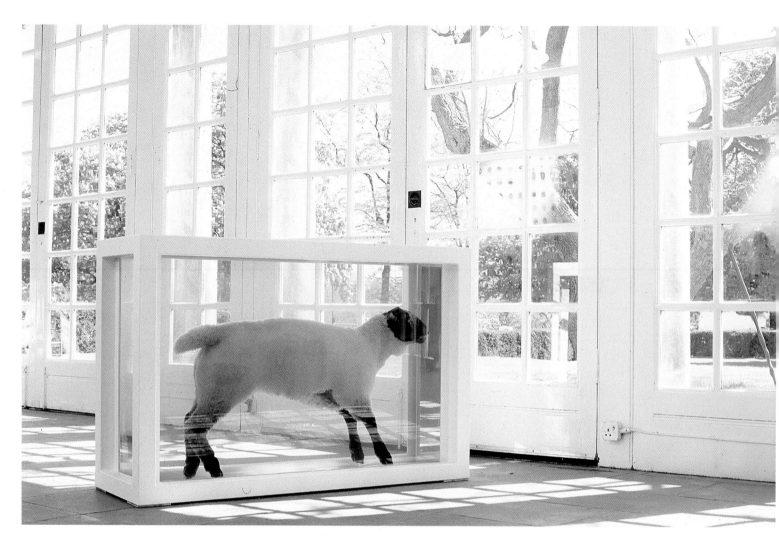

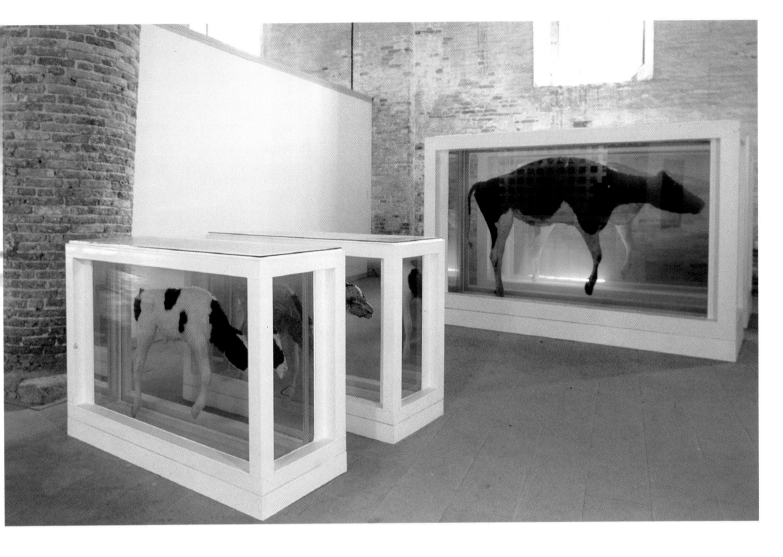

ARTIST	TITLE		PROJECT DESCRIPTION
DAMIEN HIRST	MOTHER AND CHILD DIVIDED		GLASS, STEEL, GRP COMPOSITES, SILICONE, COW, CALF, FORMALDEHYDE
	1993		SOLUTION

P 143

CLIENTS
LWT PROGRAMMES LTD
NORDOFF-ROBBINS
NINTENDO

P 144 AND 145

PROJECT DESCRIPTION
AS THE COCA-COLA COMPANY FACES INTENSE GLOBAL COMPETITION FROM
RETAILER OWN-LABEL COLAS, THE REST OF THE CARBONATED SOFT DRINKS
MARKET MUST CONSIDER THE GROWING POTENTIAL FOR A TV GAMESHOW,
ROCK GROUP OR COMPUTER GAMES CHARACTER TO PROVIDE A SERIOUS
COMPETITIVE THREAT

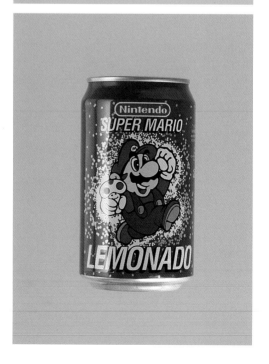

CLIENT
THE COCA-COLA COMPANY

PROJECT TITLE
THE WORLD OF COCA-COLA
ATLANTA, USA

PHOTOGRAPHY
TIMOTHY HURSLEY

PROJECT DESCRIPTION
IN THE BRAND'S HOMETOWN OF ATLANTA THE WORLD OF COCA-COLA
PROVIDES A 'SHRINE' TO THE HERITAGE, VALUES AND ASPIRATIONS OF
THE WORLD'S BEST-KNOWN BRAND

P 146 AND 147

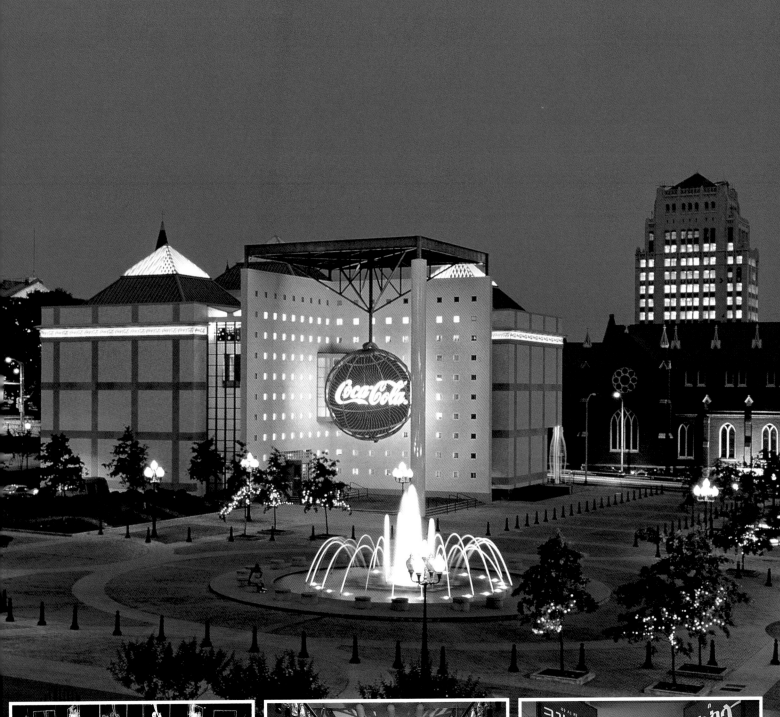

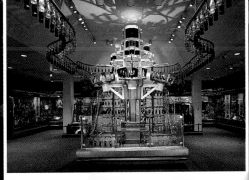

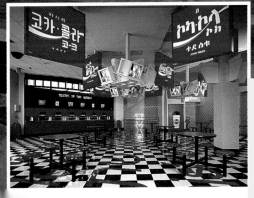

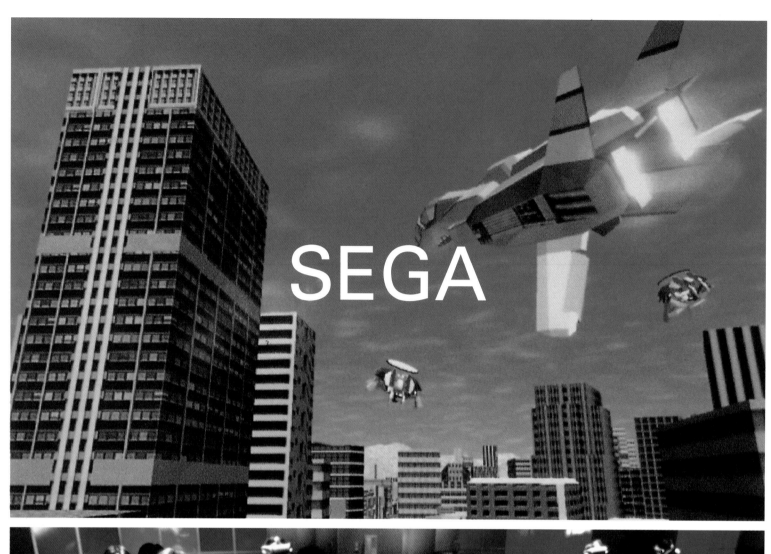

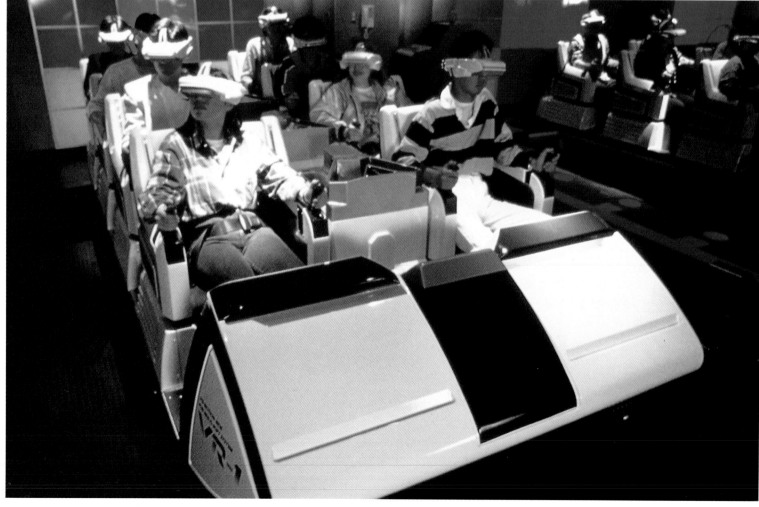

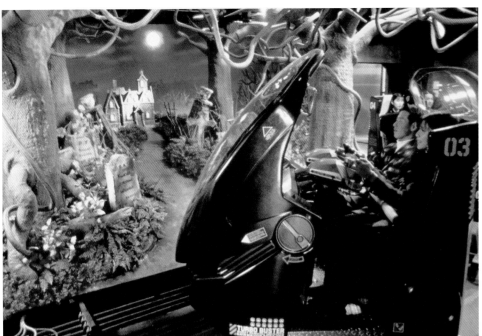

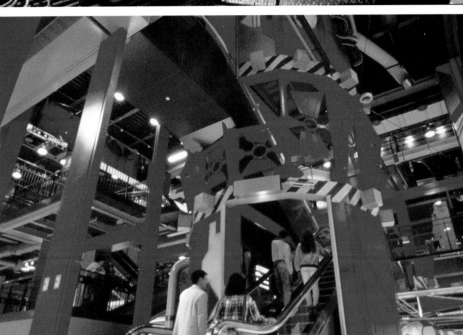

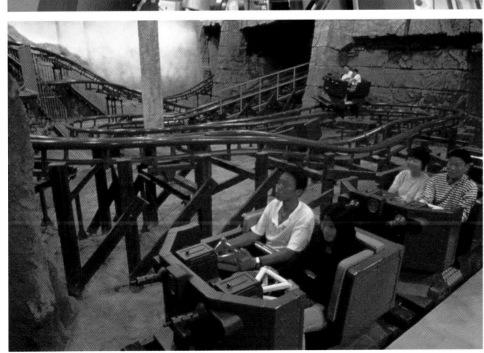

COMPANY
SEGA ENTERPRISES LTD

PROJECT TITLE
JOYPOLIS

LOCATION
YOKOHAMA, JAPAN

PROJECT DESCRIPTION
OPENED ON JULY 20 1994, JOYPOLIS REPRESENTS THE BIRTH OF A NEW
GENERATION OF LEISURE FACILITIES BASED ON THE CONCEPT OF 'INTERACTIVE
ENTERTAINMENT' AND MAKING FULL USE OF SEGA'S NEWEST AND MOST
ADVANCED TECHNOLOGY

CAPTIONS

| 1 | 3 |
| 2 | 4 | 5 |

1 SOFTWARE FOR VR-1
2 VR-1
3 GHOST HUNTERS
4 INSIDE JOYPOLIS
5 RAIL CHASE RIDE

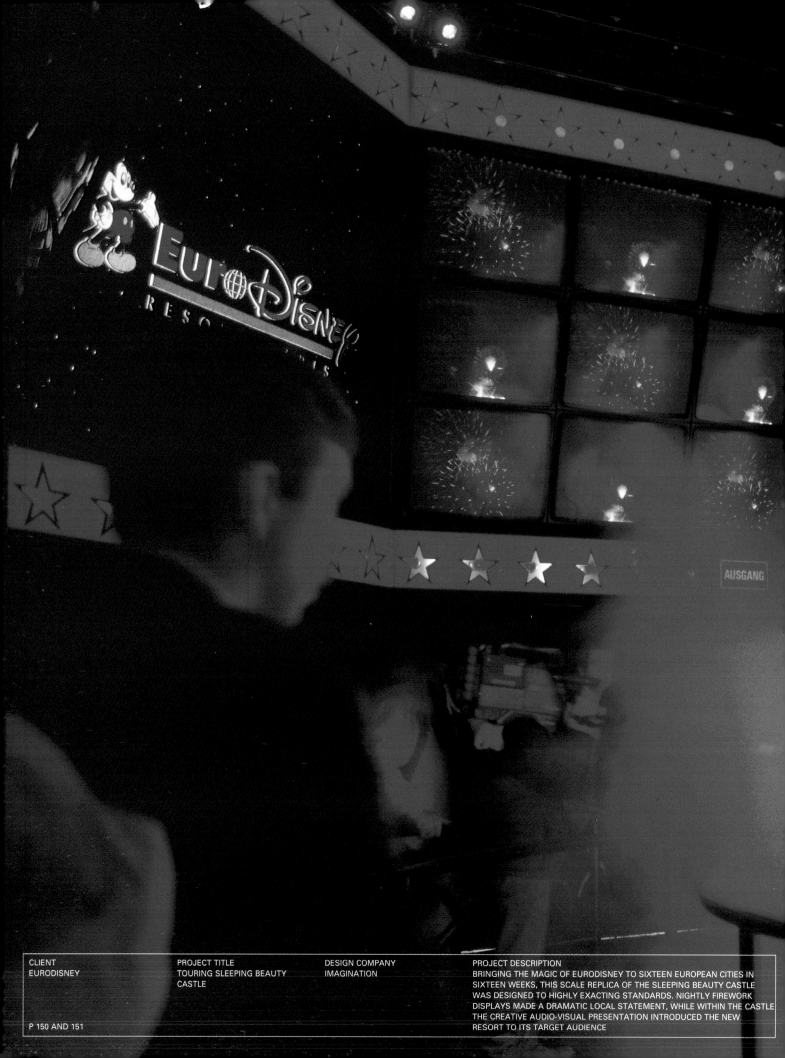

AUSGANG

CLIENT	PROJECT TITLE	DESIGN COMPANY	PROJECT DESCRIPTION
EURODISNEY	TOURING SLEEPING BEAUTY CASTLE	IMAGINATION	BRINGING THE MAGIC OF EURODISNEY TO SIXTEEN EUROPEAN CITIES IN SIXTEEN WEEKS, THIS SCALE REPLICA OF THE SLEEPING BEAUTY CASTLE WAS DESIGNED TO HIGHLY EXACTING STANDARDS. NIGHTLY FIREWORK DISPLAYS MADE A DRAMATIC LOCAL STATEMENT, WHILE WITHIN THE CASTLE THE CREATIVE AUDIO-VISUAL PRESENTATION INTRODUCED THE NEW
P 150 AND 151			RESORT TO ITS TARGET AUDIENCE

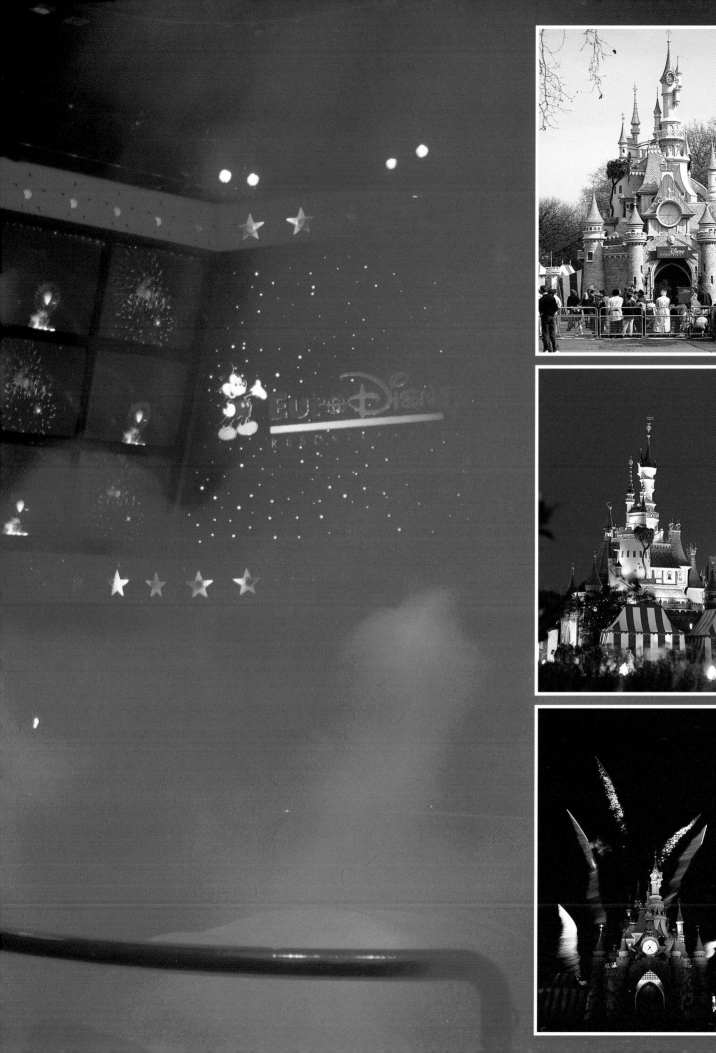

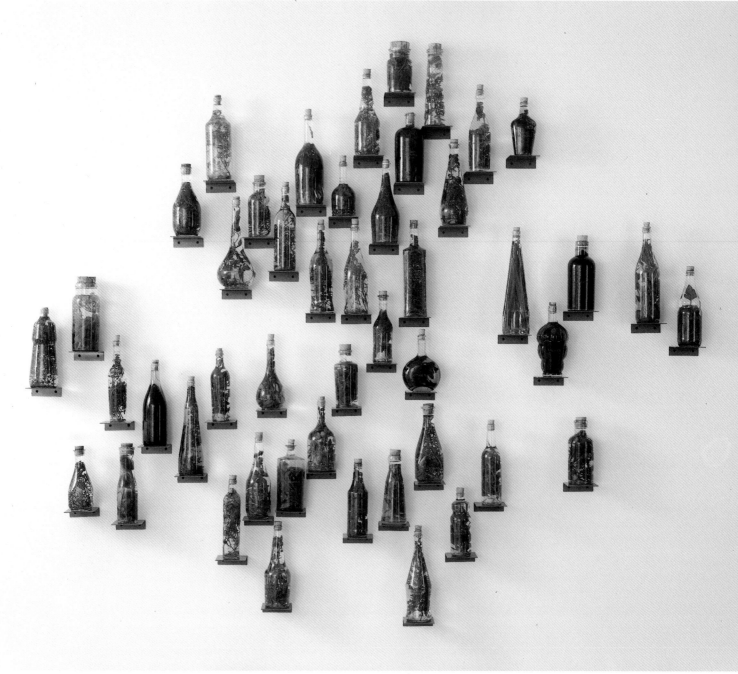

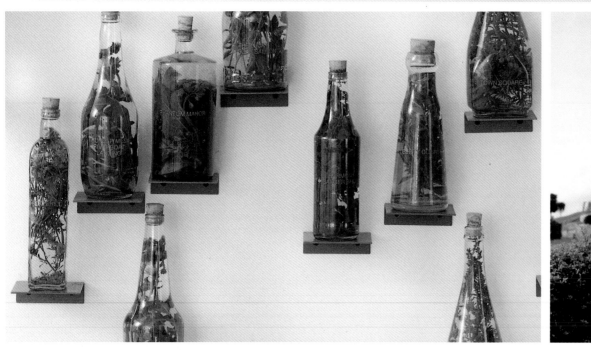

A COLLECTION OF WEED PLANTS WERE PRESERVED IN VINEGAR AFTER BEING GATHERED FROM THE BORDERS OF EURODISNEY. THE BOTTLES ARE MAPPED OUT ACCORDING TO THE LAYOUT OF EURODISNEY WITH EACH OF THE ATTRAC-TION NAMES SANDBLASTED ONTO THE BOTTLES. SEEDS WERE ALSO COLLECTED FROM THE 48 DIFFERENT WEEDS AND PLANTED AT EACH OF THE CORRESPOND-ING SITES INSIDE EURODISNEY.

ARTISTS
KATE ERICSON
MEL ZIEGLER

PROJECT TITLE
VINEGAR OF THE 48 WEEDS
1992

CAPTIONS

1, 2 WEEDS, VINEGAR, SANDBLASTED GLASS, STEEL SHELVES, 211 X 234 X 13CM
 PHOTOGRAPHY JOHN RIDDY, LONDON
 COURTESY LISSON GALLERY, LONDON
3 THE ARTISTS PLANTING SEEDS AT EURODISNEY 1992
 COURTESY MICHAEL KLEIN GALLERY, NEW YORK

P 152 AND 153

A MAGAZINE CREATED, WRITTEN,
DESIGNED AND PHOTOGRAPHICALLY
DOCUMENTED USING AGFA DIGITAL
COMPUTER EQUIPMENT IN THE BACK OF
A VOLKSWAGEN VAN, WHILE DRIVING
ACROSS EUROPE.

WE'RE TRAVELLING ACROSS EUROPE IN
A VOLKSWAGEN VAN MAKING A MAGA-
ZINE CALLED TWENTY-SIX.

THE MAGAZINE IS NOT ONLY ABOUT
TYPOGRAPHY, COMMUNICATION AND
TECHNOLOGY, IT'S A MAGAZINE ABOUT
PROCESS: THE PROCESS OF MAKING A
MAGAZINE.

WE WILL FIND OUT WHAT THIS MAGAZINE
IS ABOUT AS WE GO ALONG.
FINDING OUT IS PART OF THE PROCESS.'

CLIENT
AGFA COMPUGRAPHIC

PUBLISHER
PETER MILLER

154 AND 155 (156 AND 157 OVERLEAF)

PROJECT TITLE
26, VOL 1, NO 2

ADVERTISING AGENCY
ALTMAN & MANLEY
EAGLE ADVERTISING

CREATIVE DIRECTOR
ROBERT MANLEY

MANAGING EDITOR
ELIZABETH HENDERSON MILDE

DESIGN STUDIO
KOEPKE DESIGN GROUP

DESIGN & ART DIRECTION
GARY KEHDE

COMPUTER IMAGING/TYPOGRAPHY
MICHAEL TARDIF

ASSISTANT PHOTOGRAPHER
NIELS COOGAN LEPPERT

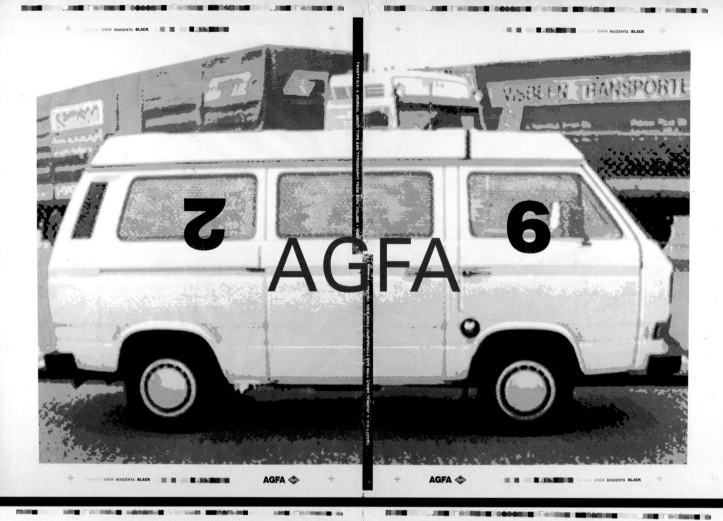

TWENTY-SIX: A JOURNAL ABOUT TYPE AND TYPOGRAPHY FROM AGFA. VOLUME 1, NUMBER 2

2 AGFA 6

let op de vier
echtheidskenmerken

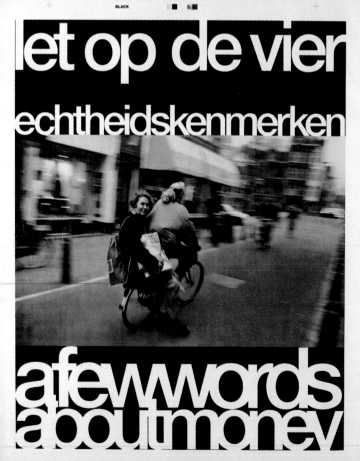

afewwwords
aboutmoney

I'm with Margaret Thatcher on this one. I don't think Europe should have a single currency. It would eliminate one of travel's most satisfying routines, the changing of money. It's like a cleansing ritual. You purge your system of England and all things English by converting your pounds into guilders. You shed Holland by exchanging your guilders for francs. And francs for Deutch marks and Deutch marks for Swiss francs and Swiss francs for whatever it is they use in Czechoslovakia. It's how you know you've left one place and arrived in another. Especially since they are so casual about border crossing within the European Community, crossing from Belgium to France on a major highway feels no different than crossing from Massachusetts to New York on the Mass Pike.

Right now, it's Friday morning and we are in Paris. We arrived last night after a swift drive through Belgium and the north of France. Somehow, it seems reasonable to drive a hundred miles an hour when the speedometer is in kilometers. Somehow the speed doesn't feel real because we're moving in metric units. And the spending doesn't feel real either because we're doing it in guilders or francs rather than dollars.

We're travelling across Europe in a Volkswagen van making a magazine called twenty-six.

Yesterday, our first day on the road, we sat in a restaurant outside Victoria Station called the American Pancake House. It was a bad restaurant, but it was the only place we could get breakfast after 10 on a Sunday morning. The British, apparently, do not brunch. In England, we learned, they serve their eggs one way—fried—and they serve them with beans. In England, they put bananas and butterscotch sauce on pancakes and call it Banana Glory; at least they do this at the American Pancake House.

We sataround, all jet-lagged and groggy, not eating much and trying to figure out what this magazine is really about. We know that it's about typography and communication and technology, but what does that mean in real terms. Like, what are we all going to do on this trip?

We were too tired to come up with many answers. Except that this isn't a magazine about typography as much as it's a magazine about process: the process of makingamagazine. We will find out what this magazine is about as we go along. Finding out is part of the process.

MIND THE GAP: This is our first phrase in British. It means, roughly, "watch your step when you get off the underground because there is a very small amount of space between the edge of the train and the platform and we would be very sorry if you hurt yourself." MIND THE GAP. Use it three times and it's yours. Someone thought the announcement on the train said, "It's my baguette." Perhaps that's what they say in Paris, on the Metro.

We're not a hundred percent sure about what we're doing, but we will try to mind the gap. ▄ ▄ ▄

Penny for the Guy: London in Brief. Let's go to real time.

Today is Wednesday November 7. I'm in a hotel on the Keizersgracht, a canal in Amsterdam. I'm trying to write about things that happened in London the day before yesterday and the day before that. It's not easy because, when you're traveling, time is very different stuff than it is when you're standing still. Road time is amorphous and gooey. Time expands and contracts in very peculiar ways. Days have no proper beginnings and endings. And an incredible amount seems to happen within these elastic days.

the swiss:

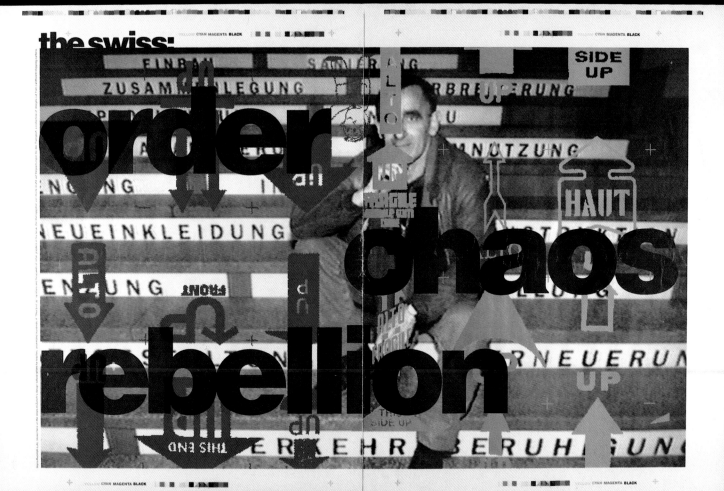

order.
chaos
rebellion

THE NIKE TOWN CONCEPT COMBINES SPORTS, FITNESS, HISTORY, PRODUCT INNOVATION AND ENTERTAINMENT, TO PROVIDE A UNIQUE RETAIL BRAND EXPERIENCE.

NIKE TOWN WAS BORN OF A DESIRE BY NIKE TO EXPERIMENT WITH HOW NIKE PRODUCT WAS DISPLAYED AND MERCHANDISED.

EACH NIKE TOWN HAS A CENTRAL AREA THAT FREQUENTLY SERVES AS THE LOCATION FOR INSTORE EVENTS, ATHLETE APPEARANCES AND SPORTS-RELATED SEMINARS.

THE NIKE TOWN ENVIRONMENT ALSO FEATURES LIFESIZE STATUES OF SUPER-STAR ATHLETES AND A WIDE RANGE OF SPORS-RELATED AUDIO-VISUAL PRESENTATIONS.

NIKE TOWN IS A SPORTS RETAIL THEATRE THAT SHOWCASES NIKE'S RICH SPORTS HERITAGE, WHILE ALSO SERVING AS A VALUABLE COMMUNITY RESOURCE FOR LOCAL SPORTS AND FITNESS ACTIVITIES.

ALL NIKE TOWNS SHARE A NUMBER OF KEY PHYSICAL ELEMENTS – HIGH-TECH MULTI-MEDIA PRESENTATIONS, SPORTS MEMORABILIA FROM THE WORLD'S TOP ATHLETES AND INNOVATIVE INTERIOR DESIGN AND RETAIL FIXTURES.

HOWEVER, DESPITE THEIR SIMILAR PRINCIPALS, EACH NIKE TOWN HAS AN ENTIRELY DIFFERENT ATMOSPHERE.

JUST DO IT

No bird soars too high,
If he soars with his own wings.
—William Blake

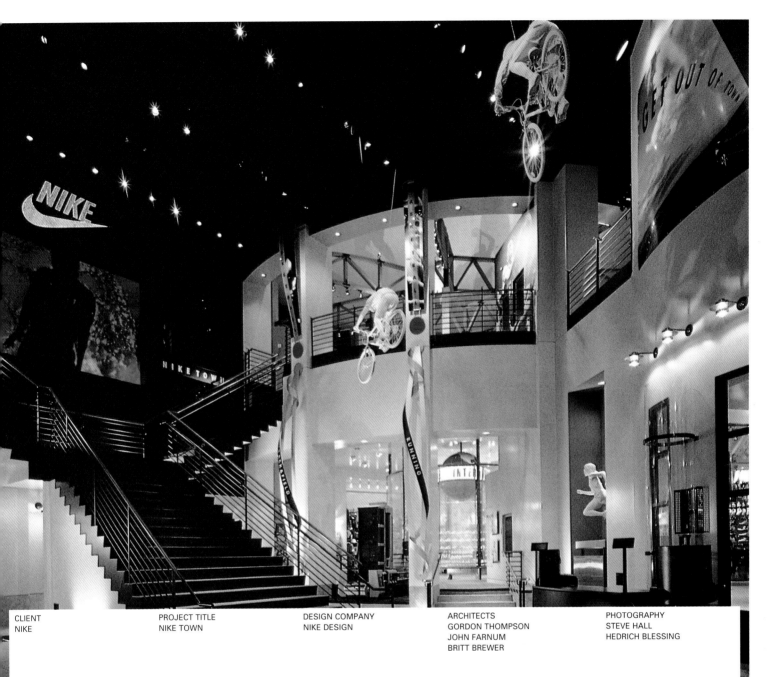

CLIENT	PROJECT TITLE	DESIGN COMPANY	ARCHITECTS	PHOTOGRAPHY
NIKE	NIKE TOWN	NIKE DESIGN	GORDON THOMPSON	STEVE HALL
			JOHN FARNUM	HEDRICH BLESSING
			BRITT BREWER	

P 160 AND 161

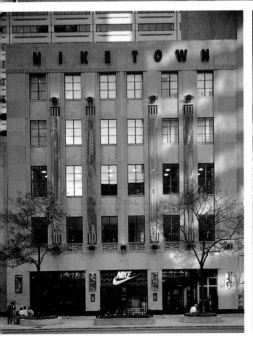

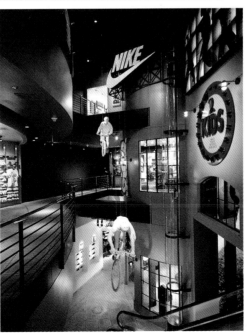

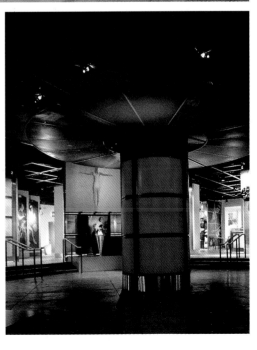

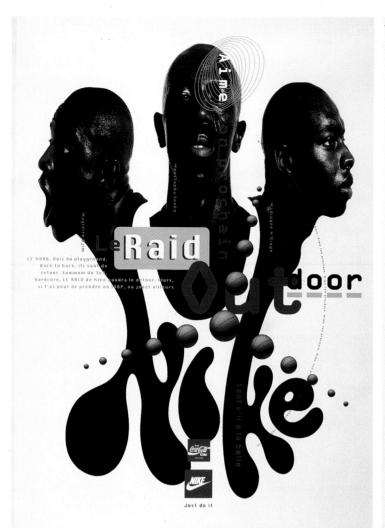

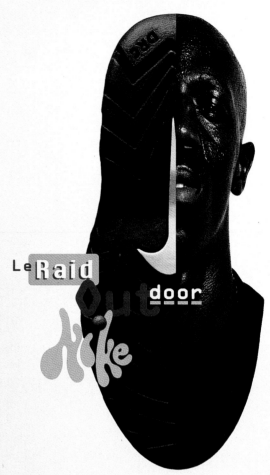

Le Raid Outdoor Nike
door

LE NORD, Rois du playground. Back to back, ils sont de retour. Sommum du 3x3 hardcore, LE RAID de Nike vaudra le détour. Alors, si t'as peur de prendre un STOP, va jouer ailleurs

Just do it

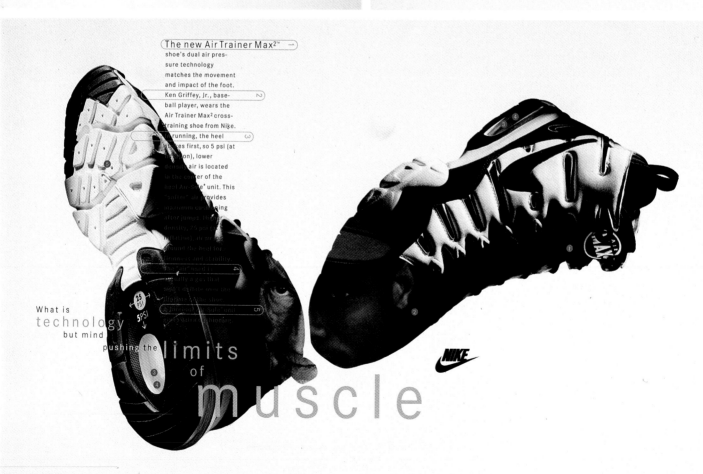

The new Air Trainer Max²™ →
shoe's dual air pres-
sure technology
matches the movement
and impact of the foot.
Ken Griffey, Jr., base-
ball player, wears the
Air Trainer Max² cross-
training shoe from Nike.
running, the heel
strikes first, so 5 psi (at
inflation), lower
density air is located
in the center of the
heel Air-Sole® unit. This
"softer" air provides
maximum cushioning
after jumps. Higher
density, 25 psi (at
inflation), air encir-
cles the heel for
firmness and stability.
The "air" isn't air. It's
really a gas that
won't deflate over the
lifetime of the shoe.
A removable Sole® unit
provides cushioning.

25 PSI
5 PSI

What is
technology
but mind
pushing the limits
of
muscle

CLIENT NIKE FRANCE	ADVERTISING AGENCY WIEDEN & KENNEDY DESIGNER ROBERT NAKATA	CAPTIONS	1, 2	PROJECT DESCRIPTION POSTER AND BROCHURE FOR A NIKE SPONSORED FRANCE OUTDOOR BASKETBALL TOURNAMENT, 1994	CREATIVES ERNEST LUPPINACCI MICHAEL PRIEVE & BOB MOORE PHOTOGRAPHY NORBERT SCHOERNER HANS PIETERSE

CLIENT NIKE USA			3	PROJECT DESCRIPTION ADVERTISEMENT FOR NIKE AIR MAX SHOES 1994	CREATIVES DAN WIEDEN & SUSAN HOFFMAN STEVE DUNN PHOTOGRAPHY HANS PIETERSE VARIOUS

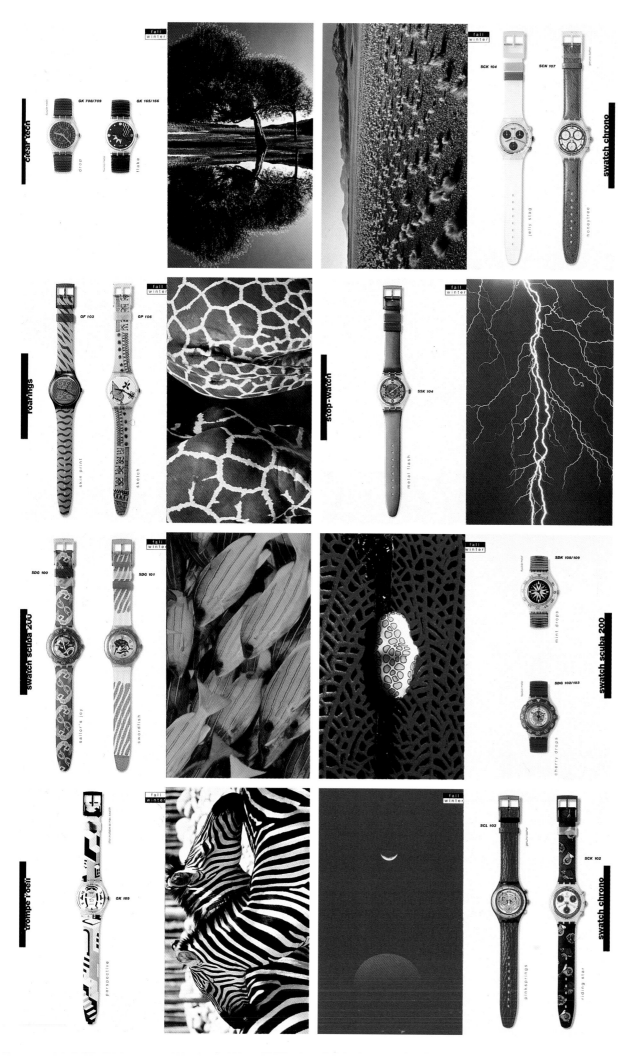

clear tech

GK 708/709 GK 165/166

drop

flake

fall winter

swatch chrono

SCK 104 SCN 107

jelly stag honeytree

fall winter

roarings

GF 103 GP 106

skin print sketch

fall winter

stop-watch

SSK 104

metal flash

fall winter

swatch scuba 200

SDG 100 SDG 101

sailor's joy swordfish

fall winter

swatch scuba 200

SDK 108/109

mint drops

SDG 102/103

cherry drops

fall winter

trompe l'oeil

GK 169

perspective

fall winter

swatch chrono

SCL 103 SCK 102

pinksprings riding star

fall winter

SWATCH

CLIENT
SWATCH

PROJECT TITLE
FALL/WINTER COLLECTION 1993 – 1994

PROJECT DESCRIPTION
SEASONAL PRODUCT LITERATURE
THE INSPIRATION BEHIND SWATCH: GREENTIC OR PINKSPRINGS, ALABAMA
OR WINDMILL, A MYRIAD OF DIFFERENT WAYS TO COLOUR A FRACTION OF
A SECOND

P 164 AND 165

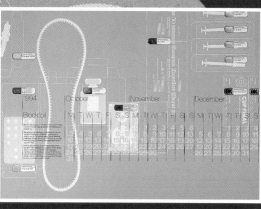

CLIENT
BLOCKFOIL (IPSWICH) LTD

PROJECT TITLE
BLOCKFOIL CALENDAR

DESIGN COMPANY
GRAPHIC THOUGHT FACILITY

DESIGNERS
PAUL NEALE
ANDREW STEVENS

ILLUSTRATION
LUCINDA ROGERS

PHOTOGRAPHY
DAVID HARRISON
GTF

P 166 AND 167

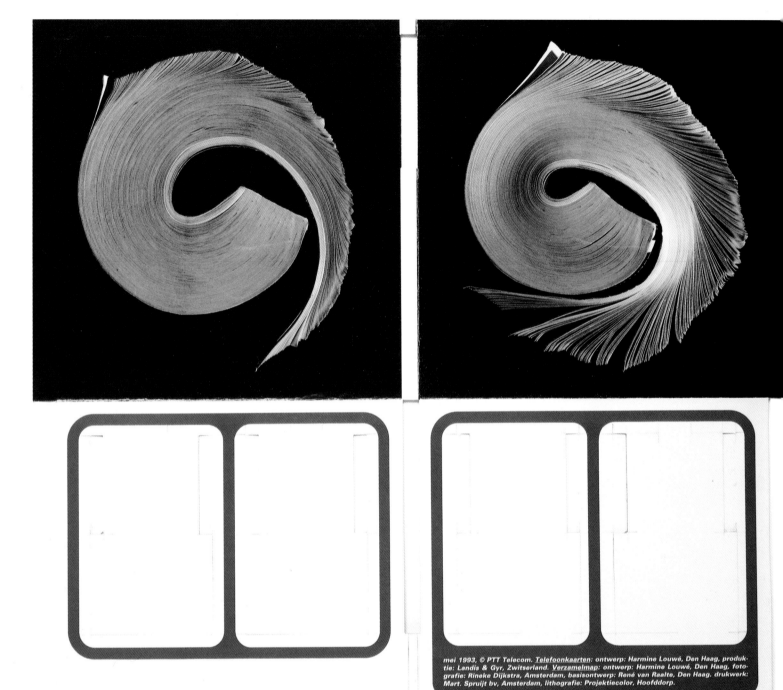

mei 1993, © PTT Telecom. Telefoonkaarten: ontwerp: Harmine Louwé, Den Haag, produk-
tie: Landis & Gyr, Zwitserland. Verzamelmap: ontwerp: Harmine Louwé, Den Haag, foto-
grafie: Rineke Dijkstra, Amsterdam, basisontwerp: René van Raalte, Den Haag. drukwerk:
Mart. Spruijt bv, Amsterdam, lithografie: Projektiecolor, Hoofddorp.

4

20

45

115

KWALITEIT

PTT TELECOM

CLIENT
PTT TELECOM
HOLLAND

PROJECT TITLE
PTT TELECOM
AND SERVICE QUALITY

DESIGNER
HARMINE LOUWE

PHOTOGRAPHY
RINEKE DIJKSTRA

PROJECT DESCRIPTION
PHONE CARDS AND WALLET 1992 – 1993

P 168 AND 169

| 94 | three dimensional design graphic design | degree show private view invitation | | ravensbourne |

 MERCURYCARD £1

49MER0NEA001558

0.1	date	11.07.94
0.2	start	18.00
0.3	finish	21.00
0.4	information	**tuc congress house**
		great russell street
		london wc1b 3ls

CLIENT
RAVENSBOURNE COLLEGE OF
DESIGN AND COMMUNICATION

DESIGN COMPANY
003

DESIGNERS
NX 44 83 81 NM
NX 74 51 15 UP

PROJECT DESCRIPTION
AN INVITATION TO A PRIVATE VIEW OF AN EXHIBITION, IN THE FORM OF
A WORKING PHONE CARD, ON THE THEME OF DIVERSITY OF LANGUAGE
AND FORM

A WORK FOR THE NORTH SEA

WHERE THE LAND MEETS THE SEA, 8 BULGARIAN WOMEN SING THEIR HAUNTING MELODIES ACROSS THE SEA.

ARTISTS	PROJECT TITLE	COMMISSIONING ORGANISATION	PHOTOGRAPHY
BETHAN HUWS	A WORK FOR THE NORTH SEA	THE ARTANGEL TRUST	I JEDRZEJCZYK
THE BISTRITSA BABI	1993		LISA HARTY

P 172 AND 173

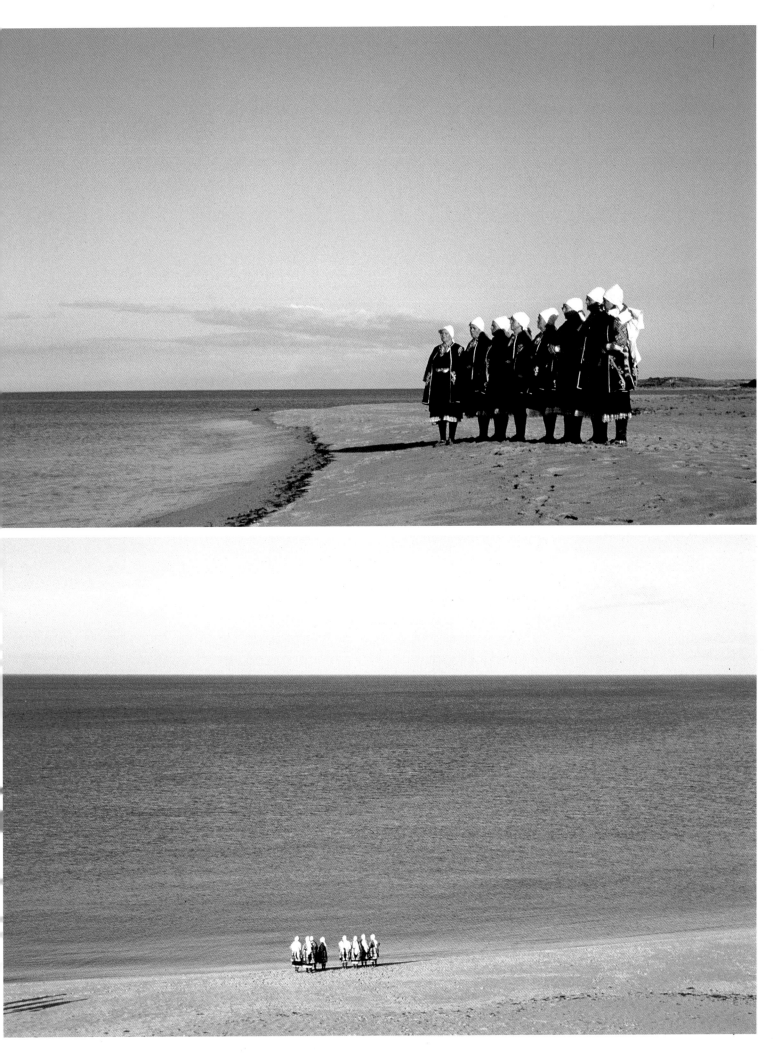

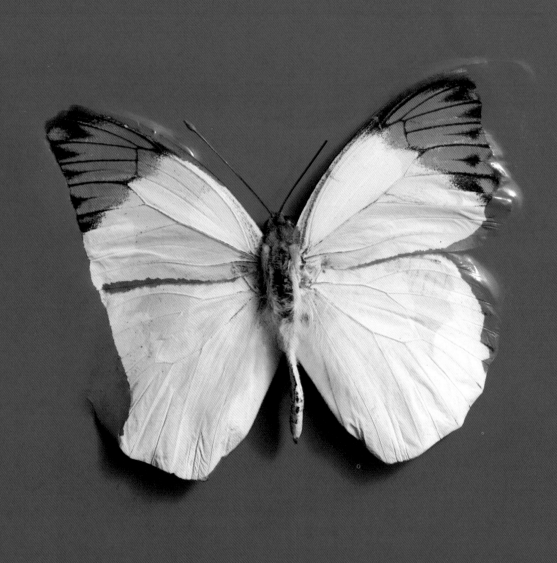

FIVE WHITE CANVASES WITH PUPAE, STEEL SHELVES WITH POTTED FLOWERS, BOWLS OF SUGAR-WATER SOLUTION, TABLE, RADIATORS, HUMIDIFIERS AND LIVE BUTTERFLIES.

ARTIST	TITLE	CAPTIONS		PROJECT DESCRIPTION	
DAMIEN HIRST	IN ANDJJ OUT OF LOVE		1	DETAIL – GLOSS HOUSEHOLD PAINT ON CANVAS AND BUTTERFLY	
	1991		2	WHITE PAINTINGS AND LIVE BUTTERFLIES	
P 174 AND 175					

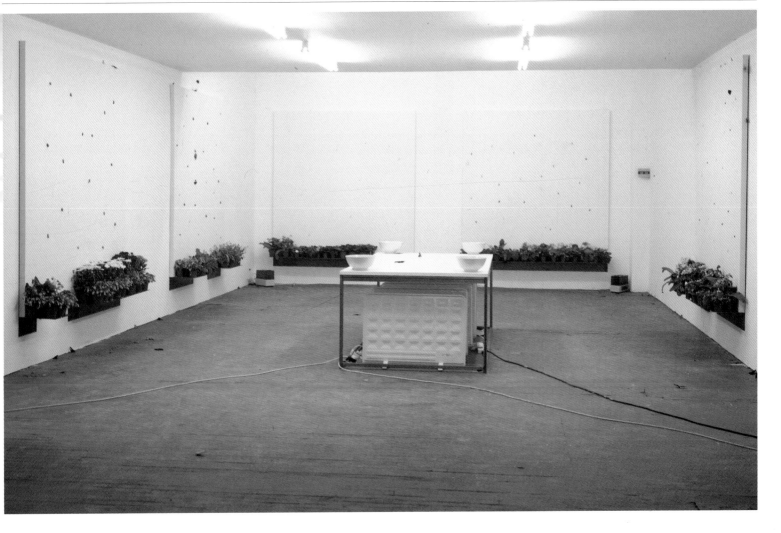

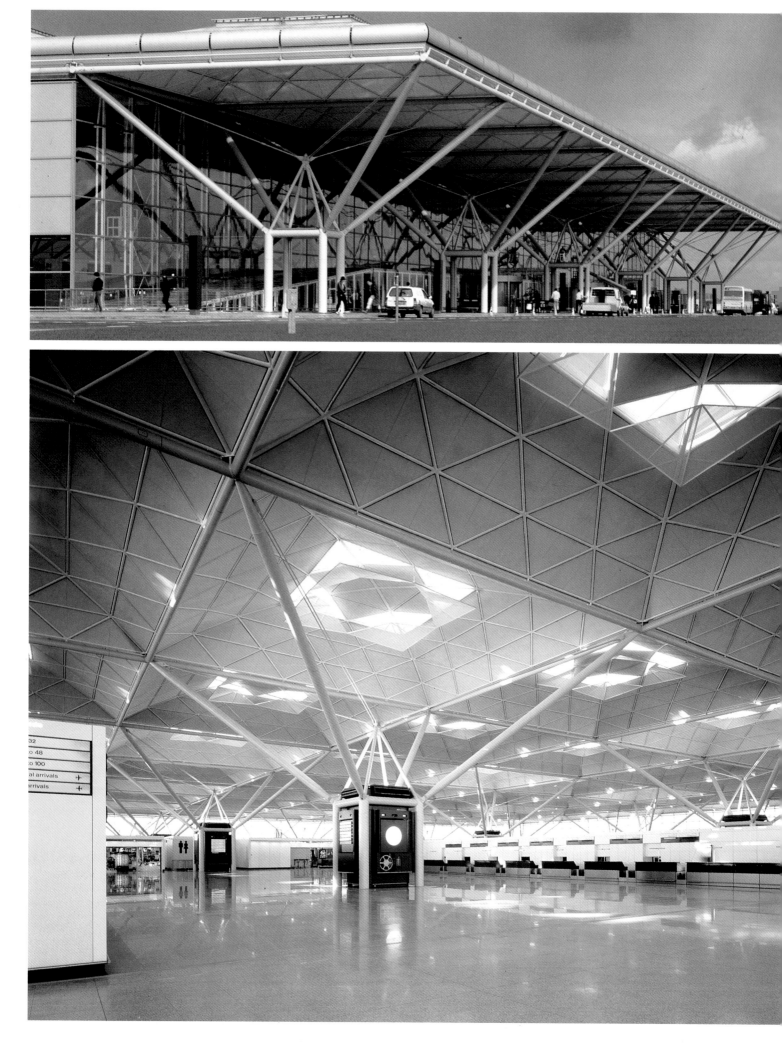

STANSTED, LONDON'S THIRD AIRPORT, WILL BE EXPERIENCED BY 15 MILLION AIR TRAVELLERS A YEAR BY THE END OF THE CENTURY.

CLIENT
BRITISH AIRPORTS AUTHORITY PLC
STANSTED AIRPORT

ARCHITECT
SIR NORMAN FOSTER
AND PARTNERS

PROJECT DESCRIPTION
INTERNATIONAL TERMINAL, LONDON'S THIRD AIRPORT, STANSTED,
COMPLETED 1991

P 176 AND 177

SWAMP CREATURE

9 GLASS

CLIENT
BRITISH AIRPORTS AUTHORITY PLC

COMMISSIONING COMPANY
PUBLIC ART DEVELOPMENT TRUST FOR
BAA PLC'S ART PROGRAMME AT
HEATHROW AIRPORT

PROJECT DESCRIPTION
INSTALLATIONS BY THREE IRISH ARTISTS FOR PIER 4A LINKS, TERMINAL 1

P 178 AND 179 (180 AND 181, 182 AND 183, 184 OVERLEAF)

BAA

ASHING

31 GHOST TOWN

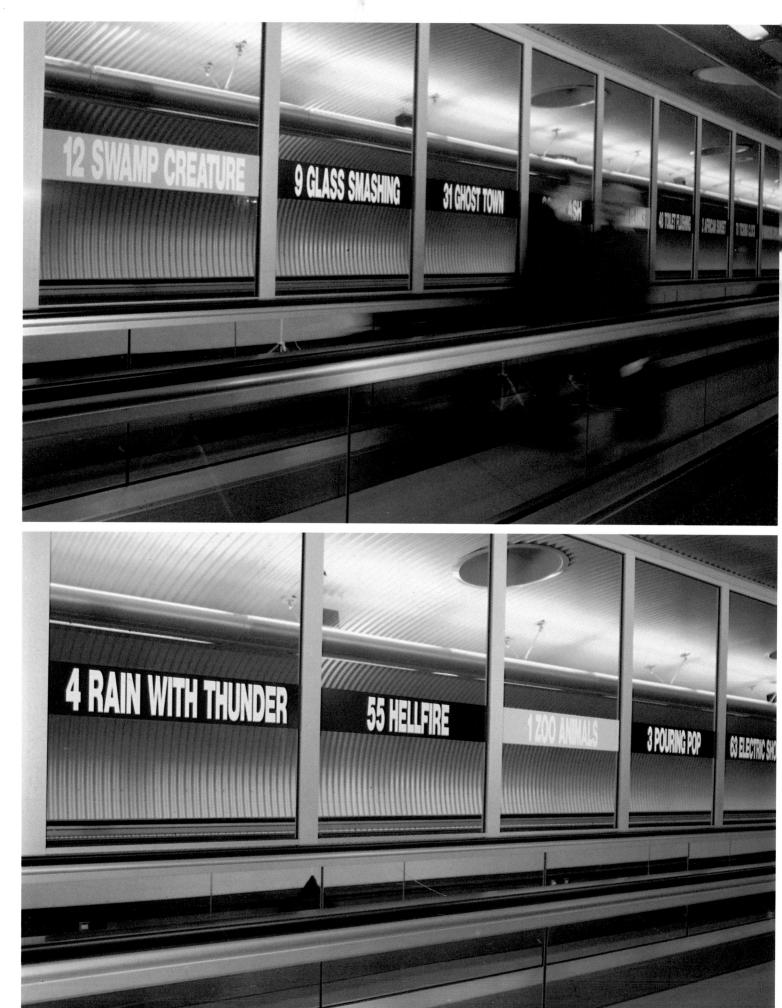

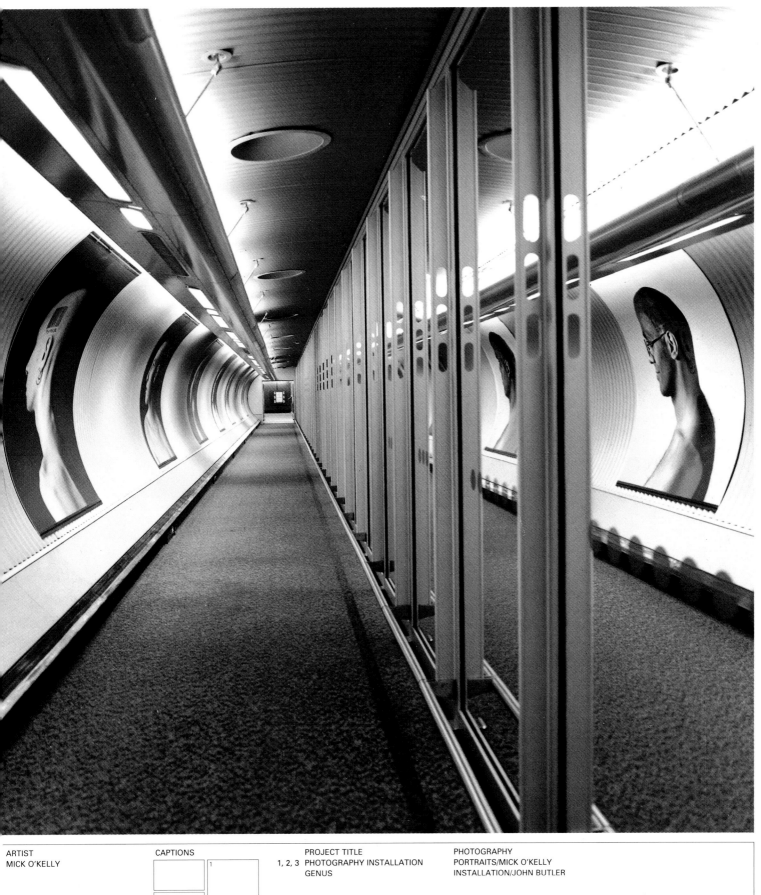

ARTIST
MICK O'KELLY

CAPTIONS
1

PROJECT TITLE
1, 2, 3 PHOTOGRAPHY INSTALLATION
GENUS

PHOTOGRAPHY
PORTRAITS/MICK O'KELLY
INSTALLATION/JOHN BUTLER

CAPTIONS
2 3

P 181 (182 AND 183 OVERLEAF)

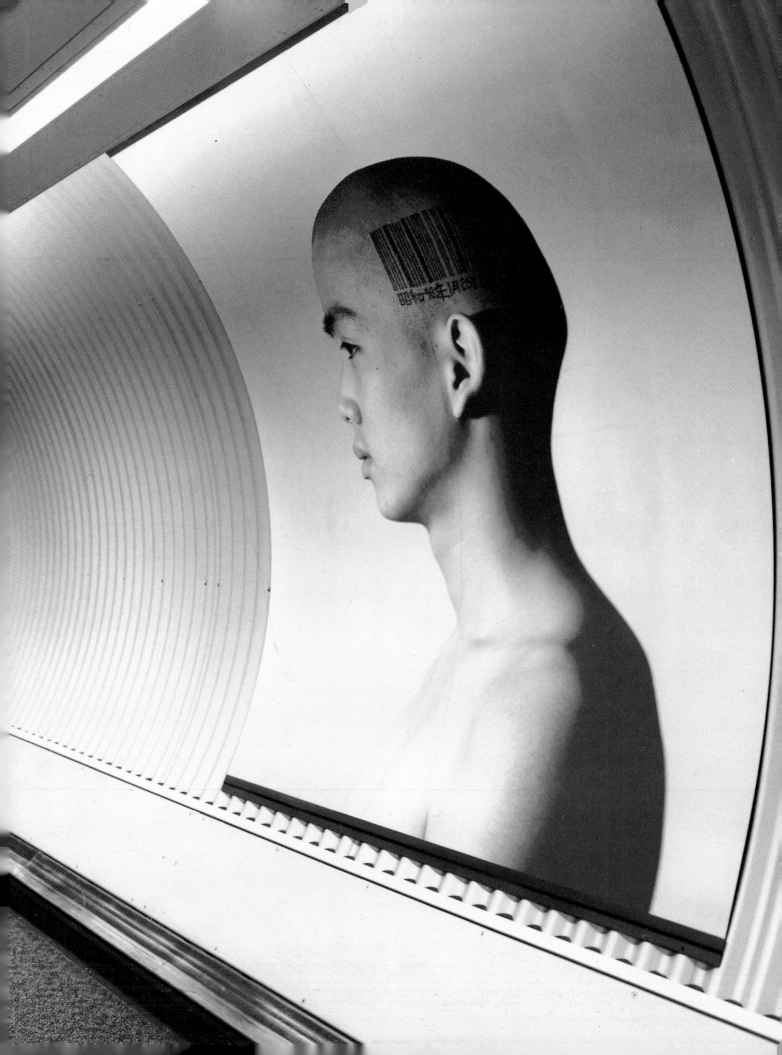

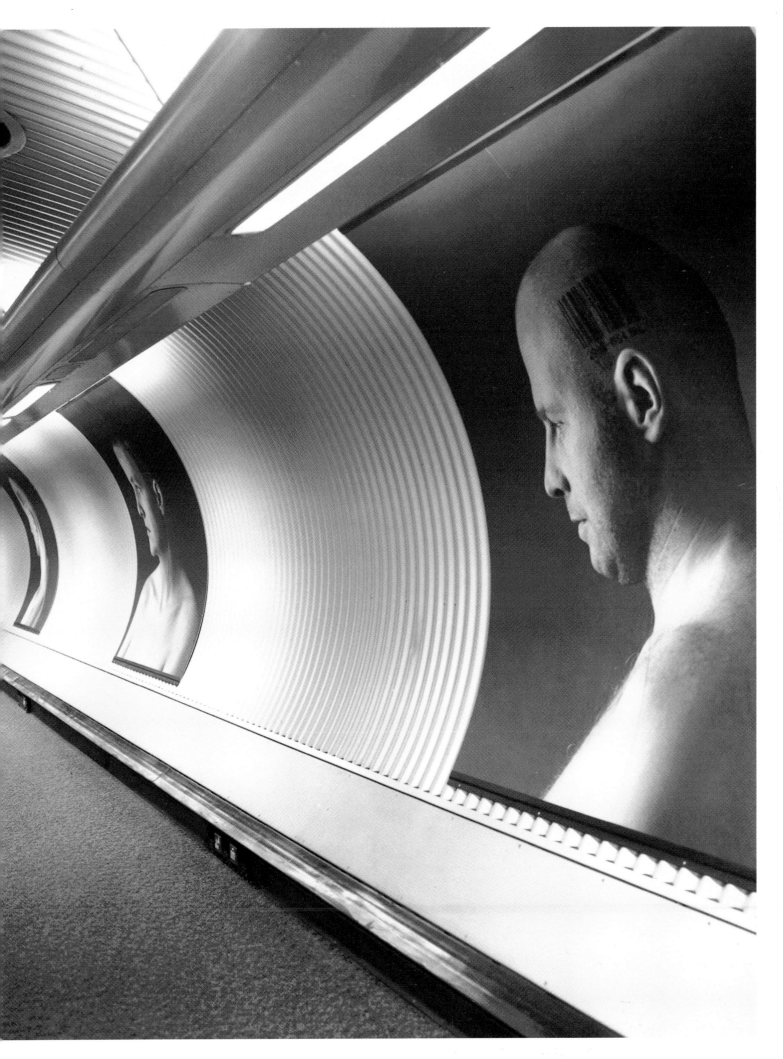

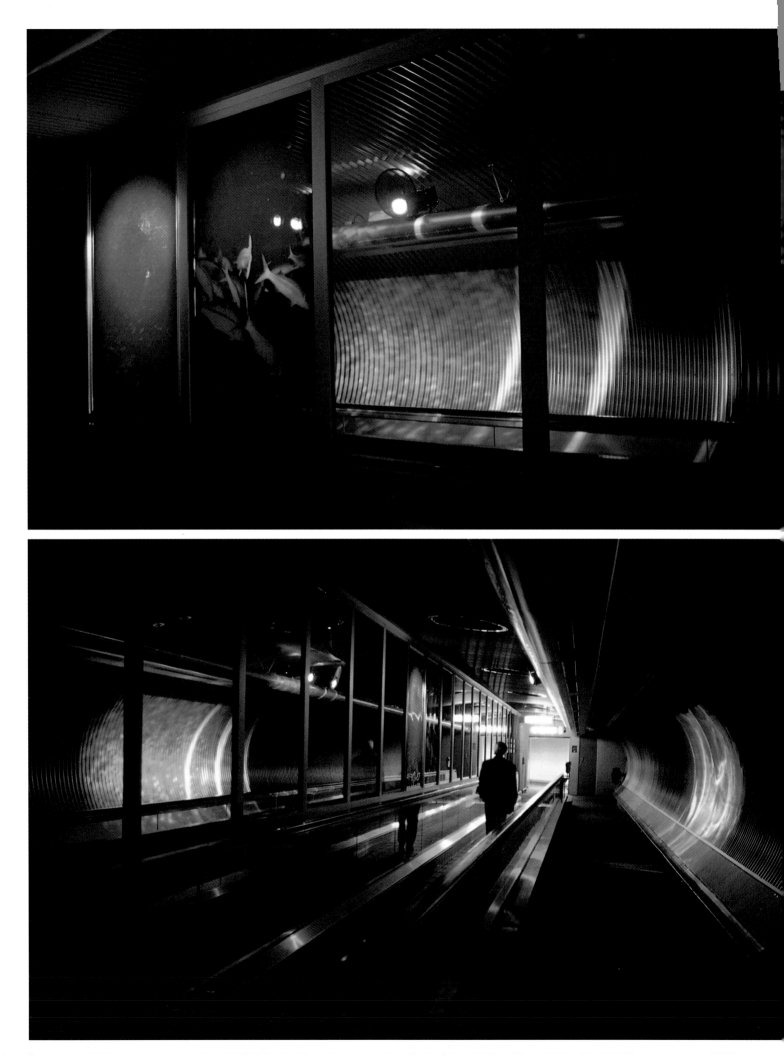

ARTIST
LOUISE WALSH

CAPTIONS

1

2

PROJECT TITLE
1, 2 LIGHT INSTALLATION

PHOTOGRAPHY
PAUL KAY
INSTALLATION/JOHN BUTLER

P 184

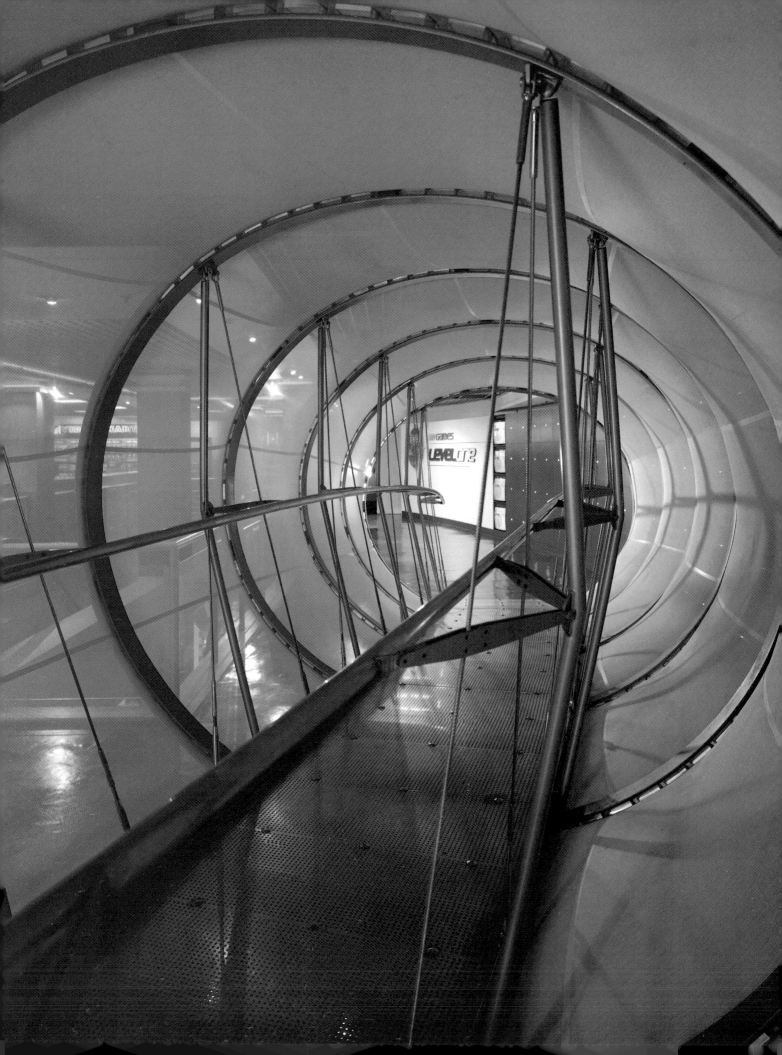

THE TRANSLUCENT MEMBRANE HAS
LIGHT, COLOUR AND IMAGERY CAST ONTO
IT FROM THE OUTSIDE, TO BE VIEWED BY
CUSTOMERS AS THEY JOURNEY ALONG
THE WALKWAY FROM THE EXISTING
STORE INTO THE NEW DEPARTMENT.

CLIENT
HMV UK LTD

PROJECT TITLE
HMV GAMES 'LEVEL ONE'

DESIGN COMPANY
RED JACKET

PHOTOGRAPHY
CHRIS GASCOIGNE

PROJECT DESCRIPTION
COMPUTER GAMES
DEPARTMENT 1993

CLIENT
UNITED PUBLISHERS S.A

P 188 AND 189 (190 AND 191, 192 AND 193 OVERLEAF)

PROJECT TITLE
VIEW ON COLOUR
NOS 2, 3 AND 4

DESIGN COMPANY
STUDIO ANTHON BEEKE
STUDIO LIDEWIJ EDELKOORT

DESIGNER
ANTHON BEEKE

PROJECT DESCRIPTION
COLOUR FORECASTING MAGAZINE

CONDENSATION

SUBLIMATION

The goal is reached, the answer is found: the ultimate result!

Le but est atteint, la solution est trouvée: le résultat final!

Da alles Farbe hat, muß alles,
was Menschen tun,
farbig gestaltet sein'
Bruno Taut (1921)

DIS

Evaporating, volatile, becoming light as a feather, drifting as if suspended in air, non-aligned, open to everything. A state of pure bliss.

Exposé, volatile, devenir léger comme une plume, planer comme suspendu dans l'air, être non conformiste, ouvert à tout, un état de plénitude profond.

PURIFICATION

A phase of intense concentration, of going through several stages of synthesis in order to arrive at a new point of departure.

Une phase de concentration intense, traversant différents états de synthèse afin d'arriver à un nouveau point de départ.

Land of Heart's Desire,
Where beauty has no ebb, decay no flood,
But joy is wisdom, Time an endless song.
W.B. Yeats (1865-1939)

CALCINATION

To begin a new project, it is necessary to burn away surplus information and accepted logic in order to clear a path for new experiences.

commencer un nouveau projet demande de détruire de surplus d'information et d'accepter la logique pour donner vie à de nouvelles expériences.

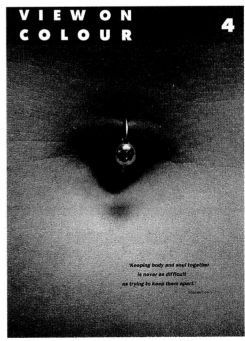

'Keeping body and soul together
is never as difficult
as trying to keep them apart.'
Stanlie Lowry

'VIEW ON COLOUR'S AIM IS TO TALK COLOUR TO COLOUR USERS. IT IS DEDICATED TO ALL AREAS THAT NEED TO KNOW WHAT IS HAPPENING IN AND AROUND COLOUR: TEXTILES, FASHION, LEISURE, COSMETICS, GRAPHICS, INDUSTRIAL DESIGN, ARCHITECTURE, INTERIOR DESIGN, PACKAGING, HORTICULTURE...'

THE MAGAZINE IS DESIGNED TO BALANCE PURE TREND INFORMATION WITH ARTICLES AND INTERVIEWS OF GENERAL COLOUR INTEREST. THIS IS DONE BY FORECASTING THE COLOURS OF TOMORROW, GIVING EXACT COLOUR GUIDELINES FOR SELECTED INDUSTRIAL END-USES, DEMONSTRATING HOW COLOURS CAN BE USED IN NEW WAYS, SHOWING HOW DIFFERENT FIELDS OF INDUSTRY USE AND INTERACT WITH COLOUR, TALKING TO THE PEOPLE THAT INFLUENCE AND LEAD OUR THOUGHTS ON COLOUR, CREATING A COMMON COLOUR LANGUAGE FOR THE FUTURE.'

ANTHON BEEKE, LIDEWIJ EDELKOORT DAVID SHAH

VIEW ON COLOUR

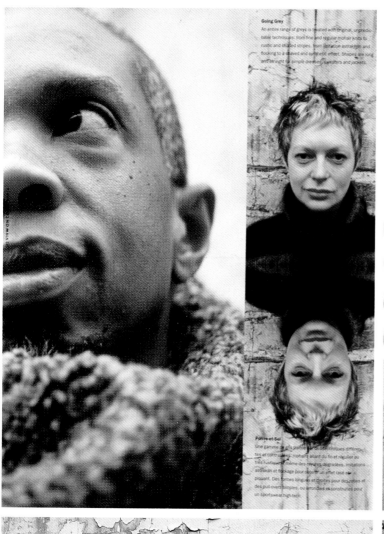

Going Grey

An entire range of greys is treated with original, ungraded table techniques: from fine and regular mohair knits to rustic and striped stripes, from imitation astrakan and flocking to a shaved and synthetic effect. Shapes are long and straight for simple dresses, sweaters and jackets.

Poivre-et-Sel

Une gamme de gris traitée avec des techniques différentes et contrastées: mohairs allant du fin et régulier au très rustiques, même des rayures dégradées, imitations astrakan et flockage pour obtenir un effet rasé et piquant. Des formes longues et droites pour des robes et des pull-overs simples, ou amorcées et construites pour un sportswear high-tech.

PANTONE 19-3903
PANTONE 17-1410
PANTONE 16-3803
PANTONE 16-0806
PANTONE 14-0000

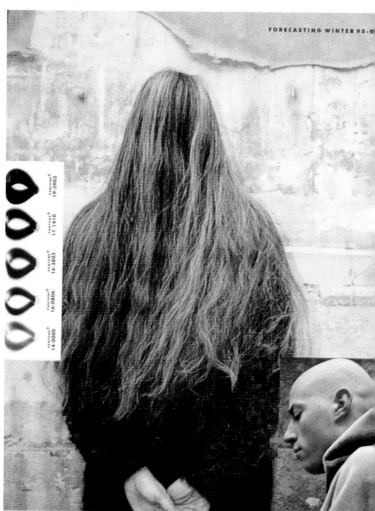

FORECASTING WINTER 95-96

PANTONE 15-1318
PANTONE 12-0720
PANTONE 18-562
PANTONE 15-4020
PANTONE 16-1326

PANTONE 12-4306
PANTONE 12-4302
PANTONE 11-0602
PANTONE 12-0812
PANTONE 11-4303
PANTONE 11-4601
PANTONE 11-0701

PANTONE 19-1327
PANTONE 17-1558
PANTONE 16-1604
PANTONE 15-1364
PANTONE 17-14
PANTONE 14-0756
PANTONE 12-0642

CLIENT
AKZO COATINGS DIVISION
THE NETHERLANDS

PROJECT TITLE
COLOURING THE FUTURE

DESIGNER
IRMA BOOM

PROJECT DESCRIPTION
1992 WEEKLY CALENDAR

RUN

PAINT

TROUBLE

CONTACT

GOLD

CAB

HELLO!!

BLACK & WHITE

Als zelfs het woord 'blond' blond kan klinken,
hoeveel waarschijnlijker dat de [z/w]
gefotografeerde haren er blond uit kunnen
zien! If the word 'blond' itself can sound blond,
then it's even easier for [b/w] photographed
hair to look blond! Wenn selbst das Wort
'blond' blond klingen kann, wie viel eher
können die [s/w] photographierten Haare blond
ausschauen! Si même le mot 'blond' peut
avoir un son blond, il est d'autant plus
probable que les cheveux photographiés
[en n/b] aient un aspect blond! Se persino la
parola 'biondo' puo sonare bionda, quanto più
facilmente possono apparire biondi i capelli
nella [b/n] fotografia! Si hasta la palabra
'rubio' puede sonar a rubio, ¡ cómo no va a ser
más verosímil aún que el pelo fotografiado

SHOCK
ING PINK

WAVE

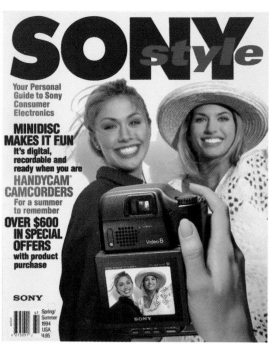

SONY *style*

Your Personal Guide to Sony Consumer Electronics

MINIDISC MAKES IT FUN
It's digital, recordable and ready when you are

HANDYCAM® CAMCORDERS
For a summer to remember

OVER $600 IN SPECIAL OFFERS
with product purchase

SONY

Spring/Summer 1994 USA $4.95

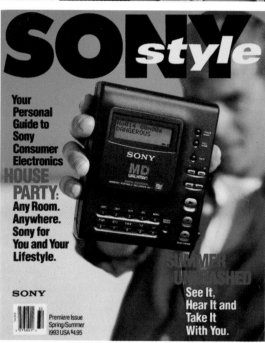

SONY *style*

Your Personal Guide to Sony Consumer Electronics

HOUSE PARTY:
Any Room. Anywhere. Sony for You and Your Lifestyle.

SONY

Premiere Issue Spring/Summer 1993 USA $4.95

SUMMER UNLEASHED
See It, Hear It and Take It With You.

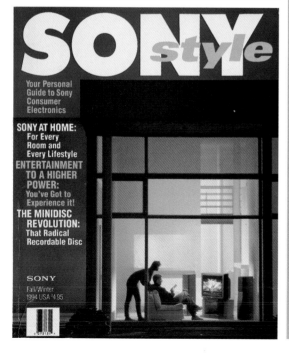

SONY *style*

Your Personal Guide to Sony Consumer Electronics

SONY AT HOME:
For Every Room and Every Lifestyle

ENTERTAINMENT TO A HIGHER POWER:
You've Got to Experience it!

THE MINIDISC REVOLUTION:
That Radical Recordable Disc

SONY

Fall/Winter 1994 USA $4.95

PRODUCT MANUFACTURER BECOMES PUBLISHER TO CREATE A CONSUMER LIFESTYLE MAGAZINE DEDICATED TO THE SONY BRAND.

IT CONTAINS FEATURES AND ARTICLES RELATING TO SONY PRODUCTS, RELEVANT LIFESTYLE COMMENTARY, ADVERTISING FROM ALL SONY INDUSTRIES, PRODUCT LISTINGS, PRICES AND INFORMATION.

MAGAZINE AVAILABLE AT NEWS-STANDS OR BY PHONE ORDER.

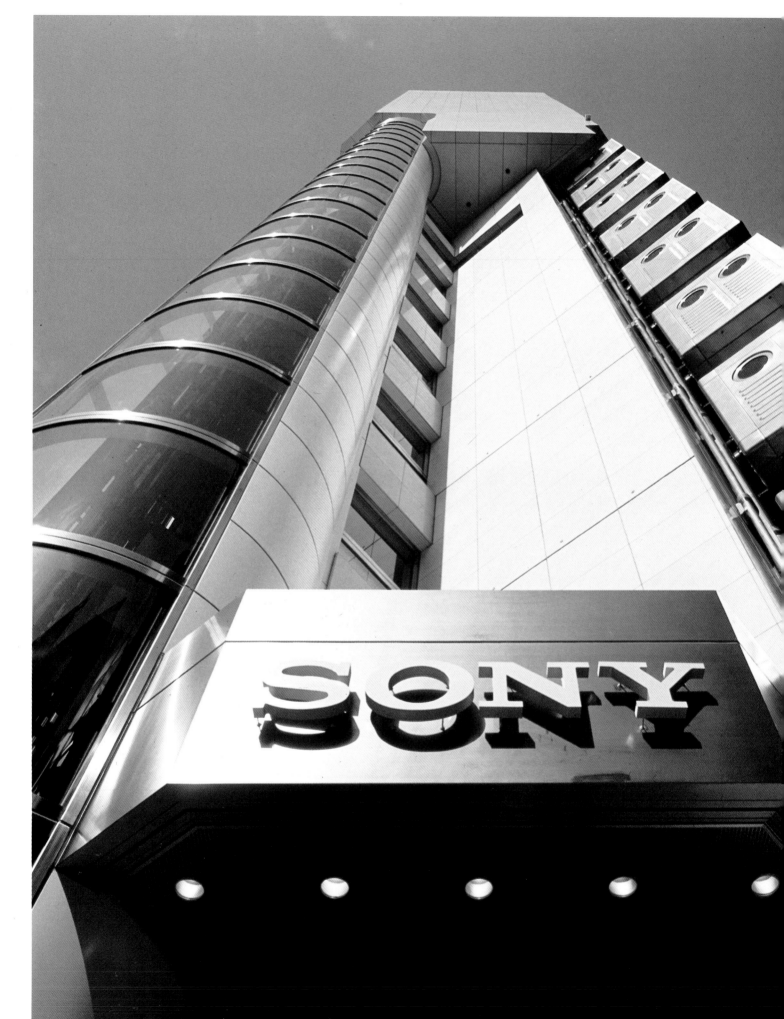

'THE MINUTE YOU OR ANYBODY ELSE KNOWS WHAT YOU ARE YOU ARE NOT IT. YOU ARE WHAT YOU OR ANYBODY ELSE KNOWS YOU ARE AND AS EVERYTHING IN LIVING IS MADE UP OF FINDING OUT WHAT YOU ARE IT IS EXTRAORDINARILY DIFFICULT REALLY NOT TO KNOW WHAT YOU ARE AND YET TO BE THAT THING.'

GERTRUDE STEIN

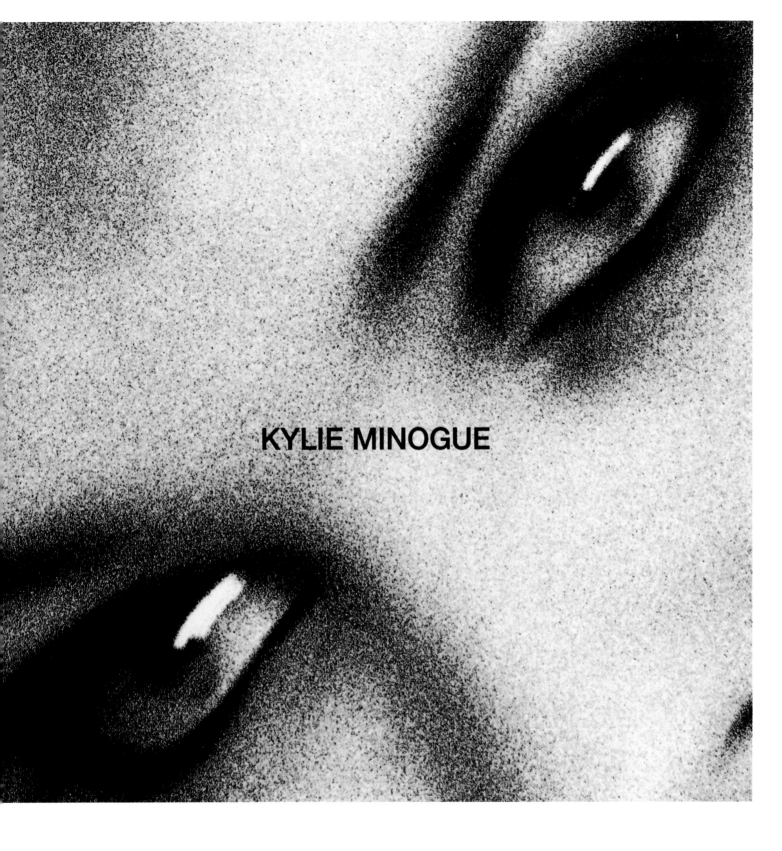

KYLIE MINOGUE

CLIENT
DECONSTRUCTION

DESIGN COMPANY
FARROW

DESIGNERS
MARK FARROW
ROB PETRIE
PHIL SIMS

PHOTOGRAPHY
ELLEN VON UNWERTH
KATRINA JEBB

PROJECT DESCRIPTION
THE 'RE-ENGINEERING' OF
KYLIE MINOGUE

P 200 AND 201 (202 AND 203 OVERLEAF)

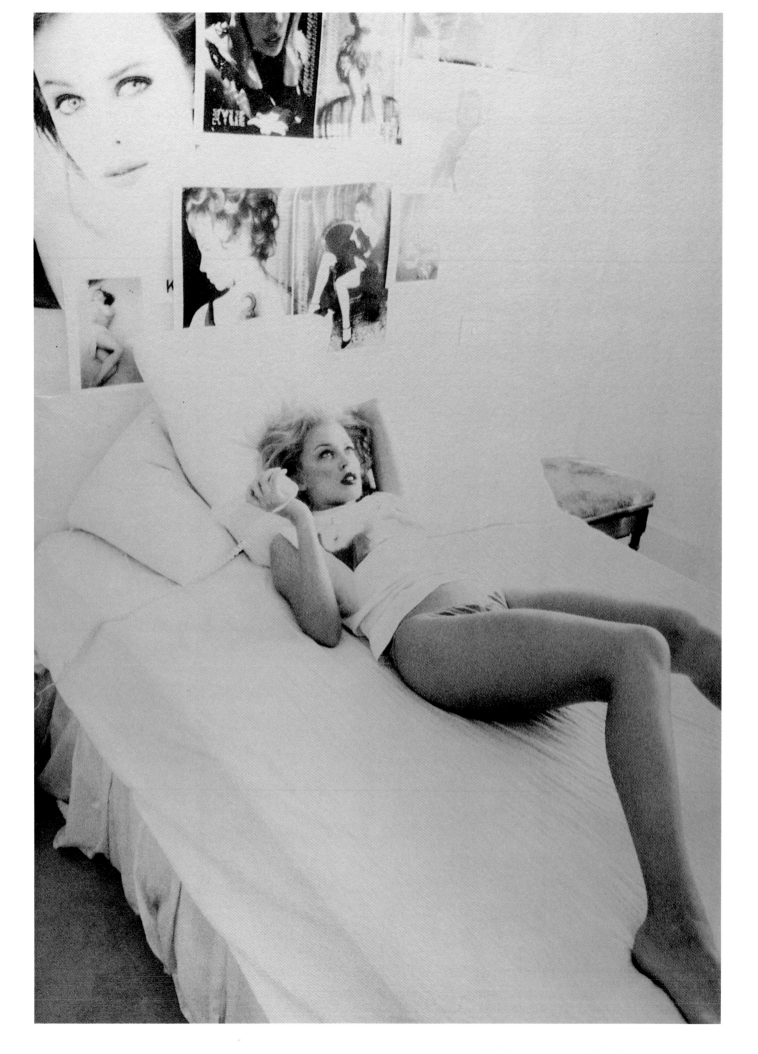

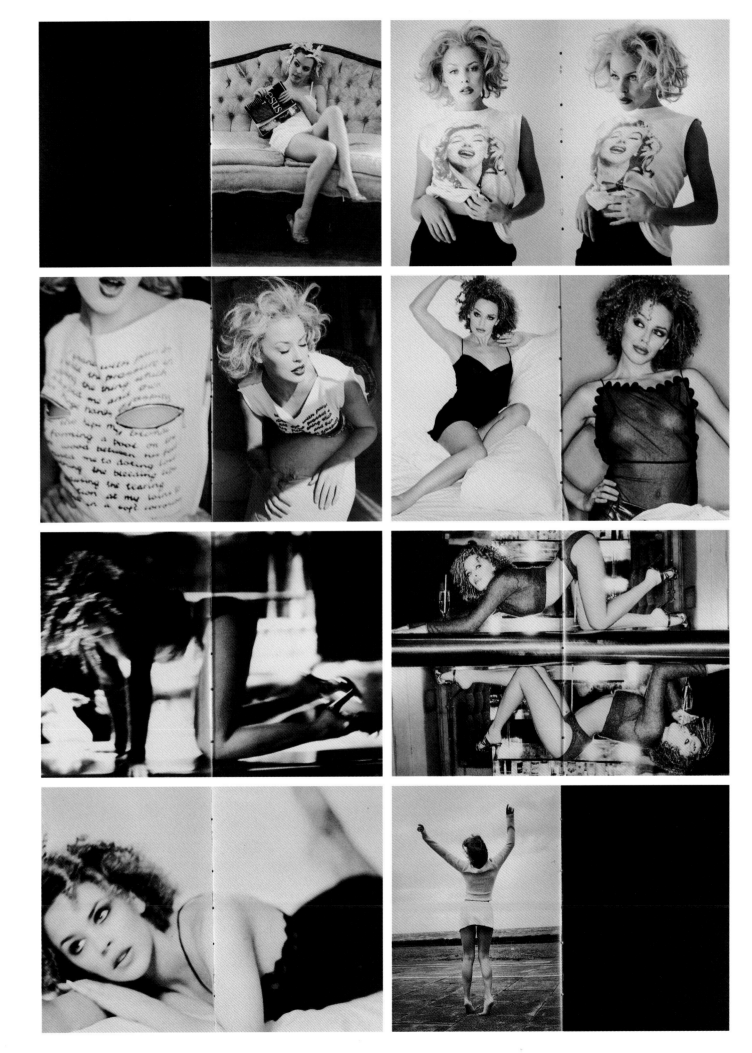

PUBLISHER
ANOTHER LTD

P 204 AND 205

PROJECT TITLE
THE KYLIE BIBLE

MAGAZINE
DAZED AND CONFUSED
1994

PHOTOGRAPHY
RANKIN

STYLING
KATIE GRAND

HAIR AND MAKE UP
SHARON IVES

PROJECT DESCRIPTION
THE 'RE-ENGINEERING' OF KYLIE MINOGUE

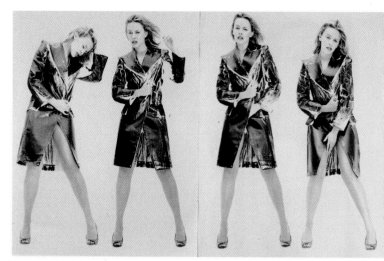

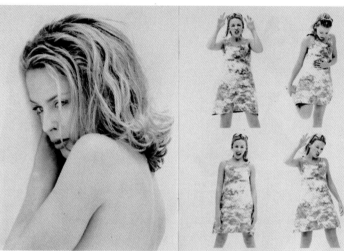

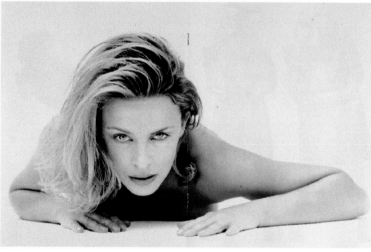

THE KYLIE BIBLE

OUTPOST IS A COLLECTABLE EXHIBITION WHICH IN 1994 INCLUDED OVER 25,000 ARTWORKS BY 250 PRACTITIONERS FROM A MULTITUDE OF DISCIPLINES.

THESE ARTWORKS WERE DISPENSED FREE OF CHARGE FROM VENDING BOXES SITUATED IN LOCATIONS AS DIVERSE AS ART GALLERIES AND FAST FOOD RESTAURANTS DURING THE EDINBURGH FESTIVAL.

THE VIEWER IS ENCOURAGED TO MAKE THEIR OWN CRITICAL DECISIONS ABOUT ART – ASIDE FROM THOSE IMPOSED ON THEM BY THE GALLERY SYSTEM AND AWAY FROM THE COMMERCIAL VALUE GIVEN TO WORKS OF ART THROUGH EVIDENCE OF AUTHORSHIP.

MOST IMPORTANTLY, OUTPOST ENCOUR-AGES THE VIEWER TO SIMULTANEOUSLY TAKE ON THE ROLE OF CURATOR, CRITIC AND COLLECTOR.

| CLIENT
EDINBURGH FESTIVAL | COMMISSIONING ORGANISATION
FAT | ARTIST
JACQUI PANNELL | PROJECT DESCRIPTION
THIS IS AN ANATOMICAL INVESTIGATION MAPPING THE BODY THROUGH THE DESCRIPTION OF ITS INDIVIDUAL COMPONENT PARTS. CHILDHOOD MEMORY IS EXPLORED THROUGH THE DOCUMENTATION OF PHYSICAL INCIDENT, USING THE PLASTER AS A COMMON SIGNIFIER OF INJURY. THE WORK ENCOURAGES SIMILAR MEMORIES WITHIN THE VIEWER AND FORCES AN EXPLORATION OF THE CONSTRUCTION OF THEIR OWN IDENTITY |
| | PROJECT TITLE
OUTPOST | CARD TITLE
A HUNDRED AND ONE WOUNDS | |

| | | ARTIST
HELEN CHADWICK | PROJECT DESCRIPTION
THESE CARDS DEAL WITH THE NOTION OF EXCHANGE. THE VIEWER RECEIVES THE DONEE CARD IN RETURN FOR THE DONATION OF A PINT OF BLOOD.
THE ARTIST REQUIRED THE TERMS OF EXCHANGE TO BE OF EQUAL BENEFIT TO ALL PARTIES INVOLVED – THE VIEWER RECEIVES A VALUABLE PIECE OF WORK, SOCIETY BENEFITS FROM THE DONATION OF VITAL FLUID – AND THE ARTIST BENEFITS FROM THE KNOWLEDGE OF THIS EXCHANGE |
| | | CARD TITLE
DONOR/DONEE | |

| | | ARTIST
MIKE NELSON | PROJECT DESCRIPTION
THIS WORK EMPOWERS THE VIEWER WITH A PHYSICAL MEANS OF ENGAGEMENT – ARSON – WITHIN THE CONTEXT THAT THE WORK IS EXPERIENCED. THE MANIFESTATION OF THIS ENGAGEMENT IS CONDITIONED BY THE VIEWER'S RELATIONSHIP TO THE INSTITUTION WHICH THEY OCCUPY |
| | | CARD TITLE
ARSON | |

P 207

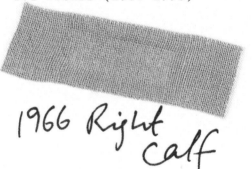

101 WOUNDS (1961–1993)

1966 Right Calf

101 WOUNDS (1961–1993)

1989 Right Instep

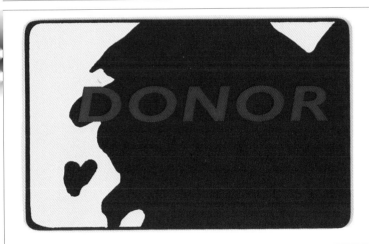

DONOR

DONEE

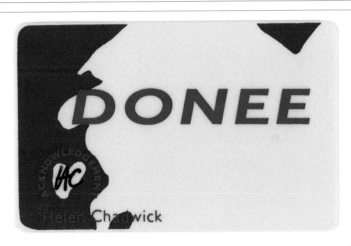

Mike Nelson
Negotiable

ARSON

CLIENT	COMMISSIONING ORGANISATION	ARTIST	PROJECT DESCRIPTION
EDINBURGH FESTIVAL	FAT	LISA BROWN	THIS WORK EXPOSES AN OFTEN PRIVATE FEMALE RITUAL THROUGH THE DISTRIBUTION OF DISCARDED HAIR WAXING STRIPS WHICH PREVIOUSLY RENDERED THE BODY 'PERFECT'. THE VIEWER IS OFFERED THE OPPORTUNITY TO CHALLENGE AND RECONSTRUCT THEIR OWN IDEALS OF FEMALE 'PERFECTION' WHEN DECIDING WHETHER TO UTILISE THE UNUSED WAX OF THE SIGNATURE CARD
	PROJECT TITLE	CARD TITLE	
	OUTPOST	PERFECT BESTIALITY	

		ARTIST	PROJECT DESCRIPTION
		PIP BRUCE	WHEN THE ENVELOPE IS OPENED THE PARTIALLY DEVELOPED PHOTOGRAPH CONTAINED WITHIN CONTINUES TO EXPOSE. THIS PROCESS CAN ONLY BE HALTED BY THE VIEWER PLACING THE WORK IMMEDIATELY BACK WITHIN ITS COVERING. THE WORK INVITES THE SPECTATOR TO ENGAGE IN IDEAS OF POSSESSION AND PERMANENCE BY OFFERING THEM THE CHOICE OF EITHER MOMENTARILY EXPERIENCING THE IMAGE, OR PRESERVING IT UNSEEN
		CARD TITLE	
		POSSESSION	

		ARTIST	PROJECT DESCRIPTION
		STAN O	EACH URINE FILLED SACHET WAS LOCATED WITHIN MAJOR INSTITUTIONS THROUGHOUT THE CITY, MARKING OUT THE TERRITORY OCCUPIED AND ENGAGED BY THE ARTIST. THE SIGNATURE CARD TAKES THE FORM OF THE LAMINATED FRAGMENT OF A GLOVE WHICH ENABLED THE ARTIST TO MAKE THE WORK AND ENABLES THE VIEWER TO 'TOUCH' AND SYMBOLICALLY 'OWN' THE WORK
		CARD TITLE	
		PISS MARK	

ARTIST
THOMAS TATUM

CARD TITLE
PURE

PROJECT DESCRIPTION
ONE HALF OF A CHEQUE IS 'BROUGHT' WITH THE OTHER HALF, HIGHLIGHTING THE LACK OF REAL COMMERCIAL VALUE IN ART AND REDUCING ARTWORK TO A PURE TRANSACTION OF PRODUCT. IN FILLING OUT THE CHEQUE THE VIEWER QUESTIONS AND DETERMINES THE VALUE OF THE ARTWORK THEMSELVES – THEY DECIDE IN MONEY TERMS, HOW MUCH THE WORK IS WORTH TO THEM AND HOW MUCH THEY ARE WILLING TO PAY

ARTIST
EMMA DAVIS
CLIVE SALL

CARD TITLE
RED CROSS

PROJECT DESCRIPTION
THIS WORK ENGAGES WITH A NOTION OF HEALING WHICH OCCURS ON TWO LEVELS. FIRSTLY, THE REPRESENTATION OF THE ILLNESS IS CUT AWAY IN ORDER TO CURE THE AILING BODY – THE ARTIST ACTS AS SURGEON AND HEALER TO THE AFFLICTED OCCUPIER OF THE IMAGE. SECONDLY THE VIEWER IS 'HEALED' THROUGH THE AESTHETIC OF THE 'ILLNESS' ITSELF WHILST INVESTIGATING IT AS AN INDEPENDENT IMAGE OF TEXTURE AND COLOUR

ARTIST
FRANCOIS LE FRANC

CARD TITLE
100 NATURAL HOME SETTINGS
SYCAMORE FANTASY

PROJECT DESCRIPTION
THE 100 FORMICA WOOD LAMINATED CARDS, APPROPRIATING A CATALOGUE OF SAMPLES, SIGNIFY THE OPPORTUNITY OF A VOLUPTUOUS TOTAL ENVIRONMENT. THE SAMPLES, DESPITE THEIR SIZE, CONSTITUTE A COMPLETE AND IDEAL SET OF CHOICES, OFFERING THE DOMESTIC CONSUMER THE PROMISE OF BOTH NOSTALGIA AND EXPECTATION

ABBEY NATIONAL

Abbey National plc, P.O. Box 382, Prescot Street, London E1

Pay

Cheque Number Sort Code Account Num

"001048" 09"0126": 2035 "06651"

09-01-26

19

£

Only

MR T J TEATUM

SYCAMORE ECSTASY

No. 01/074

100 natural home settings
FRANCOIS LEFRANC

£ 0.50

CLIENT EDINBURGH FESTIVAL	COMMISSIONING ORGANISATION FAT	ARTIST REBEKAH CAMERON	PROJECT DESCRIPTION EACH SACHET CONTAINS THE FRAGMENTS OF ONE HALF OF A PHOTOGRAPH – EVIDENCE OF A PERSONAL RELATIONSHIP FROM THE ARTIST'S PAST.
	PROJECT TITLE OUTPOST	CARD TITLE SEPARATED	THE VIEWER IS DRAWN INTO THE CONSTRUCTION OF THE NARRATIVE AND COMBINESS THE HALVES TO REVEAL THE FULL IMAGE TOGETHER WITH A TEXTUAL DESCRIPTION

		ARTIST TERRY HAGERTY	PROJECT DESCRIPTION THE SEALED ENVELOPE INVITES THE INVESTIGATION OF ITS CONTENTS. UPON OPENING THE PIGMENT IT CONTAINS IS TRANSFERRED TO THE HANDS
		CARD TITLE BRY	OF THE VIEWER THEREBY IMPLICATING THEM IN THE PROCESS OF IMAGE MAKING. THIS INTERACTIVE ENGAGEMENT ENCOURAGES AN ACTUAL PHYSICAL EXPERIENCE WITH THE WORK AND ITS MEANS OF PRODUCTION

		ARTIST JACQUELINE PANNELL	PROJECT DESCRIPTION THIS IMAGE INVESTIGATES THE CONCEPTUAL SPACE BETWEEN TWO AND THREE-DIMENSIONAL CONDITIONS. THE VIEWER IS ENCOURAGED TO
P 210		CARD TITLE MOMENTS WITH OBJECTS THE PIN	CONSIDER THE PROCESS OF THE PRODUCTION OF THE WORK THROUGH AN INTER-ACTIVE SPATIAL ENGAGEMENT

Moments With Objects
The Pin

Jacqueline Pennell

ARTIST
ALEXANDRA POWERS

CARD TITLE
SYRUP OF FIGS

PROJECT DESCRIPTION
THE WAY IN WHICH WE PERCEIVE OUR OWN SELF-IMAGE AND HOW IT IS
RE-INVENTED IS EXAMINED BY USE OF THE HAIRSTYLE AS FASHION ICON.
THE SIGNATURE CARD PRESENTS THE INVENTED WORD 'SYRUPTITIOUS'
(A MUTATED FORM OF SURREPTITIOUS) SEWN IN THE ARTISTS OWN HAIR

ARTIST
ALAN OUTRAM

CARD TITLE
STOLEN GOODS

PROJECT DESCRIPTION
ATTACHED TO THE CARDS ARE 100 OBJECTS STOLEN FROM DIFFERENT LOCA-
TIONS. THE IMAGES DEAL WITH CONDITIONS OF OWNERSHIP, MONETARY
VALUE AND POSSESSION. THE CARDS 'VALUE' CHANGES ACCORDING TO
WHERE IT WAS STOLEN FROM, AND WHERE IT WAS RETRIEVED. THE CARDS
ALSO OFFER THE EXPERIENCE OF RECEIVING STOLEN GOODS

ARTIST
EMMA DAVIS
CLIVE SALL

CARD TITLE
RED CROSS

PROJECT DESCRIPTION
THIS WORK ENGAGES WITH A NOTION OF HEALING WHICH OCCURS ON TWO
LEVELS. FIRSTLY, THE REPRESENTATION OF THE ILLNESS IS CUT AWAY IN
ORDER TO CURE THE AILING BODY – THE ARTIST ACTS AS SURGEON AND
HEALER TO THE AFFLICTED OCCUPIER OF THE IMAGE. SECONDLY, THE VIEWER
IS 'HEALED' THROUGH THE AESTHETIC OF THE 'ILLNESS' ITSELF WHILST
INVESTIGATING IT AS AN INDEPENDENT IMAGE OF TEXTURE AND COLOUR

P 211

STOLEN GOODS

STOLEN GOODS

STOLEN GOODS

STOLEN GOODS

STOLEN GOODS

STOLEN GOODS

CAKE SHOP

CAKE SHOP

BLACKPOOL PIER

SCRIPTURE UNION

MODEL VILLAGE
WITHERNSEA

OXFAM

IN THE LATE 19TH CENTURY, GROVE ROAD WAS A TYPICAL ROW OF TERRACE HOUSES OF THE KIND BUILT THROUGH- OUT THE EAST END OF LONDON.

BY THE EARLY 1990'S THE TERRACE WAS NO MORE. FROM THE INTERIOR OF THE LAST REMAINING HOUSE, AN EXTRAORD- INARY SCULPTURE WAS MADE BY THE ARTIST RACHEL WHITEREAD.

THIS WORK COMMEMORATES MEMORY ITSELF THROUGH THE COMMONPLACE OF THE HOME. WHITEREAD'S IN-SITU WORK TRANSFORMS THE SPACE OF THE PRIVATE AND DOMESTIC INTO THE PUBLIC – A MUTE MEMORIAL TO THE SPACES WE HAVE ALL LIVED IN AND EXPERIENCED.

ARTIST
RACHEL WHITEREAD

PROJECT TITLE
HOUSE 1993

COMMISSIONING ORGANISATION
THE ARTANGEL TRUST

PHOTOGRAPHY
EDWARD WOODMAN

P 212 AND 213

CLIENT
LEYBOLD AG

COMPANY
BAUMANN & BAUMANN

PROJECT DESCRIPTION
INTERIOR AND EXTERIOR INFORMATION SYSTEM
1990

PP 36 AND 37

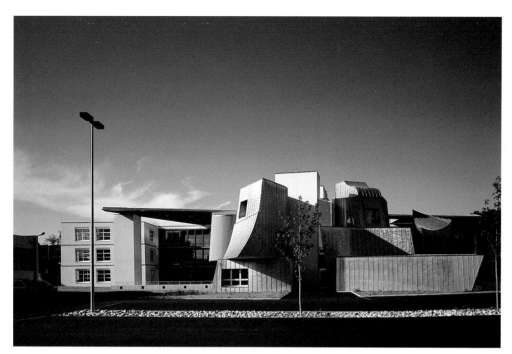

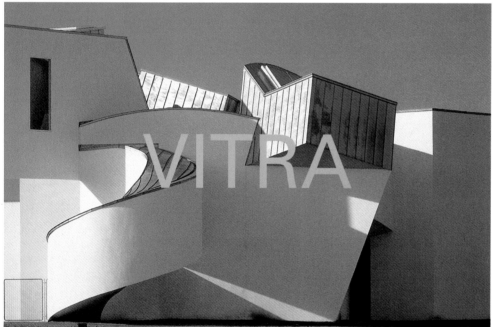

VITRA

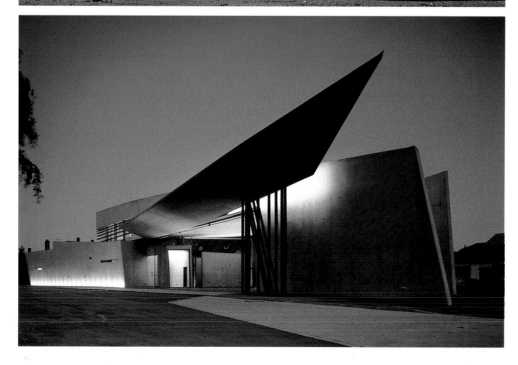

'WHEN THE VITRA DESIGN MUSEUM WAS OPENED ON NOVEMBER 3 1989, FRANK GEHRY'S UNCONVENTIONAL ARCHITECTURE PROVIDED US WITH A SIGNIFICANT INITIAL ADVANTAGE. THE FACT THAT OUR MUSEUM WAS NOT ONLY GEHRY'S FIRST BUILDING IN EUROPE BUT ALSO THE INAUGURATION OF A NEW PHASE IN THE ARCHITECT'S WORK, DREW VISITORS FROM ALL OVER THE WORLD.'

ALEXANDER VON VEGESACK

CLIENT
VITRA GMBH

CAPTIONS
1
2
3

PROJECT TITLE
1 VITRA CENTRE
2 VITRA DESIGN MUSEUM
3 VITRA FIRE STATION

ARCHITECT
FRANK O GEHRY
FRANK O GEHRY
ZAHA M HADID

PHOTOGRAPHY
RICHARD BRYANT
ARCAID

P 216 AND 217

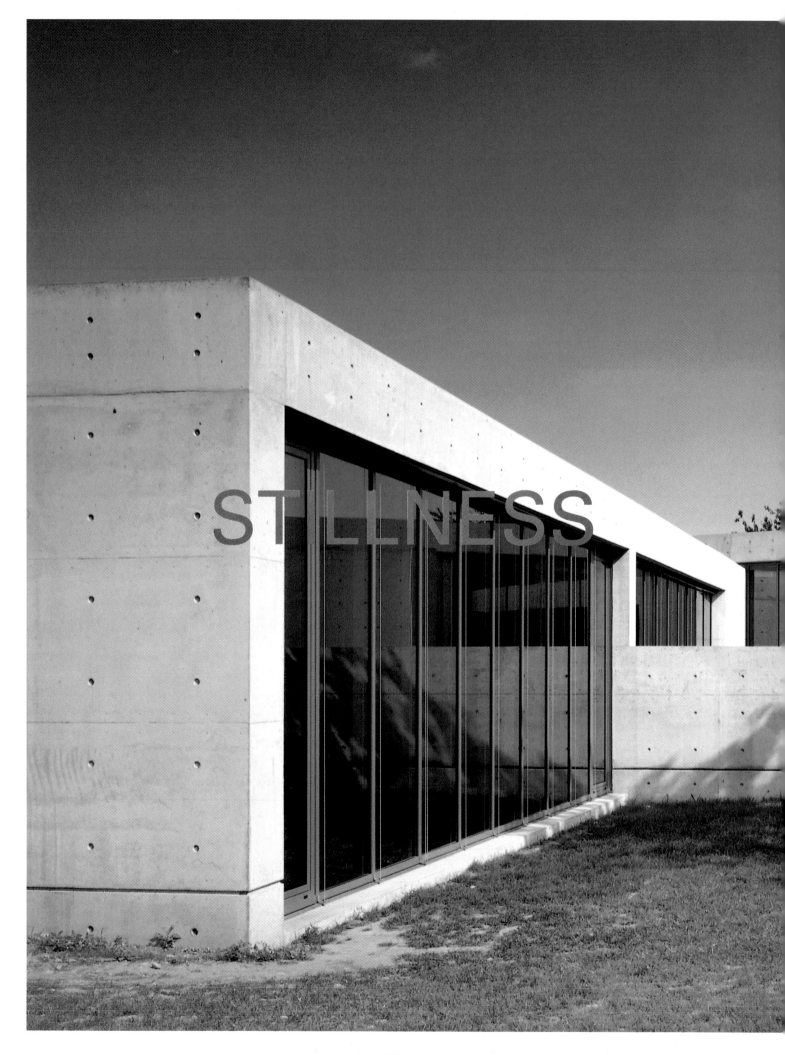

STILLNESS

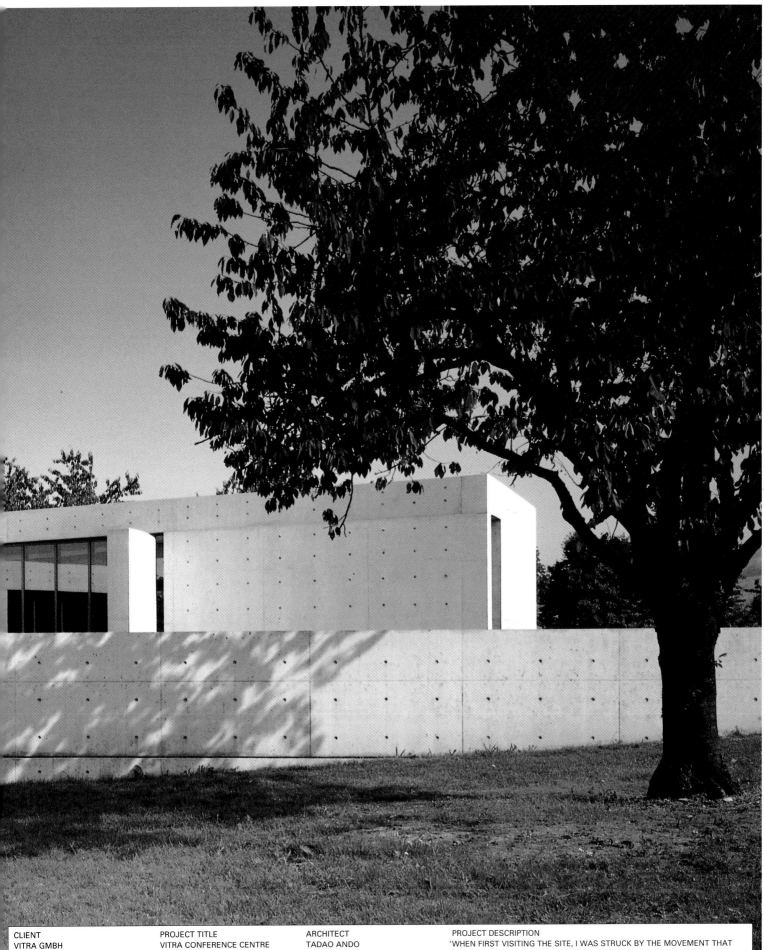

CLIENT
VITRA GMBH

PROJECT TITLE
VITRA CONFERENCE CENTRE

ARCHITECT
TADAO ANDO

PHOTOGRAPHY
RICHARD BRYANT

PROJECT DESCRIPTION
'WHEN FIRST VISITING THE SITE, I WAS STRUCK BY THE MOVEMENT THAT
THE FRANK GEHRY DESIGN MUSEUM PROJECTED SO POWERFULLY.
OPPOSITE GEHRY'S ARCHITECTURE OF MOVEMENT I INTRODUCED THE
ELEMENT OF STILLNESS. THIS ARCHITECTURE OF STILLNESS BEGINS TO
ACQUIRE RICH LIFE WHEN THE ELEMENTS OF NATURE – LIGHT AND WIND –
AND THE MOVEMENT OF PEOPLE ARE INTRODUCED WITHIN IT.' TADAO ANDO

'TODAY THE DIFFERENCE BETWEEN A GOOD AND A POOR ARCHITECT IS THAT THE POOR ARCHITECT SUCCUMBS TO EVERY TEMPTATION AND THE GOOD ONE RESISTS IT.'

L WITTGENSTEIN

CLIENT	PROJECT TITLE	ARCHITECT	PHOTOGRAPHY	PROJECT DESCRIPTION
HANS & CAROLINA NEUENDORF	MAJORCA HOUSE	PAWSON SILVESTRIN	RICHARD BRYANT ARCAID	HOLIDAY VILLA FOR A GERMAN ART DEALER. THE LONG NARROW POOL PROJECTS FROM THE TERRACE TOWARDS THE HORIZON ENDING IN A WATERFALL
		ARCHITECTS JOHN PAWSON CLAUDIO SILVESTRIN		
P 220 AND 221				

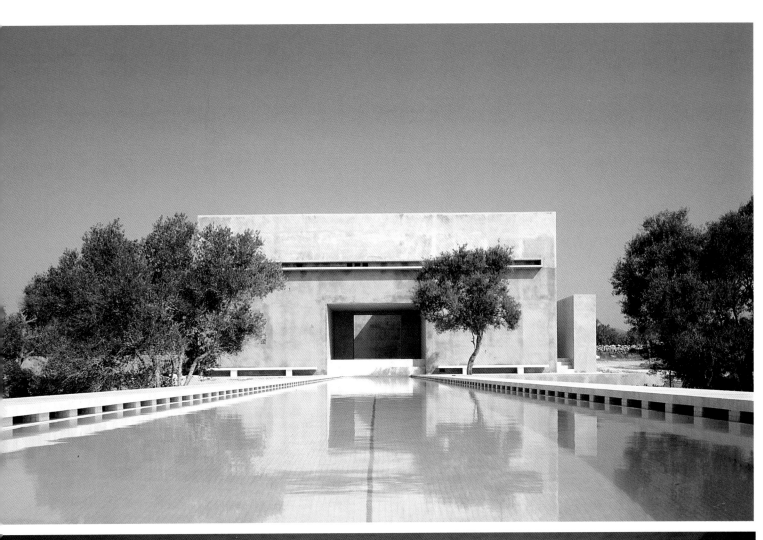

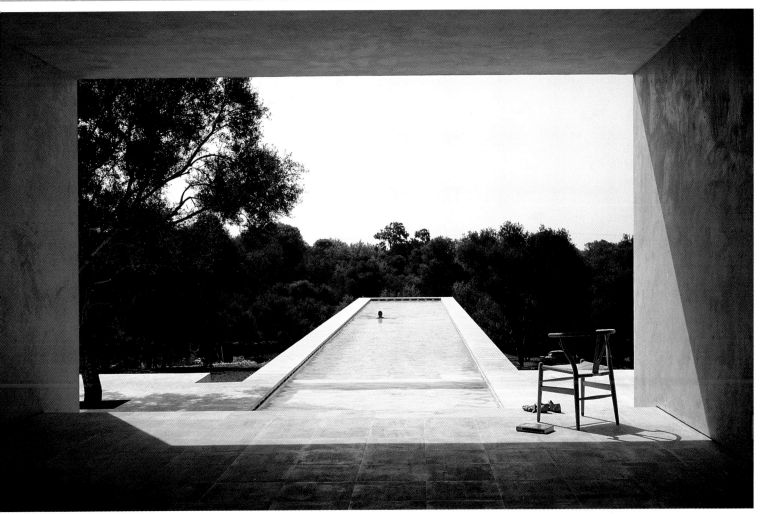

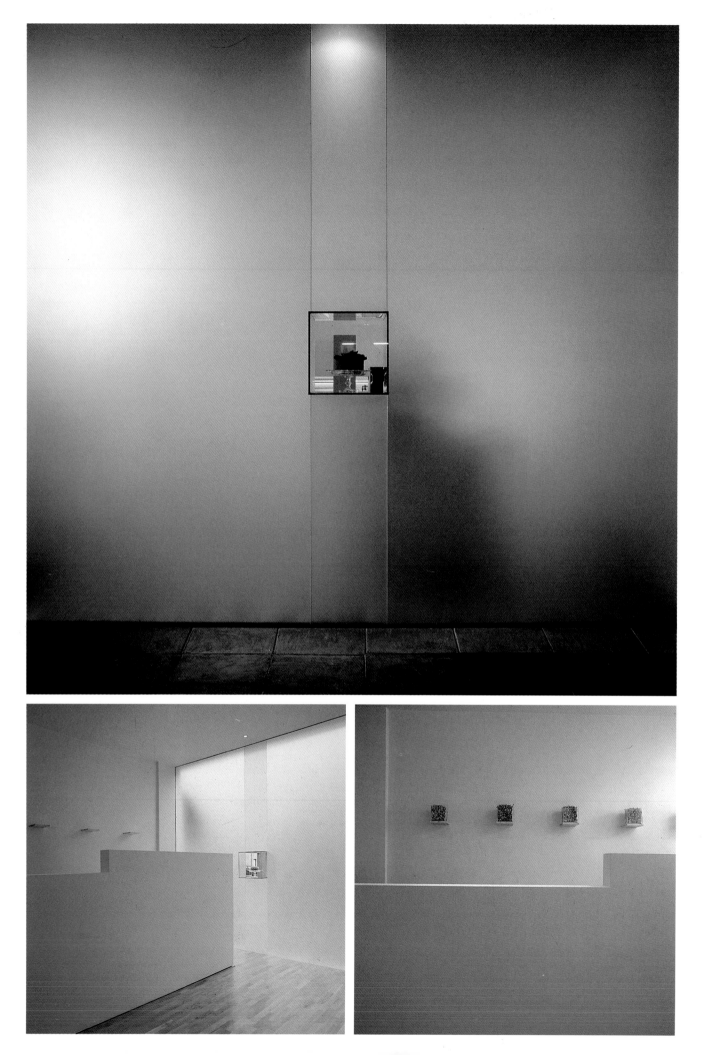

A WALL OF TRANSLUCENT ACID-ETCHED GLASS FORMS THE SHOP FRONT. THIS MASK FACADE IS PUNCTURED BY A CLEAR GLASS CUBE, JUST LARGE ENOUGH FOR THE DISPLAY OF A SINGLE CAKE SET AT ITS CENTRE.

DURING THE DAY THE GLASS FILTERS THE SUNLIGHT IN. AT NIGHT, SEEN FROM OUTSIDE, ARTIFICIAL LIGHT PRODUCES A MYSTERIOUS QUALITY.

CLIENT	PROJECT TITLE	ARCHITECT	PHOTOGRAPHY	PROJECT DESCRIPTION
RAJA CORTAS	CANNELLE	PAWSON SILVESTRIN	IAN DOBBIE	CAKE SHOP INTERIOR AND FACADE
		ARCHITECTS		
		JOHN PAWSON		
		CLAUDIO SILVESTRIN		
P 222 AND 223				

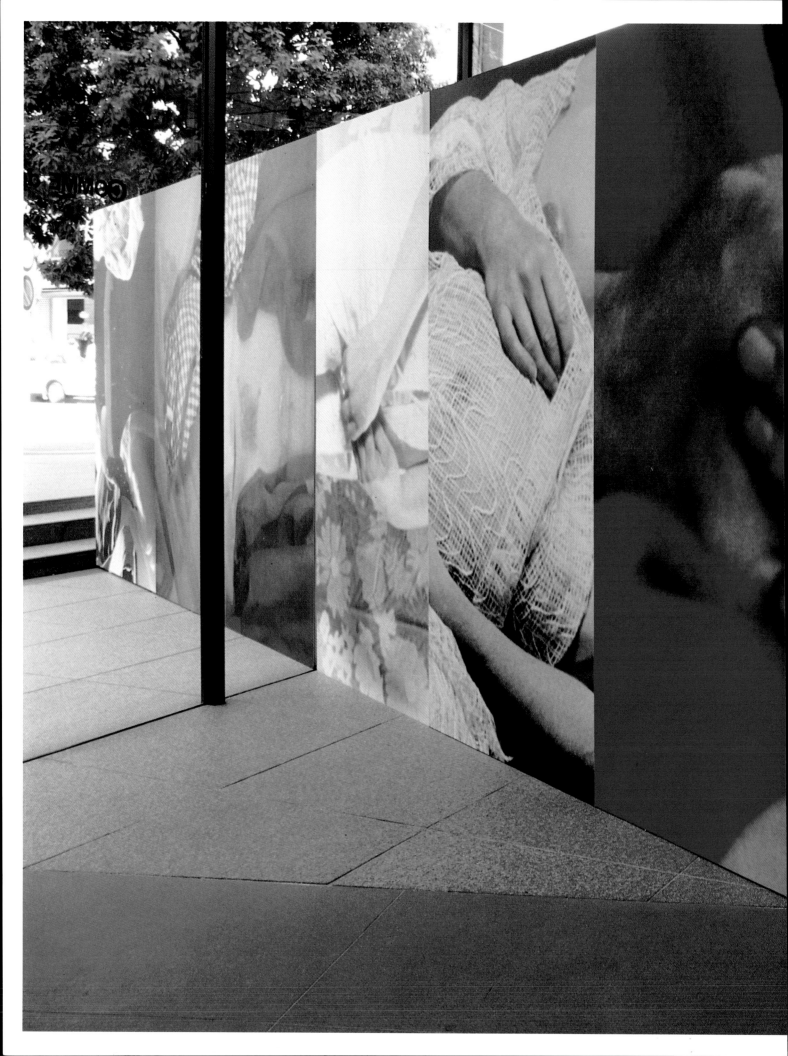

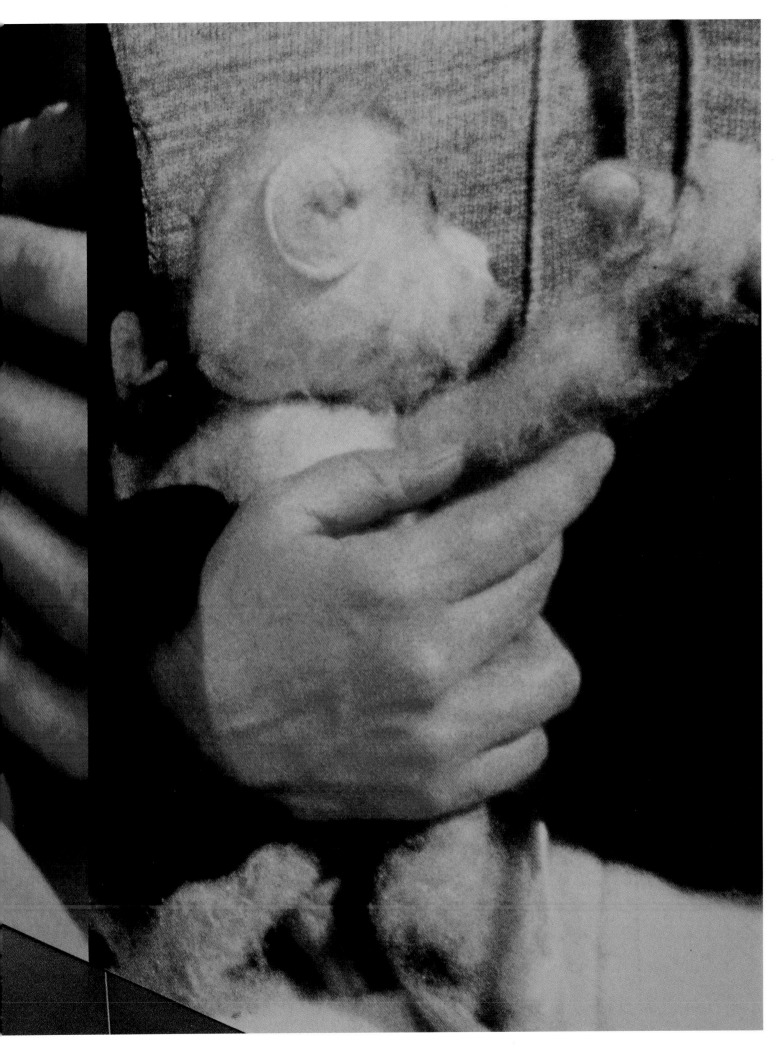

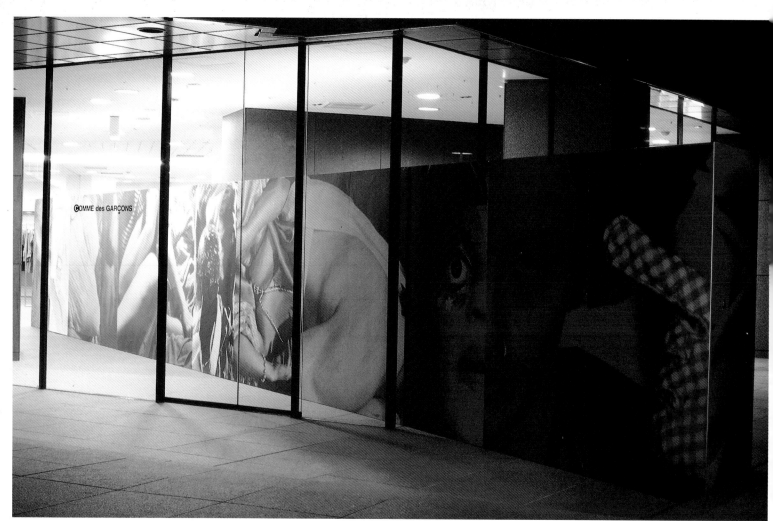

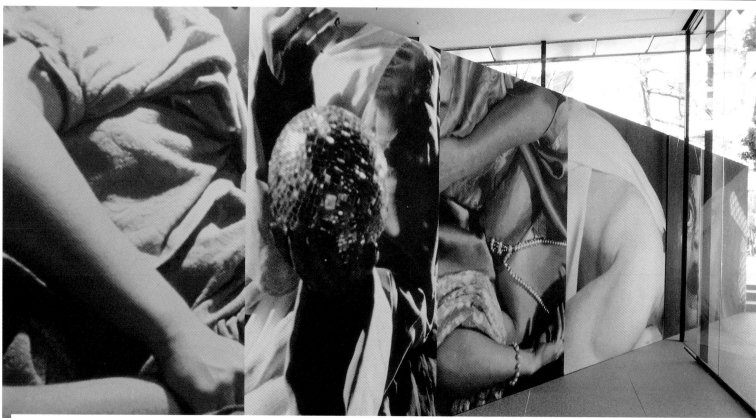

COMPANY	PROJECT	ARTIST	PROJECT DESCRIPTION
COMME DES GARÇONS	DIRECT MAIL CAMPAIGN	CINDY SHERMAN	A SERIES OF 5 CARDS WERE SENT TO COMME DES GARÇONS' CUSTOMERS ANNOUNCING THE AUTUMN/WINTER 1993 – 1994 COLLECTION AND SPRING/SUMMER 1994 COLLECTION

P 226 AND 227 (224 AND 225 PREVIOUS; 228 AND 229, 230 AND 231 OVERLEAF)

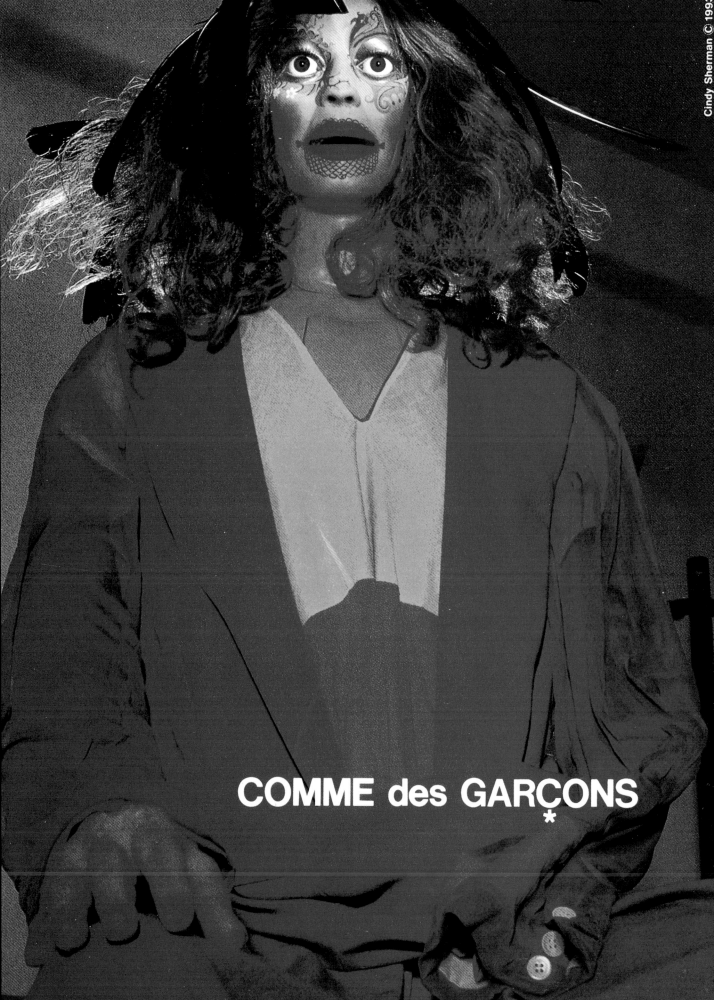

COMME des GARÇONS
*

COMME des GARÇONS
*

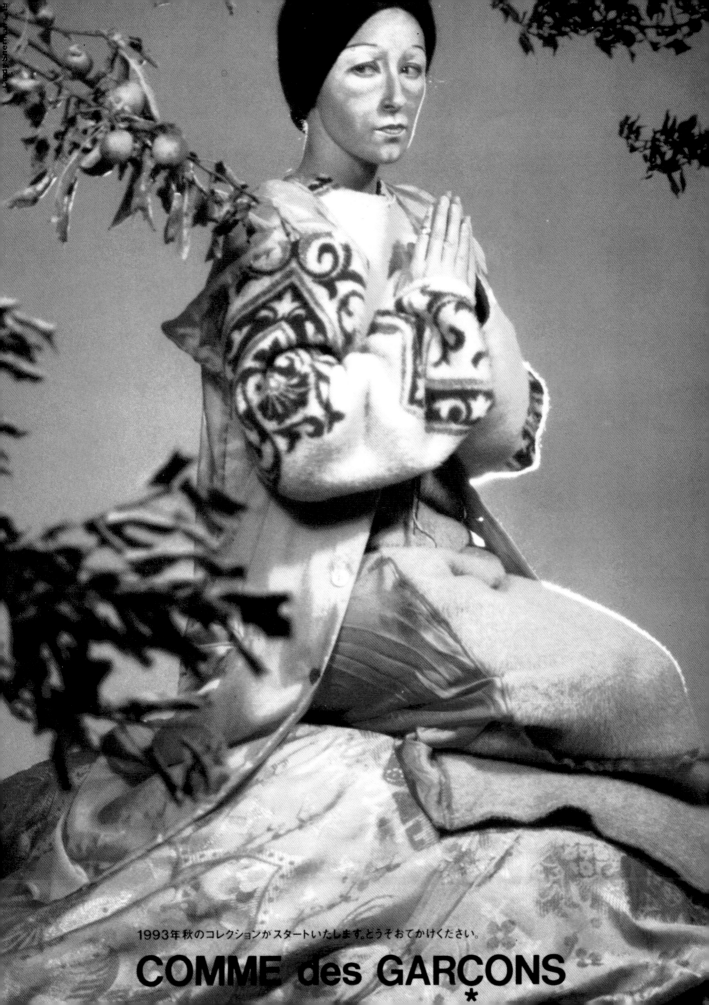

1993年 秋のコレクションがスタートいたします。どうぞおでかけください。

COMME des GARÇONS
*

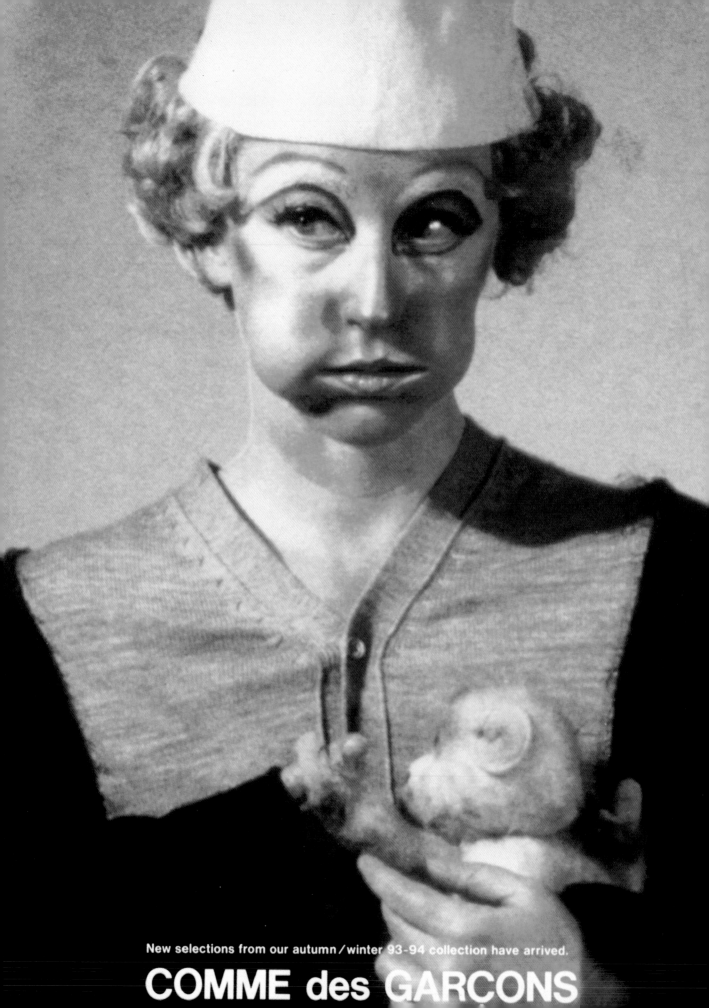

New selections from our autumn / winter 93-94 collection have arrived.

COMME des GARÇONS

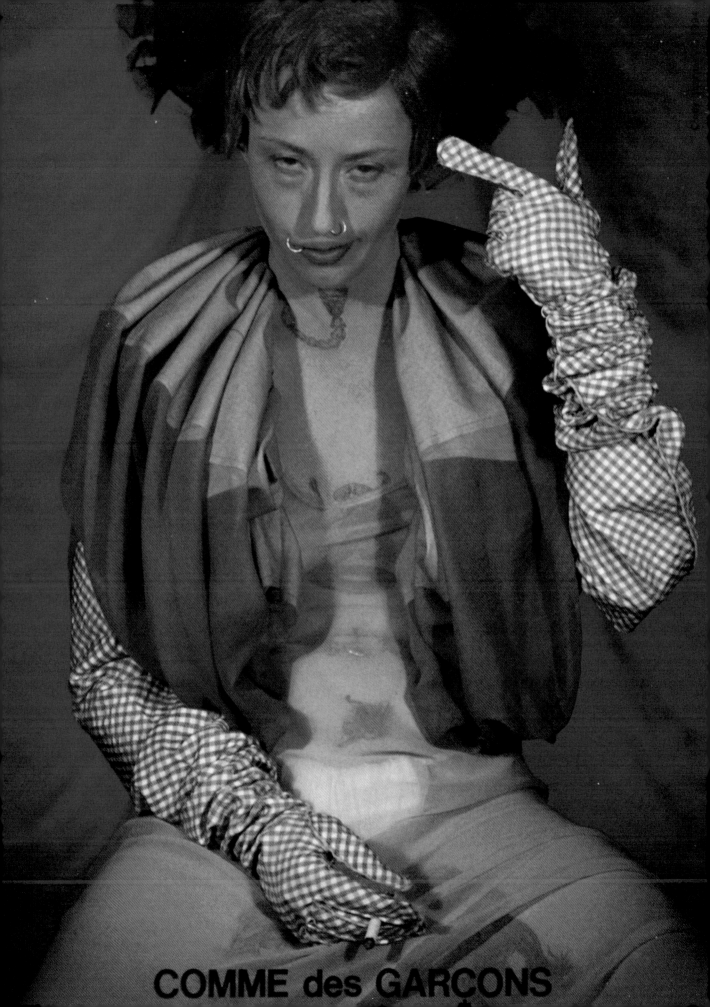

COMME des GARCONS

CLIENT	PROJECT TITLE	DESIGNER	PHOTOGRAPHY	PROJECT DESCRIPTION
REGIS	MOTO	DAVID JAMES	EDDIE MONSOON	FASHION CATALOGUE FOR MANUFACTURER OF PLASTIC AND RUBBER CLOTHING. THE BROCHURE IS MADE OF PLASTIC AND CAN BE SCREWED TO ENABLE ITS CONTENTS TO LITERALLY UNFOLD BEFORE THE VIEWER IN DOING SO EXPLOIT THE INTRISIC PHYSICAL PROPERTIES OF THE MATERIALS THEMSELVES

'SOME BOOKS ARE TO BE TASTED,
OTHERS TO BE SWALLOWED, AND SOME
FEW TO BE CHEWED AND DIGESTED.'

FRANCIS BACON

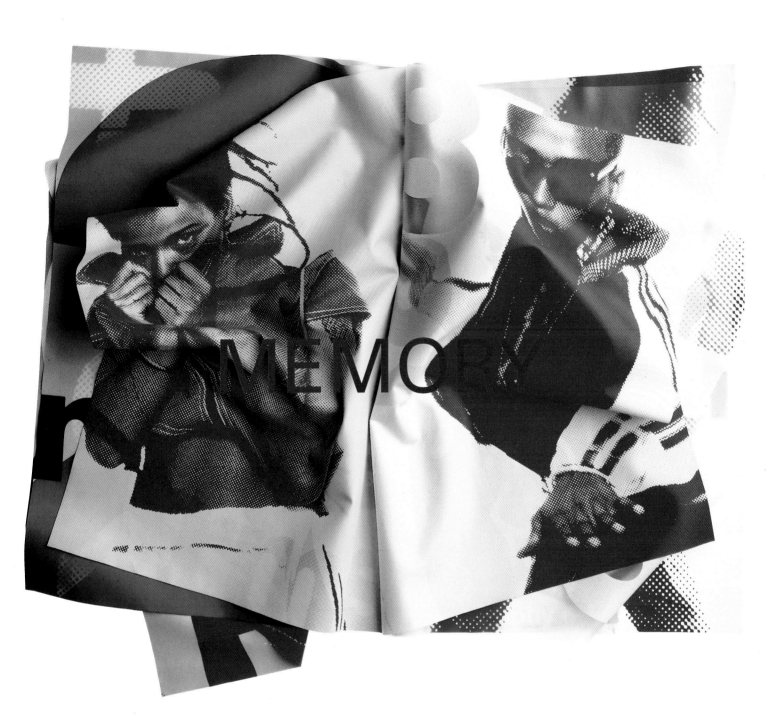

CLIENT
EMIGRE MAGAZINE

PROJECT TITLE
CATALOGUE

DESIGN COMPANY
MEVIS & VAN DEURSEN

DESIGNER
LINDA VAN DEURSEN

PHOTOGRAPHY
JODOKUS DRIESSEN

PROJECT DESCRIPTION
DOUBLE PAGE SPREAD FROM ISSUE 25

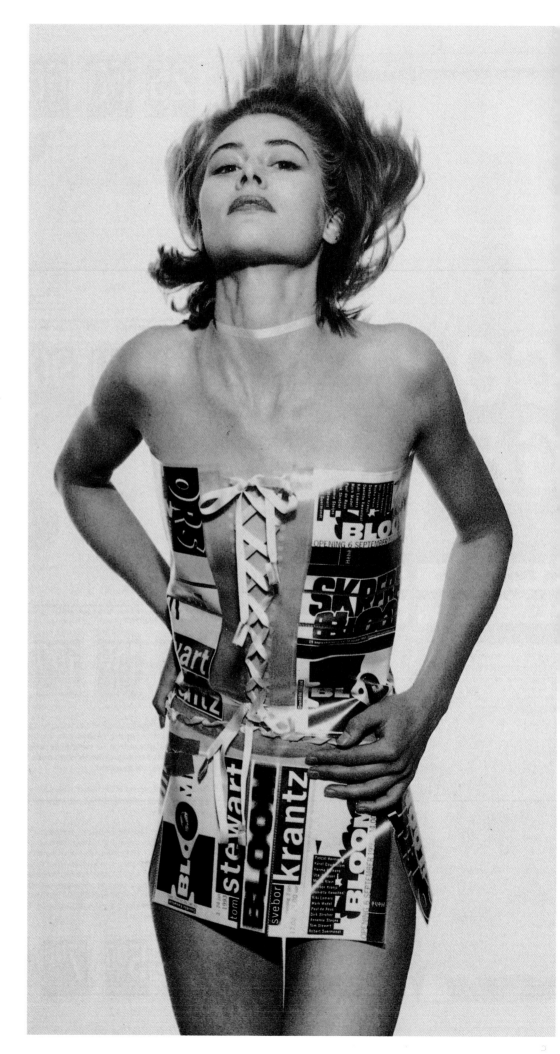

A FASHIONABLE PIECE OF LITERATURE

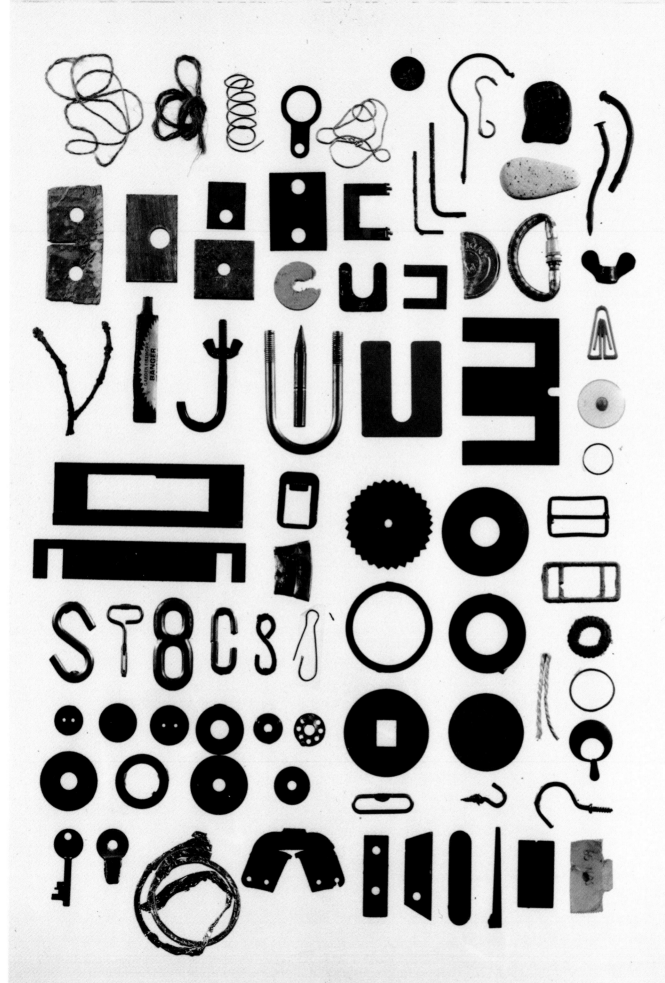

PUBLISHER
FUSE/FONTSHOP INTERNATIONAL

P 238

PROJECT TITLE
ANALPHABET 1994

DESIGNER
PAUL ELLIMAN

PROJECT DESCRIPTION
'READING TYPOGRAPHY WRITING LANGUAGE, AN INVITATION TO READ BUT NOT TO WRITE: ANALPHABET, A COLLECTION OF THINGS THAT UNINTENTIONALLY REVEAL ASPECTS OF THE FORM OF LANGUAGE BUT CONCEAL THE ACT OF LANGUAGE, EMPHASISED BY THEIR APPARENT NAMELESSNESS. IN FACT, NAMING THEM RECALLS THE CLASSICAL DIGNITY OF ORAL LANGUAGE; ESCUTCHEONS, GROMMETS, CORE-WINDING, CURTAIN WEIGHTS, COINS, STONES, BUTTONS, RUBBER WASHERS, A POZI-DRIVE, A U-BOLT, AN O-RING, LINKS, BOTTLE-TOPS, CUP-HOOKS, CLAMPS, TRIMS, SEALERS, CLIPS, BRACKETS, SWEETS, KEYS, STRINGS, SPRINGS, NUTS, METAL, STONE, ETC.'

PUBLISHER
FUSE/FONTSHOP INTERNATIONAL

PROJECT TITLE
ALPHABET 1992

DESIGNER
PAUL ELLIMAN

PROJECT DESCRIPTION
USING A PHOTO-BOOTH AT UNIVERSITY COLLEGE LONDON, 25 PEOPLE COMMUNICATE THE EXPERIENCE OF LANGUAGE
IN ITS WRITTEN, EXPRESSED AND ASSOCIATIVE FORMS

Alphabet

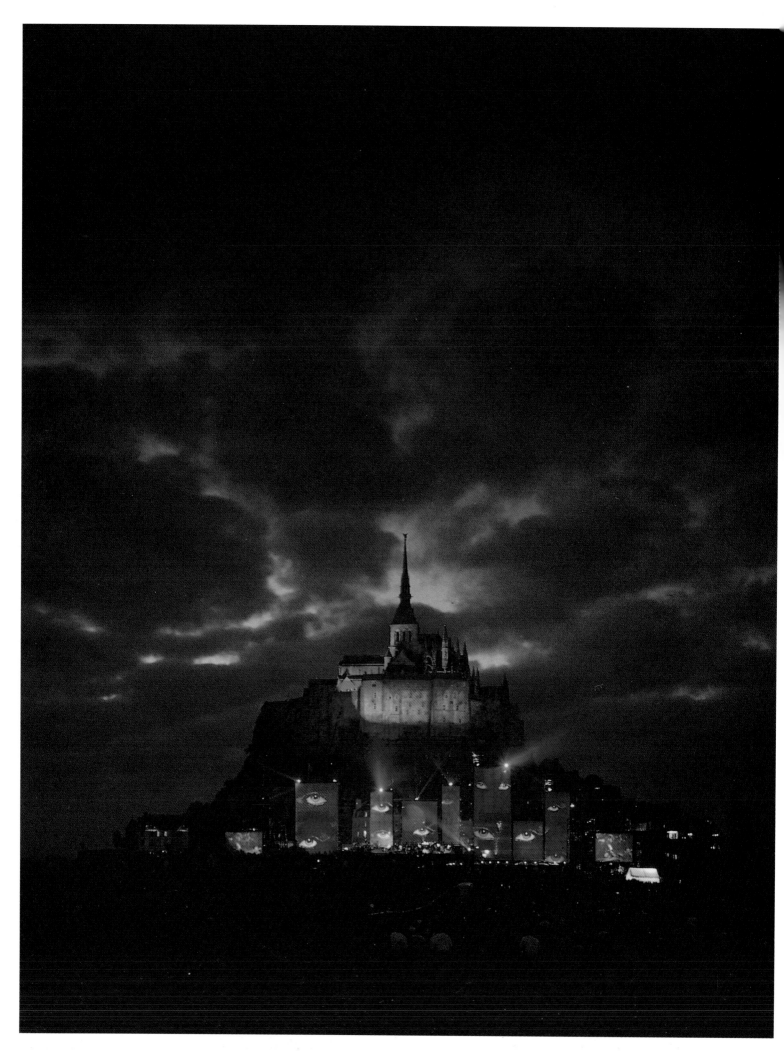

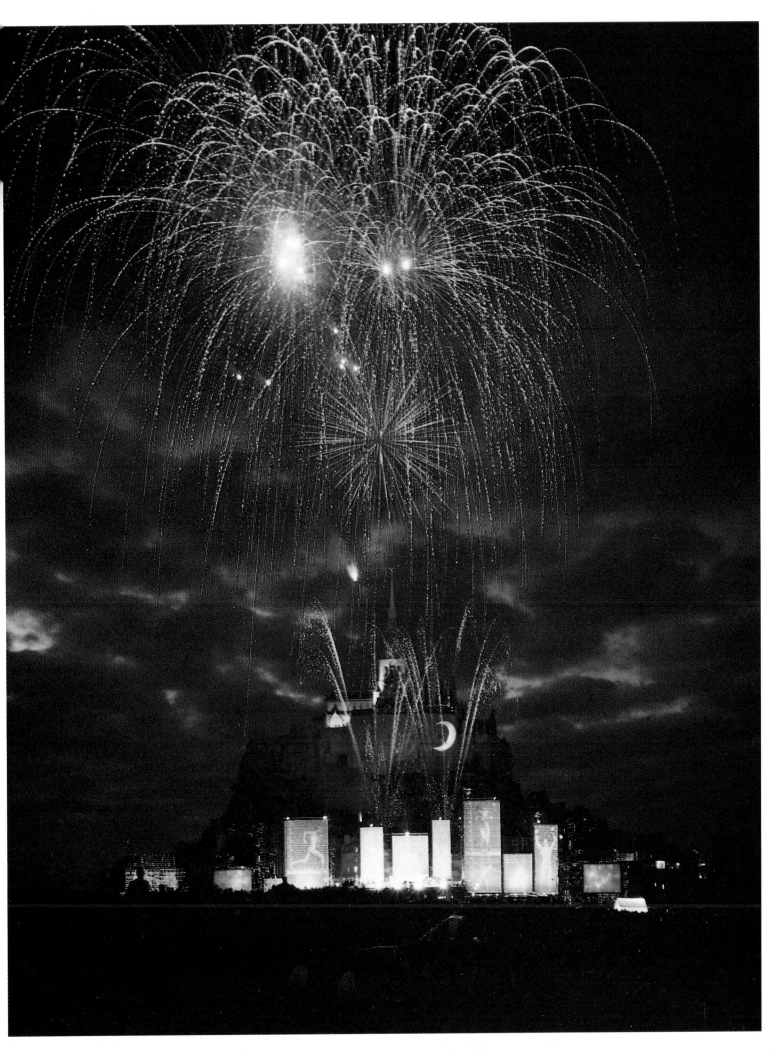

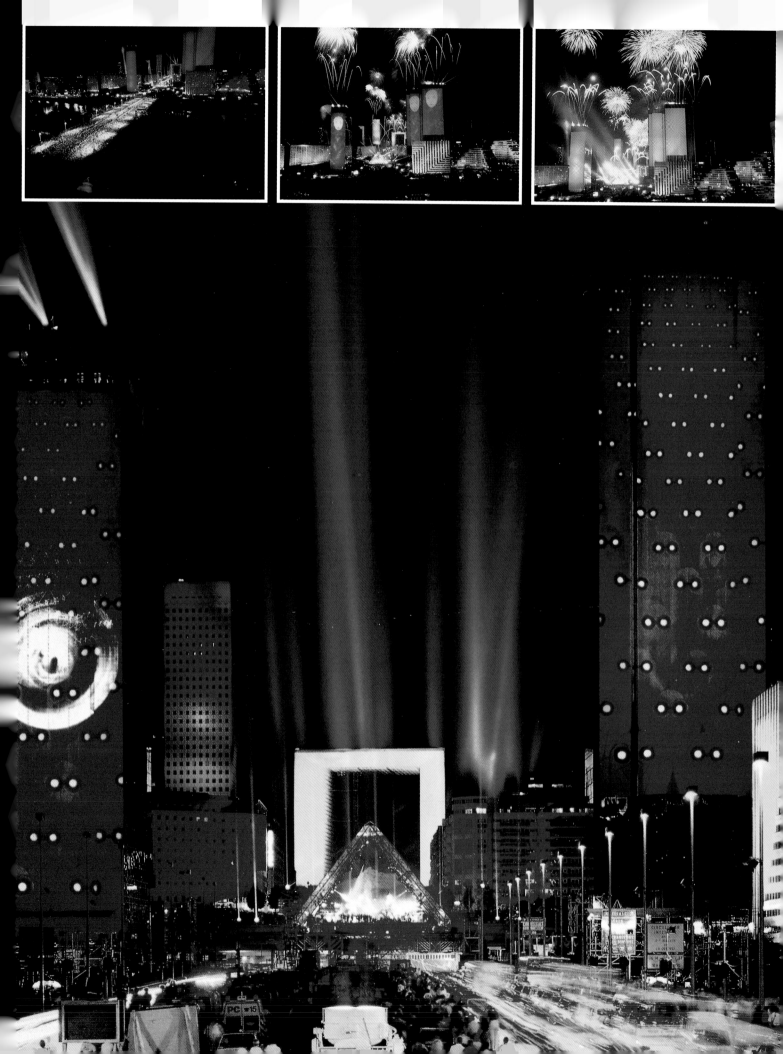

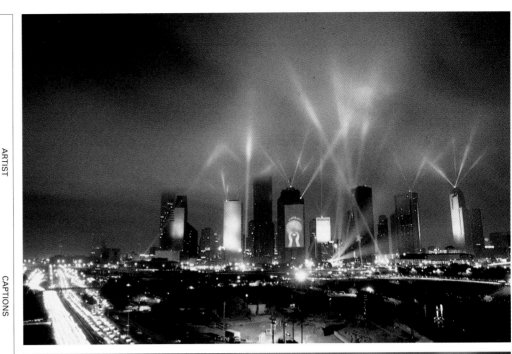

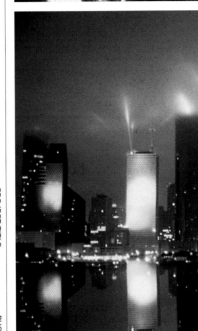
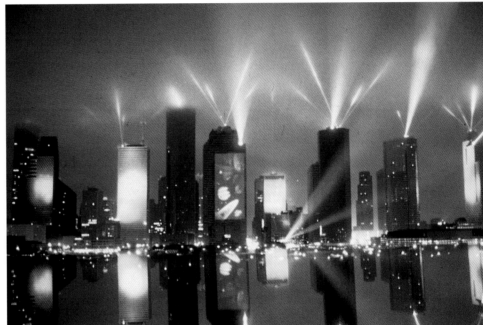

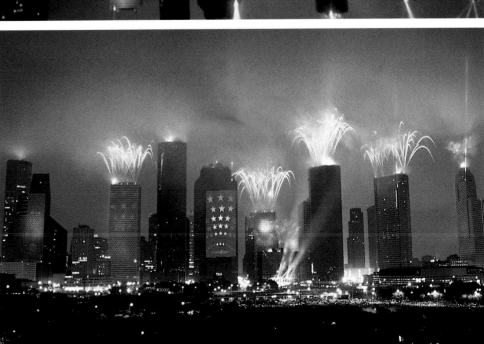

ARTIST
JEAN-MICHEL JARRE

CAPTIONS

1	2

1, 2

PROJECT TITLE
MONT SAINT-MICHEL
EUROPE IN CONCERT
THE 1993 TOUR

PHOTOGRAPHY
SERGE DELCROIX

PROJECT DESCRIPTION
FIFTEEN TOWNS AWASH WITH LIGHT AND SOUND AS
PART OF A STUNNING AND UNFORGETTABLE EUROPEAN
TOUR

CLIENT
FRENCH GOVERNMENT

ARTIST
JEAN-MICHEL JARRE

CAPTIONS

1, 2	3	4

5	6	7

1, 2, 3, 4

PROJECT TITLE
PARIS - LA DEFENSE
A CITY IN CONCERT

PHOTOGRAPHY
A FEVRIER
ALAIN BOU
E BONNIER-BEREWISE

PROJECT DESCRIPTION
CLOSING OF BICENTENNIAL OF THE FRENCH REVOLUTION
CELEBRATIONS

5, 6, 7

PROJECT TITLE
RENDEZ-VOUS HOUSTON

PHOTOGRAPHY
A DE WILDENBERG

CLIENT
CITY OF HOUSTON

'IMAGINATION AND FICTION MAKE UP MORE THAN THREE-QUARTERS OF OUR REAL LIVES.'

SIMONE WEIL

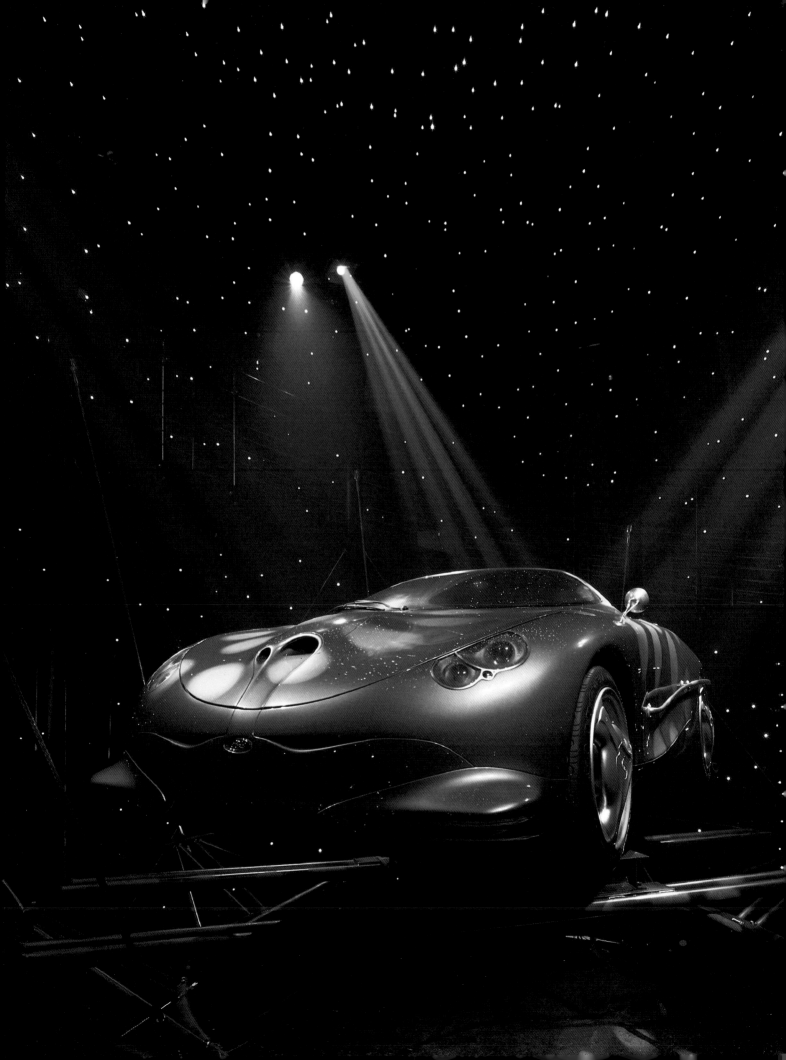

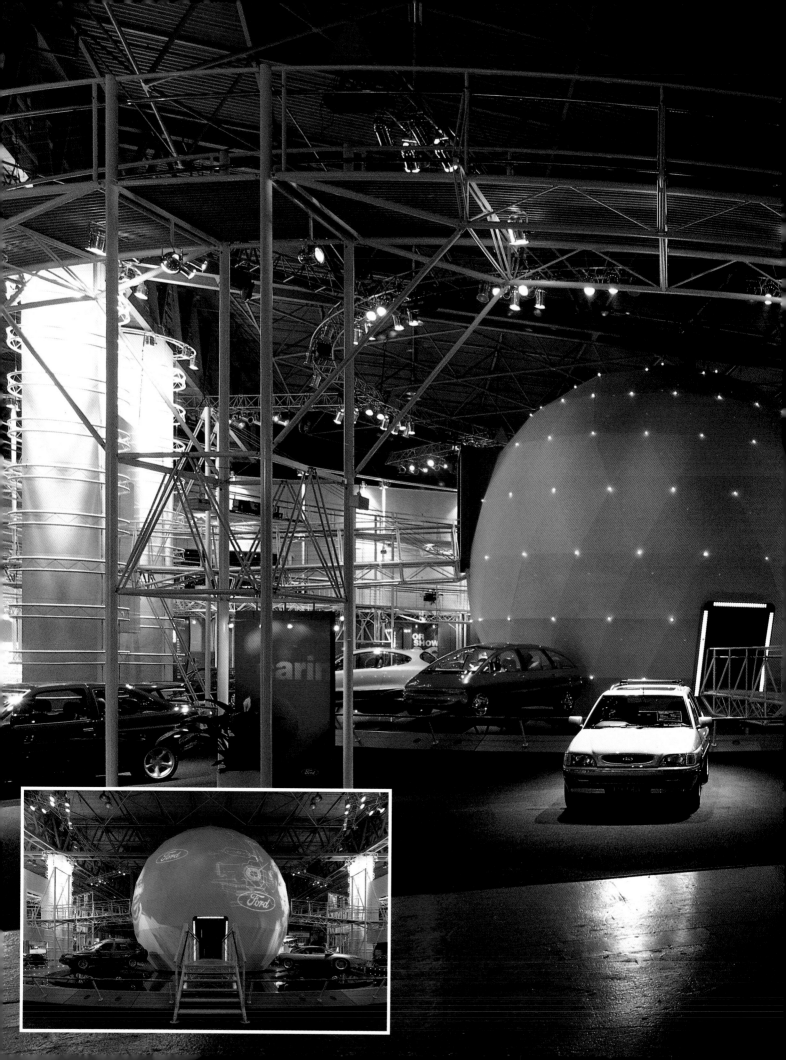

CLIENT
FORD MOTOR COMPANY

PROJECT TITLE
FORD MOTOR SHOW
EXHIBITIONS

DESIGN COMPANY
IMAGINATION

PROJECT DESCRIPTION
A 'SPHERE OF INNOVATION' ENVELOPS VISITORS IN THE WORLD OF THE
BRAND AND PROVIDES THE FOCUS FOR FORD'S 1992 PAN-EUROPEAN
MOTOR SHOW EXHIBITION PROGRAMME

P 246 AND 247 (244 AND 245 PREVIOUS)

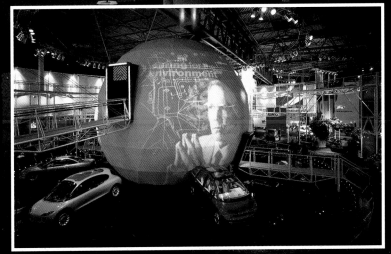

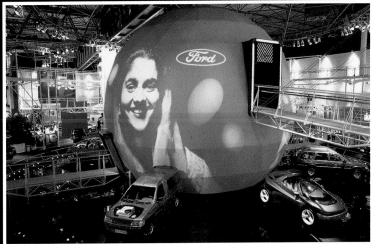

CLIENT
FORD MOTOR COMPANY

PROJECT TITLE
FORD AT THE LONDON
MOTOR SHOW 1993

DESIGN COMPANY
IMAGINATION

PROJECT DESCRIPTION
ACROSS EUROPE, FORD HAS LED THE WAY IN TRANSFORMING MOTOR SHOWS INTO EXCITING, IMAGINATIVE AND INTER-
ACTIVE LEISURE EVENTS FOR THE CONSUMER. THIS INNOVATIVE WALK-THROUGH EXPERIENCE, THEMED AROUND 'SAFETY
AND TECHNOLOGY', WAS DEVISED FOR THE 1993 LONDON MOTOR SHOW. HOUSED IN A COMPLETELY ENCLOSED 1,457 SQ
METRE SPACE, THE FORD EXPERIENCE COMBINED THEATRICAL TECHNIQUES WITH AUDIO-VISUAL TECHNOLOGY, GRAPHICS
AND VIDEO

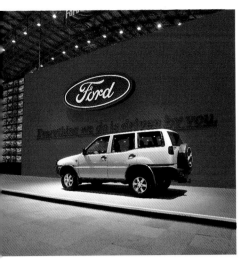

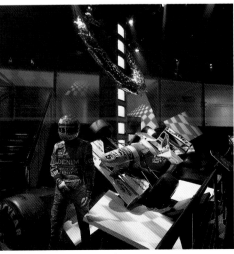

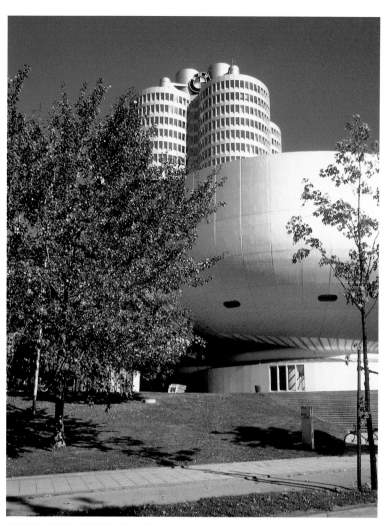

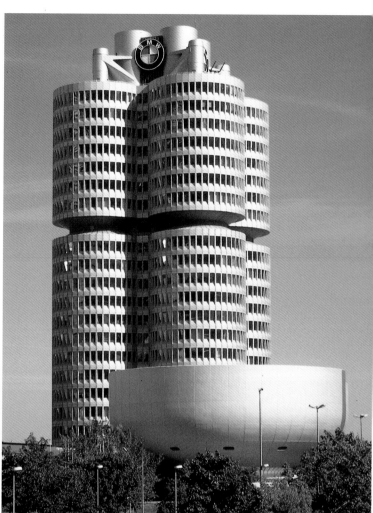

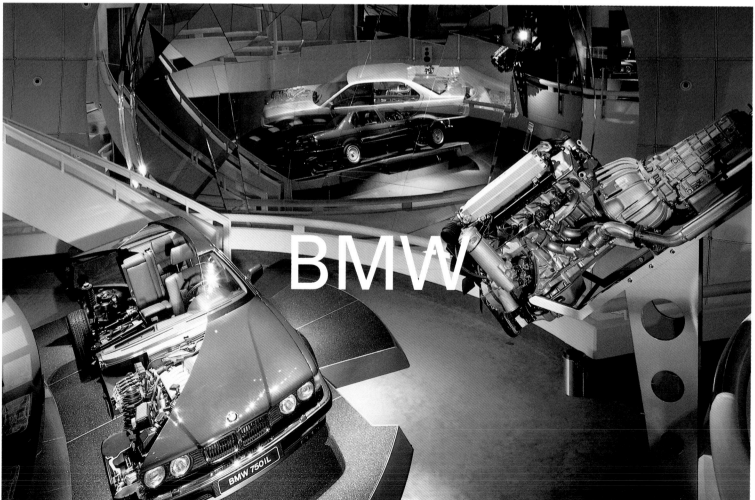

BMW

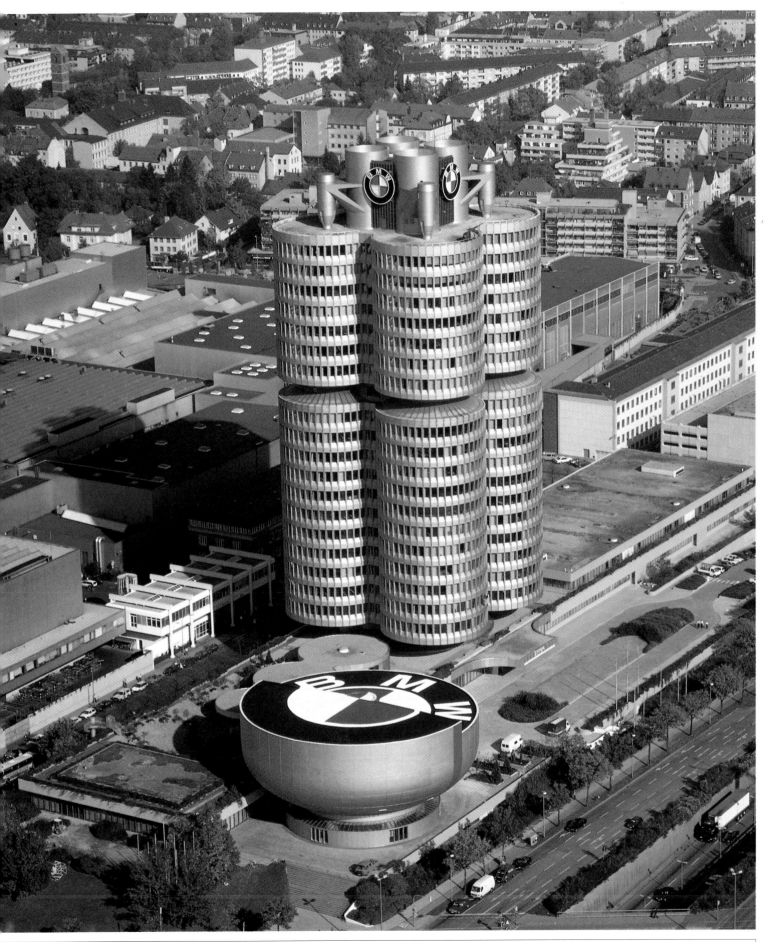

CLIENT	PROJECT	ARCHITECT	PROJECT DESCRIPTION
BMW AG	BMW MUSEUM	PROFESSOR KARL SCHWAUZER	BMW'S HEADQUARTERS AND THE BMW MUSEUM, MUNICH 1973
		FILM ARCHITECT	
		ROLF ZEHETBAUER	

AMLUX CENTRE PROVIDES A PHYSICAL
EXPRESSION OF THE TOYOTA BRAND.

ITS SIX FLOORS INVITE THE VISITOR TO
EXPLORE THE WORLD OF TOYOTA
THROUGH A BEWILDERING ARRAY OF
INTERACTIVE, INFORMATIVE AND ENTER-
TAINING ENVIRONMENTS AND PRESEN-
TATIONS. THESE INCLUDE A HOLOGRAPHIC
FACTORY, FUTURE CAR DESIGN STUDIO,
TECHNOLOGY GALLERY, SURROUND
SOUND THEATRE, BODY SONIC AND
AROMA SYSTEMS, MEDIA STATIONS AND
A LIVE EVENTS FLOOR FOR CONFERENCES
PARTIES, DINING AND CONCERTS.

TOYOTA'S AMLUX CENTRE IS A TESTIMONY
TO THE POWER OF DESIGN TO CREATE
DIALOGUE AND BUILD RELATIONSHIPS
THROUGH INDUCED EXPERIENCES.

CLIENT
TOYOTA MOTOR
CORPORATION

DESIGN COMPANY
DENTSU INC

ARCHITECTS
NIKKEN SEKKEI LTD
TAKENAKA CORPORATION

PROJECT DESCRIPTION
TOYOTA AUTO SALON AMLUX, TOKYO

P 252 AND 253

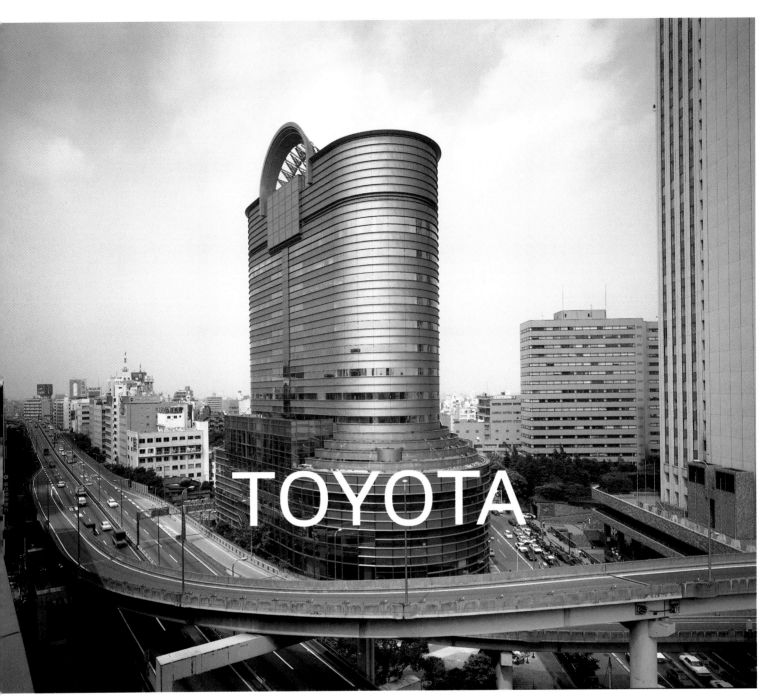

TOYOTA

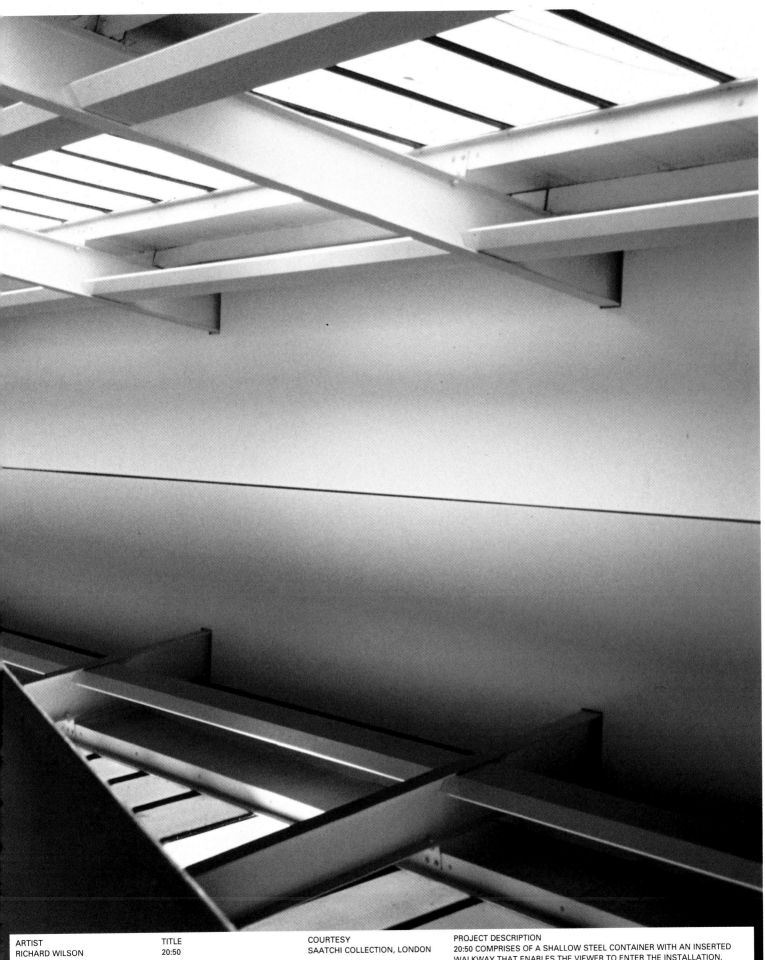

ARTIST	TITLE	COURTESY	PROJECT DESCRIPTION
RICHARD WILSON	20:50	SAATCHI COLLECTION, LONDON	20:50 COMPRISES OF A SHALLOW STEEL CONTAINER WITH AN INSERTED WALKWAY THAT ENABLES THE VIEWER TO ENTER THE INSTALLATION. THE CONTAINER IS FILLED WITH SUMP OIL WHICH ACTS LIKE A REFLECTING POOL. THE DENSITY OF THE OIL MAKES IT IMPOSSIBLE TO ESTIMATE ITS DEPTH

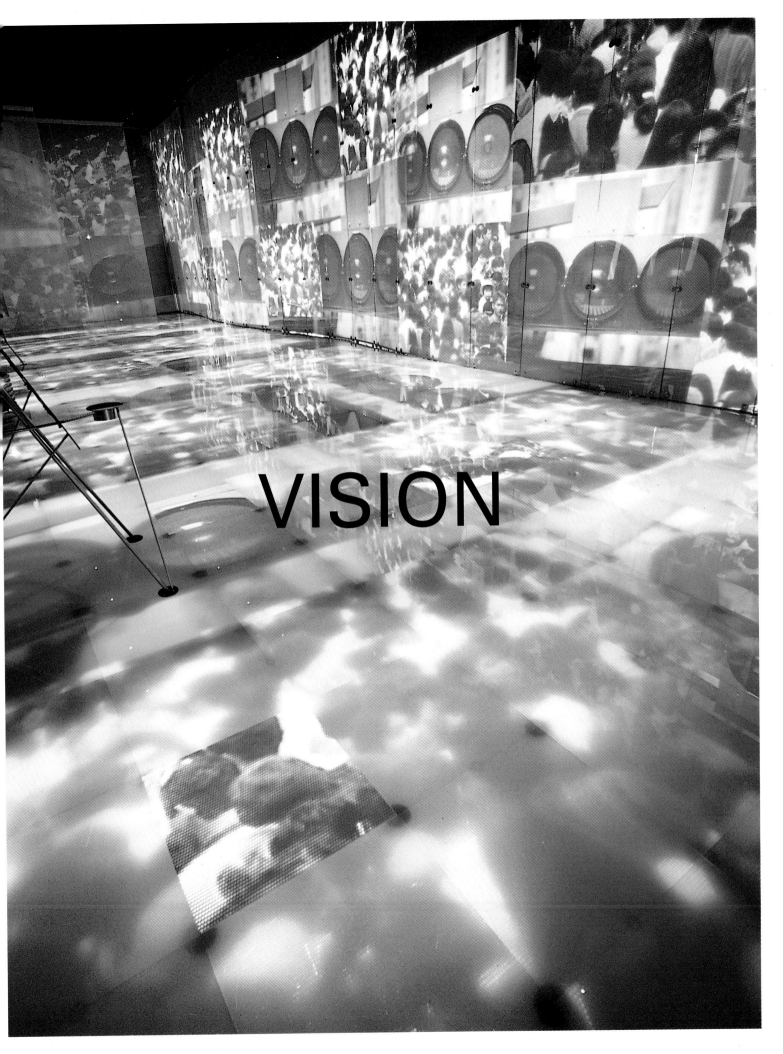

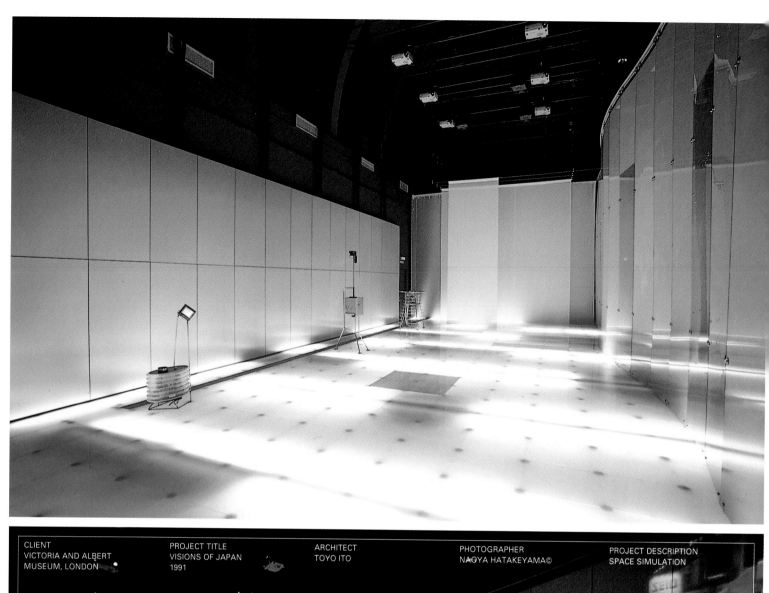

CLIENT
VICTORIA AND ALBERT
MUSEUM, LONDON

PROJECT TITLE
VISIONS OF JAPAN
1991

ARCHITECT
TOYO ITO

PHOTOGRAPHER
NAOYA HATAKEYAMA©

PROJECT DESCRIPTION
SPACE SIMULATION

P 258 (AND 257 PREVIOUS)

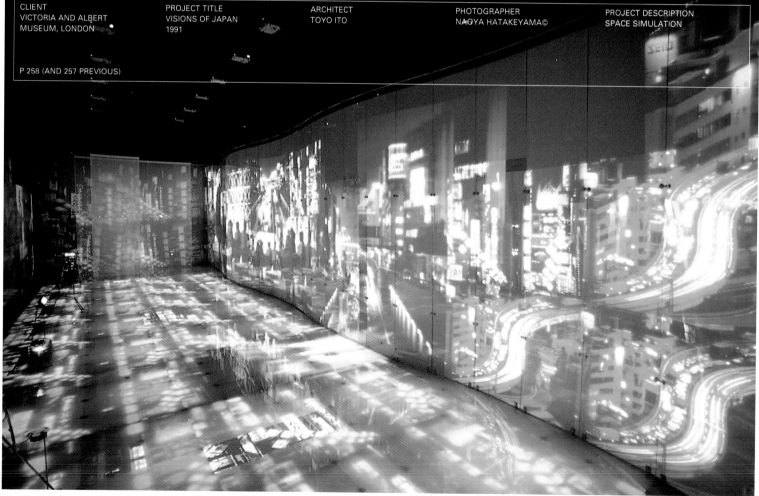

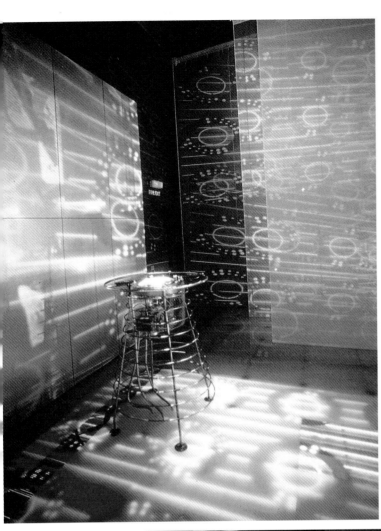

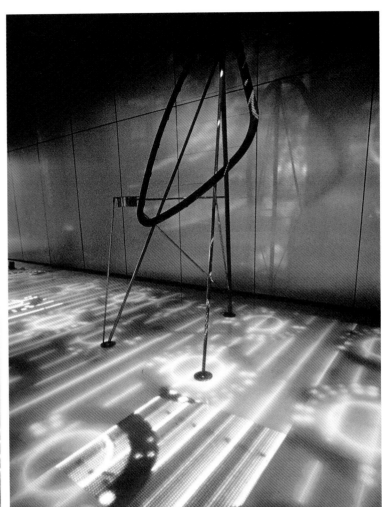

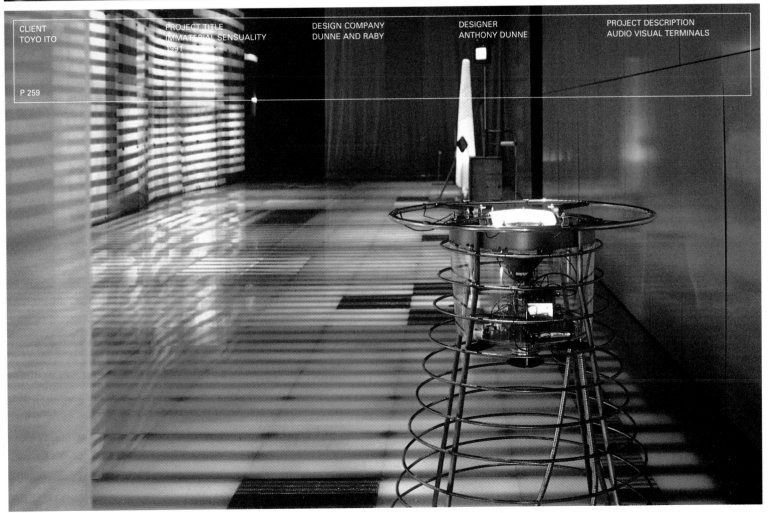

CLIENT	PROJECT TITLE	DESIGN COMPANY	DESIGNER	PROJECT DESCRIPTION
TOYO ITO	IMMATERIAL SENSUALITY 1991	DUNNE AND RABY	ANTHONY DUNNE	AUDIO VISUAL TERMINALS

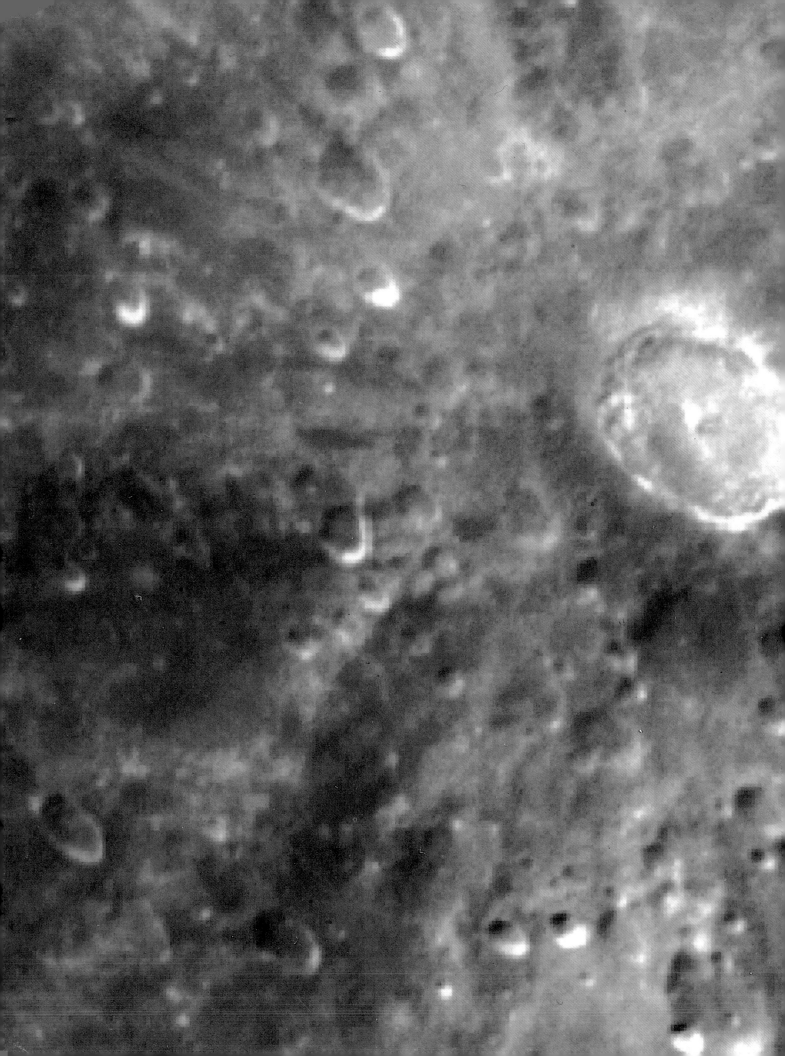

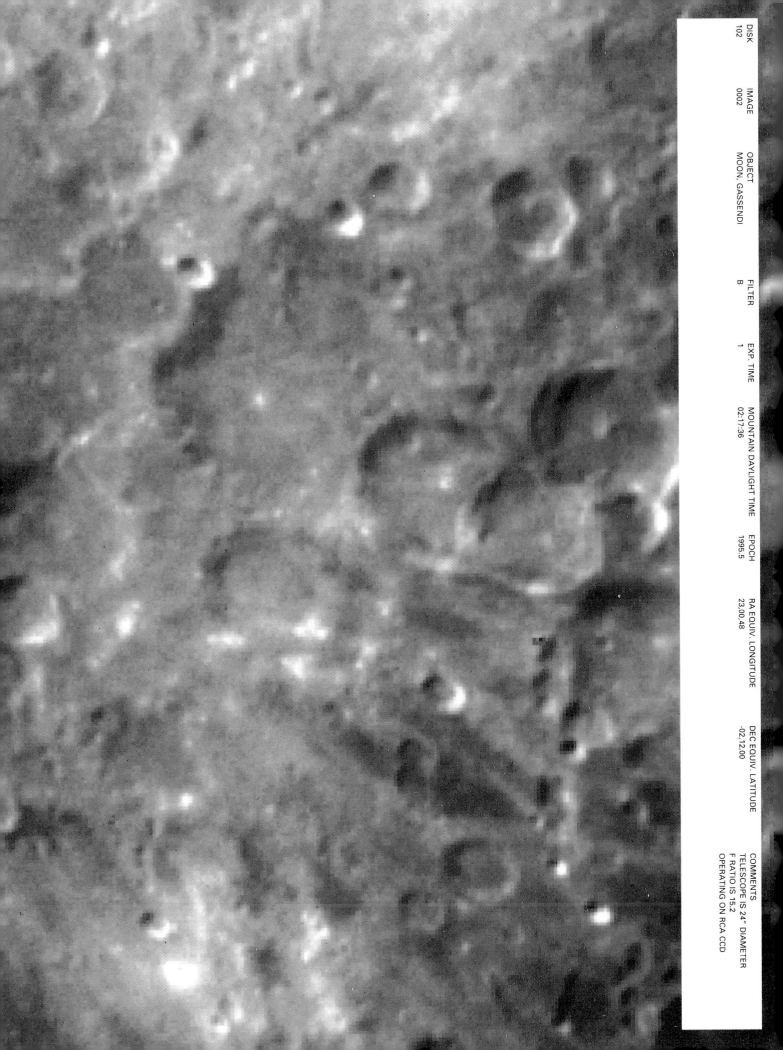

DISK
111

IMAGE
0010

OBJECT
MOON

FILTER
B

EXP. TIME
0.1

MOUNTAIN DAYLIGHT TIME
03:43:07

EPOCH
1995.5

RA EQUIV. LONGITUDE
23.00.48

DEC EQUIV. LATITUDE
-02.12.00

COMMENTS
TELESCOPE IS 24" DIAMETER
F RATIO IS 15.2
OPERATING ON RCA CCD

DISK
115

IMAGE
0014

OBJECT
MOON

FILTER
B

EXP. TIME
0.1

MOUNTAIN DAYLIGHT TIME
03:48:15

EPOCH
1995.5

RA EQUIV. LONGITUDE
23,00,48

DEC EQUIV. LATITUDE
-02,12,00

COMMENTS
TELESCOPE IS 24" DIAMETER
F RATIO IS 15.2
OPERATING ON RCA CCD

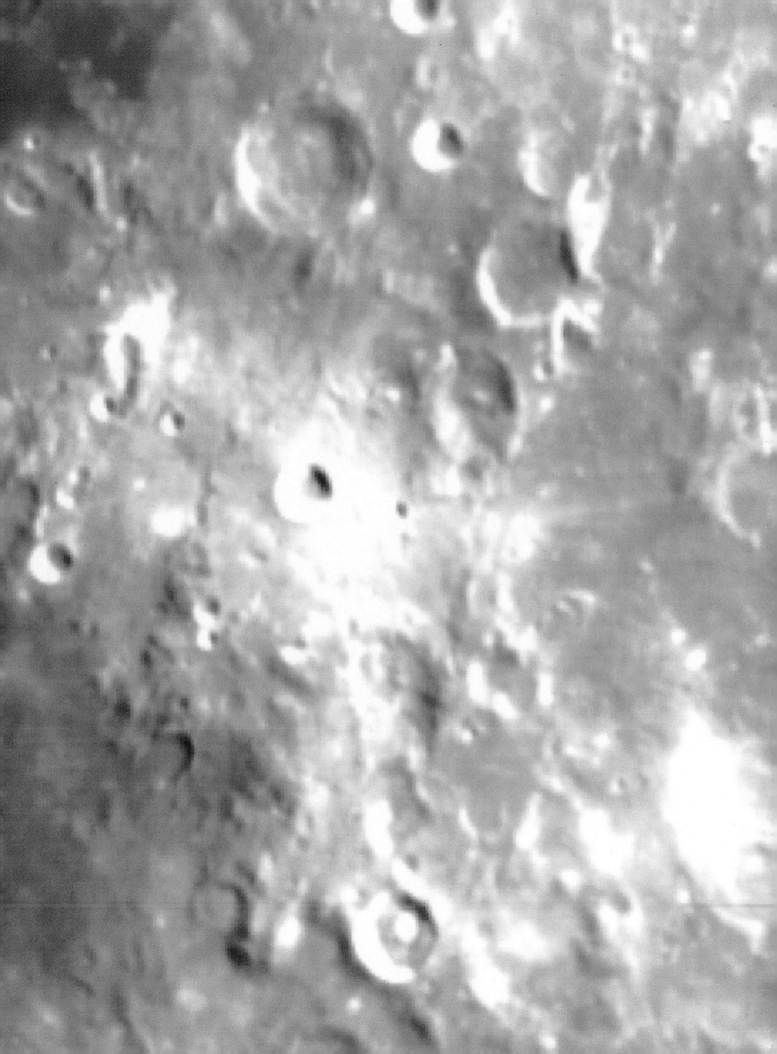

DISK
106

IMAGE
0005

OBJECT
MOON, COPERNICUS

FILTER
B

EXP. TIME
0.1

MOUNTAIN DAYLIGHT TIME
03:34:50

EPOCH
1994.5

RA EQUIV. LONGITUDE
23,00,48

DEC EQUIV. LATITUDE
-02,12,00

COMMENTS
TELESCOPE IS 24" DIAMETER
F RATIO 15.2
OPERATING ON RCA CCD

DISK
123

IMAGE
0020

OBJECT
M-15

FILTER
R

EXP. TIME
45

MOUNTAIN DAYLIGHT TIME
04:46:12

EPOCH
1995.5

RA EQUIV. LONGITUDE
21,29,42

DEC EQUIV. LATITUDE
12,09,00

COMMENTS
GLOBULAR CLUSTER

OVERLEAF